THE PERFORMING ART OF THE
AMERICAN AUTOMOBILE

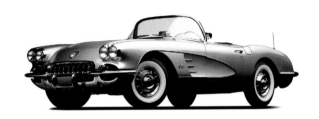

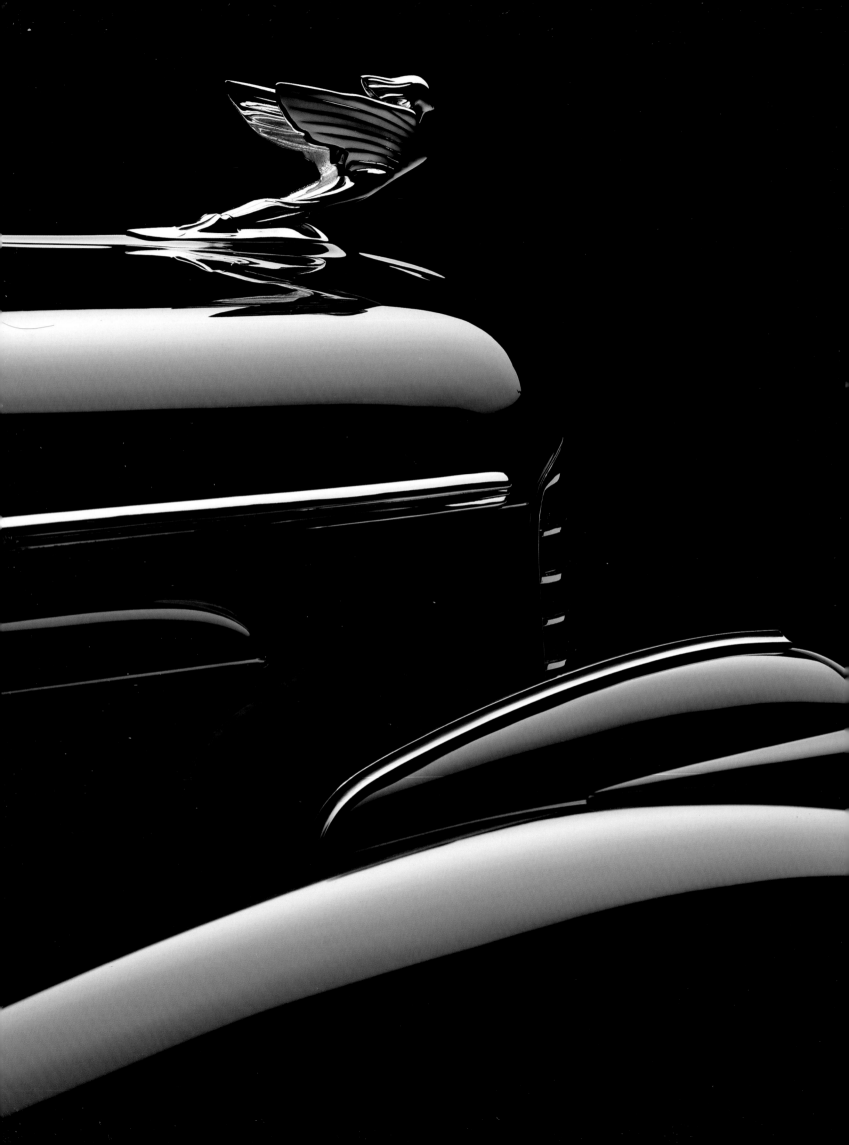

THE PERFORMING ART OF THE
AMERICAN AUTOMOBILE

The Hendricks Collection on Exhibit at the Gateway Colorado Auto Museum

BY JONATHAN A. STEIN

INTRODUCTION BY JOHN S. HENDRICKS

PHOTOGRAPHS BY MICHAEL FURMAN

ILLUSTRATIONS BY PETER HEARSEY DESIGN BY SUSAN MARSH

COACHBUILT PRESS
PHILADELPHIA

CONTENTS

INTRODUCTION

Dreams in Art and Steel

JOHN S. HENDRICKS

At an early age I discovered that cars reveal something very intriguing about the human spirit. Long before I succumbed to the sculptural beauty of the Duesenbergs, Packards, and Auburns of the 1930s, I experienced cars as magic machines that provoked dreams of adventure on the open road.

When I was five years old in 1957, I had already been captivated by a world full of automobiles. I knew all the names and model years of the cars we passed on the highways and my father would delight in showing off my knowledge to his friends. To a child growing up in

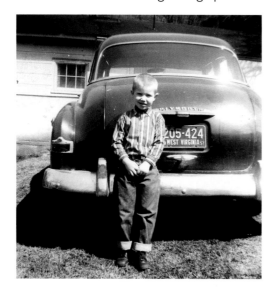

the mountains of West Virginia, cars represented adventure and exploration. My imagination was fueled by my father's beautiful old road maps from the 1930s that romanticized journeys on the American road. As a young man, Dad had traveled extensively in the western United States and he regaled me with stories of his journeys. He still had his old road maps that helped me understand where his adventures took place. I fondly remember sitting behind the wheel of his parked 1952 Plymouth Cranbrook with the well-worn Sinclair Oil maps of Colorado and Utah by my side as I fancied myself driving across the country to the wild West. For some reason, Provo, Utah, was a favorite fantasy destination. I guess I just liked the sound of that place, Provo.

And so to me, from the very beginning, a car represented an adventure machine that could transport me to places unknown. All of the wonders of the United States seemed within reach if only I could drive the dowdy Plymouth in the driveway.

Our family moved to Huntsville, Alabama when I was six. It was 1958 and Huntsville was the center of the nation's

new space program. Werner Von Braun and his rocket team were hard at work on the Redstone Rocket that would carry a satellite into orbit. Little did I know that orbiting satellites would someday make my career in cable television possible.

It was in the summer of 1958 when my big sister's new boyfriend came over for a visit in a car I'll never forget. My life changed that day as my sense of the aesthetic was abruptly awakened by the glistening curves of the 1958 Corvette that literally roared into my life. I simply could not stop touching every curve and every piece of chrome. After all the gawking neighbors had left, I was still admiring the marvelous machine. The sculpted form of the Corvette that had emerged from Harley Earls' design team at General Motors had successfully produced the first true art experience for a seven-year-old boy. And it was art that rolled and growled. I still remember the warm wind in my face, the head-jerking acceleration, and being pushed tight against the door in left turns taken at speeds which would have sent the Plymouth tumbling off the road. I fell in love with speed and power and art all in one summer afternoon.

Like countless other boys across America, I busied myself with model car building and relished the successful completion of every Chevy, Ford, and Chrysler. In school, I perked up when the teacher told us where rubber came from, how friction stopped a car or how a battery stored energy. Science, nature, history, and geography just seemed to sink in more when there was a car involved.

On my 16th birthday in the spring of 1968, I took possession of my first car, a gift from my sister and her husband. The black 1959 Ford Galaxie 500 was such a beast with its 352 cubic-inch, 300-horsepower Thunderbird V-8 engine. What the massive Ford lacked in design art was more than made up in roaring performance. I soon ruined the automatic transmission by burning rubber at 40 mph by revving the engine in neutral and shifting to 2nd gear much to the delight of my friends . . . at least until the day the transmission nearly twisted out from under the car. I was grounded for a few months until a new mistress of motion beckoned to me.

One simply cannot understand the allure of the Camaro unless you were a teenage male somewhere in America

in 1967 and 1968. For over a year I plotted with my father on how such a prize could be obtained. A key number is still etched in my mind: $82.17. According to my father, that was the monthly car payment required for the purchase of a new Camaro with a sticker price of $2,575. An after school job and my parents' generosity resulted in a 1968 white Camaro coupe that was the envy of my classmates.

To this day, the curves of the Camaro coupe capture a design movement that transcends function and stimulates an unmistakable experience of sculptural art by the beholder. Auto enthusiasts today, my son included, eagerly await the rebirth of the 1969 Camaro courtesy of modern design talents like Chip Foose and modern coachbuilders like Unique Performance.

In the decades since I was a teenager transfixed by the Camaro, I have had the pleasure of owning and experiencing automobiles, both foreign and domestic, that combine automotive art with boisterous performance. While I treasure my experiences on winding country roads in a Porsche, I continue to be fascinated most by the American spirit of automotive style and performance. From E.L.

Cord's and Fred Duesenberg's powerful and elegant Model J of the 1930s to Steve Saleen's stunning S7 — that set a new track record at LeMans in 2002 — American ingenuity for achieving performance in a vehicle clothed in sculptural art should be recognized and celebrated. The 1939 Packard by Howard 'Dutch' Darrin and the 1954 Olds F-88 by Harley Earl offer ample proof that America is second to none in achieving "performing art" in automotive design.

There is a story to be told about the pioneering spirit of America's automotive entrepreneurs. There are tales of innovation, engineering, design, and business success and failure that offer lessons to all who desire to comprehend the workings of the free enterprise system in addressing our need to move as a society. Telling these stories is the mission of the Gateway Auto Museum, an educational facility that our family created in Gateway, Colorado.

Yes, I made it to Colorado. It was inevitable. And when you visit our auto museum located in the spectacular red rock canyon country of western Mesa County, Colorado, you'll know why. This is a place where remote journeys into

the unspoiled American West by car, by foot, by horseback, and by raft are still possible. This is where the planet opens up in awe-inspiring canyons that reveal the ancient story of the earth's formation. It is a place where the lush ponderosa pine forests of the Colorado plateau intersect with the desert under the watchful gaze of the snow-covered La Sal Mountains of Utah. This is the country where the car commercials are filmed, the place where SUVs are perched atop towering buttes and rock monuments. It is the place that symbolizes the American spirit of adventure and exploration. It is the place for me.

Working with The Nature Conservancy and the Mesa Land Trust, our family is conserving thousands of acres of pristine wilderness lands surrounding the old mining settlement of Gateway. The nearby Gateway Canyons Resort serves as a base for unique eco-friendly adventures on our private conservation lands. All structures, including the auto museum, are constructed in adobe-style southwestern architecture that are at peace with the surrounding high-desert landscape.

The Gateway Colorado Auto Museum is home to the Hendricks Collection. These are the cars that for me represent America's century-long quest for "performing art" in vehicles that allow us all to undertake our personal journeys of discovery. Through the years, I've developed an acquisition list of those cars that "speak" to me about American aspirations for art, performance, and adventure. If I had to pick one car that best illustrates the collection theme, it would be the 1937 Hudson Terraplane that clearly represents the achievement of performing art in the American automobile.

From Henry Leland's elegant little 1906 closed Cadillac coupe that kept the driver protected from the elements to the large and powerful 1961 Chrysler

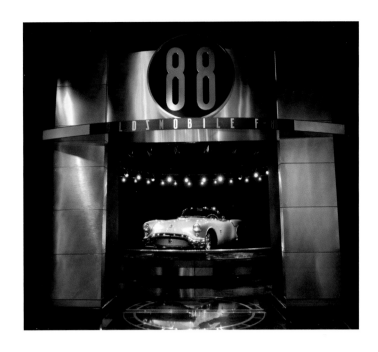

300G with its graceful swept-wing styling, American car builders have always had more in mind than utility. Through the years, our country's car designers have given full expression to the American spirit of adventure and style. We have wrapped ourselves in their metallic visions of art and power and we have been forever changed as a society. Our changing moods and artistic tastes have been frozen in time and steel. Cars are objects worthy of study.

I hope you enjoy the book. Jonathan Stein's insightful prose recounts the story of each car and its era with enlightening style. Susan Marsh's elegant graphic design allows the reader to make the important visual connections that bring the subject matter to life. With his stunning illustrations, Peter Hearsey has brought to life many of the creative and business forces behind the American Automobile. And as you will see, Michael Furman's spectacular photography has brilliantly captured what many of us treasure in our lifelong love affair with the American car.

Gateway, Colorado
January 2006

PREFACE

The Automobile in Context

JONATHAN A. STEIN

Michael Furman's beautiful photos in *The Performing Art of the American Automobile* depict the cars on display at the Gateway Colorado Auto Museum. Although every one of these gleaming examples of America's automotive past is part of the Hendricks Collection, this book is not just about a museum, a single collection or the individual cars.

Quite simply, this book is about a full 100 years of the American automobile. The earliest car in the collection is a 1906 Cadillac and the latest is a 2006 Ford Mustang Stallion by designer and custom car builder Chip Foose. When the Cadillac was built, the automobile industry was still in its infancy and mass production with a moving assembly line was still seven years away.

It's fitting that moving assembly and modern mass-production came together at Ford's Highland Park plant in August 1913. The Ford Model T put more Americans on wheels than any other car for the first half of the 20th century. Not only did it provide basic personal transportation, it could be adapted to many

types of commercial and agricultural use. It was also the car that introduced many intrepid drivers to the joys and perils of motor sport. The impact of the car was so great that it's equally fitting that the Gateway Colorado Auto Museum displays a pair of these iconic Fords.

Wagons had long trekked westward across the vast expanse of North America. However, the real business of settling America's interior didn't take place until railroads linked East and West. Towns and cities grew and previously remote regions could be settled. The automobile allowed even greater movement out of major population centers and facilitated the growth of suburbia. This forever changed how and where Americans lived, worked and raised their families.

During the 20th century, the automobile and American society became so deeply intertwined as to be indivisible. As a result, it is impossible to address the automobile out of context. The automobile could never have become a success without good roads and there was no need for good long-distance roads until the automobile became a viable and

reliable alternative to the railroad. With those roads came an entire supporting infrastructure, including service stations, roadside restaurants, tourist courts (motels) and other related business. To allow the new motoring traveler to find his or her way, good maps were also essential. At first that job fell very much to the privately-supported AAA and its blue book travel guides. Subsequently, the many oil companies joined in providing colorful and detailed maps.

With roads, maps, services and a burgeoning American auto industry, the motorcar quickly evolved from an exclusive play-toy of the wealthy to an essential tool for people in all walks of life. Quite literally, it also became one of the driving forces behind the nation's economy.

The cars contained in every section of this book reflect the era in which they were built and driven. *Mass Mobility* is about Americans discovering motorcars by the thousands, while *Timeline* focuses on the rapid technical and stylistic development of the automobile. *Hollywood High Style* showcases some of the fabu-

lous automobiles that cut such a swath through American culture at a time when the haves and have nots were separated by an incredible gulf. *Production Resumes* centers on the auto industry's post-war conversion back to a civilian economy in a seller's market. The 1950s were a time of incredible hope and prosperity, and that state of mind and economy is reflected in *Fifties Style*. *Detroit Muscle* is all about the age of large and powerful engines — just before emissions and crash regulations put an end to the day of the factory hotrod. *American Horsepower* is a look at the country's obsession with personalizing a car's appearance and performance.

To follow the automobile from its earliest days on rough dirt tracks to an age where four and six lane highways cross 3,000 miles of mountains, plains, deserts and rivers is a journey of 100 years. To the modern eye, the 1906 Cadillac looks like a beautifully-finished telephone booth — also an antique — on wheels. Capable of speeds akin to those achieved by a team of horses and a light carriage, the Cadillac offers a mighty contrast to the 2006 Mustang Stallion. With 325 horsepower — 295 more than the Cadillac — the Stallion will reach 150 mph with a level of comfort and safety unimagined 100 years earlier.

So please, walk through this book just as you would walk through the Gateway Colorado Auto Museum. Think of each automobile, not as a car or as a piece of art, but as a symbol of the age it represents. Think about the narrow two-lane roads, the roadside restaurants and the political and social climate of the day. If you're able to place yourself in the very time when one of these cars plied the roads of America, John Hendricks, Michael Furman and I have done our jobs well.

Reading, Pennsylvania
March 2006

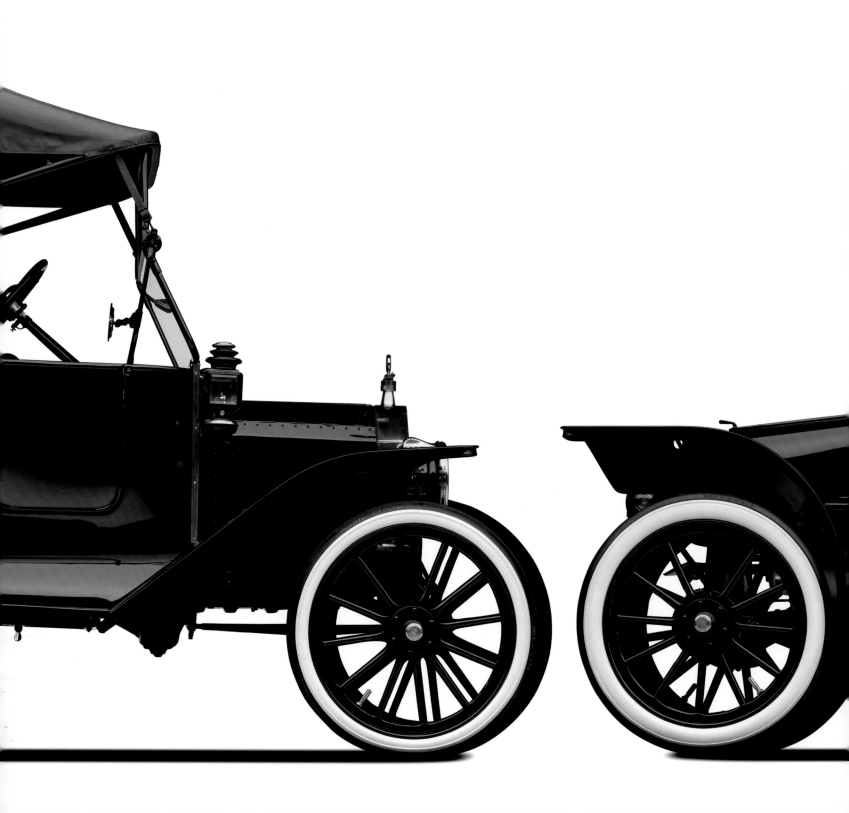

MASS MOBILITY

America Gets Behind the Wheel

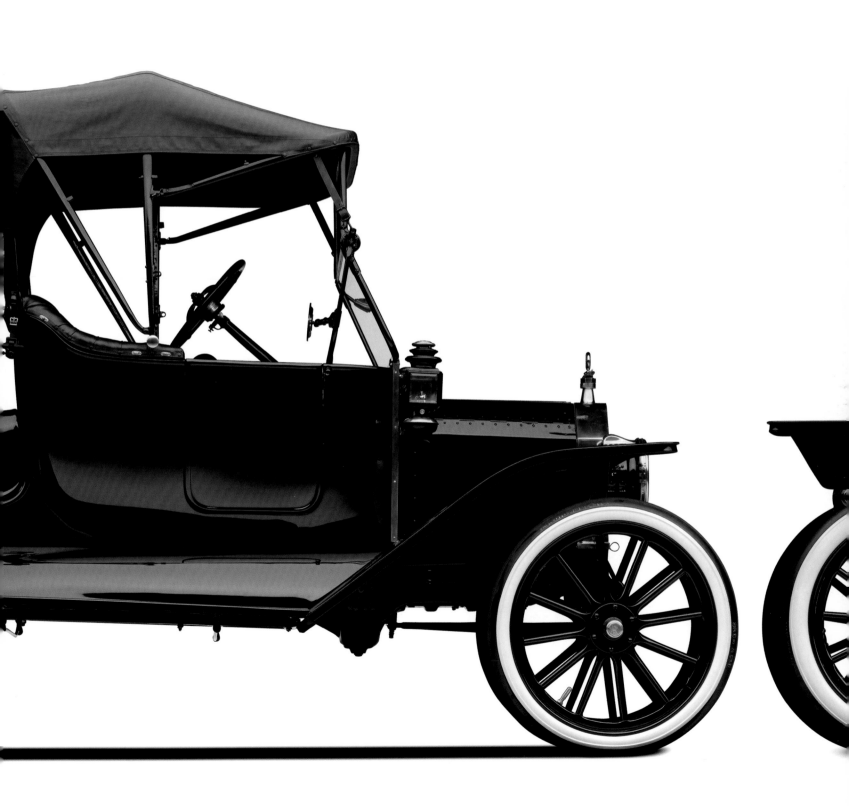

As the Twentieth Century opened, the United

States relied largely on railroads and horses for commerce and transportation. The vast majority of Americans saw no need to change the status quo. In fact, many citizens saw the motorcar and the motorist as an outright menace that should be thwarted at any cost.

Alexander Winton

Railroads were relatively quick, safe and reliable. Shortly after the turn of the century, one could hop on a train in New York and be in Chicago 20 hours later, while San Francisco was another 70 or so hours away from the Windy City. In 1903, Dr. Horatio Nelson Jackson and Sewell K. Crocker attempted the first trans-continental automobile trip. Their Winton faced all sorts of natural obstacles and breakdowns before successfully completing the epic journey in 63 days.

The negative response from thousands of farmers and others resistant to change was just one of the reasons America wasn't ready for the automobile. The sad truth was that at the turn of the century, the United States only had about 150 miles of paved roads — all of which were confined to cities and towns. There weren't enough good roads to justify more automobiles — and there weren't enough automobiles to warrant the expense of developing those roads.

Despite the lack of roads, men named King and Duryea and Winton and Olds persisted with the concept of the automobile. Along the way, they met as much resistance from the mud-clogged roads as they did from the farmers, communities and local authorities.

Duryea and Winton were among the first to market commercially available internal combustion–powered motorcars, although other men throughout the country were tinkering away in barns and sheds. There were literally hundreds of would-be automakers scattered all over the country. Their backgrounds varied from blacksmiths and wagon makers (John M. Studebaker) to bicycle manufacturers (George and Percy Pierce) to makers of machine tools (Henry Leland of Cadillac).

At first, automobiles were little more than play toys for the very rich. The motorcar was great for scorching along a hard packed road on a fine summer's day, but was best

suited for the carriage house come winter's foul weather. Everything changed as cars became more powerful, increasingly reliable and able to withstand rain, snow and cold weather. Greater creature comforts included folding tops and side screens, as well as the first fully-enclosed cars. Those changes allowed Winton to produce cars in series and Ransom Eli Olds to turn out thousands of Curved Dash Oldsmobiles — and it created the perfect mood into which Henry Ford would introduce his amazing Model T.

These wonderful early cars captured people's imagination, spirit of adventure and freedom. The fully-enclosed 1906 Cadillac is lovely in both its anachronistic exterior design and its execution. The Pierce-Arrow shows quality at every turn and the Winton was a thoughtfully-conceived and well-made machine. However, it was Henry Ford's Model T that changed the world and put Americans on wheels by the millions.

Henry Ford

Although the two Model Ts featured in the following pages started out as very similar cars separated by just two years, they represent two very different ideals of the automobile. The 1914 is a Model T runabout exactly as conceived by Henry Ford. It was incredibly strong and reliable transportation for two people. The yellow 1912 "speedster" began as very much the same car, but was adapted to the needs of the individual motorist in a uniquely American way. As a result, few cars could simultaneously be so alike and so different — the T was the first affordable car built in huge volumes for everyman and it was the first car that thousands of young motorists used as the foundation for their unique vision.

All of these cars joined together to make American society one that thrived on independence. It was an independence that simply couldn't be achieved based on a set schedule for trains and coaches. It could only be attained according to a man's own watch and his ability to crank over his motorcar and take to the open road when and where he saw fit.

1906 CADILLAC MODEL H COUPE

MODEL: H | STYLE: TWO-DOOR COUPE | SERIAL NUMBER: 21910

The Cadillac Automobile Company was founded from the remains of the Henry Ford Company in 1902. William H. Murphy and Lemuel W. Bowen, who had financed Ford's early manufacturing effort, called upon Henry Martyn Leland to evaluate the financially troubled company with a view towards liquidation. Leland was an obvious choice because of his background in precision machine tooling and engine design. In fact, his powerful 10 horsepower single-cylinder Leland and Falconer engine had been considered by the Olds Motor Works to replace the engine in the Curved Dash Olds. Although not adopted by Olds due to time and tooling considerations, the highly-efficient engine became the cornerstone of a new automobile that would be called the Cadillac.

As a result of the agreement that prohibited the use of the Ford name, the new company was named after the French explorer, Le Sieur Antoine de la Mothe Cadillac, who discovered Detroit in the early 18th Century. The first Cadillacs appeared in 1903 and were small runabouts powered by that Leland and Falconer horizontal engine mounted beneath the passenger compartment.

Leland's prior machine tool and gear manufacturing company had been known for its incredible precision and adherence to the strictest manufacturing standards. That reputation soon extended to the Leland Cadillacs which were known as carefully-conceived and beautifully-executed automobiles of the highest quality and a price that matched.

Cadillac's first closed car, dubbed the Osceola, was built in 1905 on a single-cylinder chassis. For many years, the Osceola served as H. M.'s personal transportation. Leland must have liked the upright Fisher-bodied coupe because, in 1906, the Model H became the first Cadillac chassis to be offered with a two-door coupe body produced in series. Reminiscent of the Osceola, the styling of the attractive Model H coupe was still very much rooted to the era of the horse-drawn carriage. Such closed cars were very unusual at a time before safety glass. Most automobiles of the day reserved glass for the front windshield only. A folding fabric top

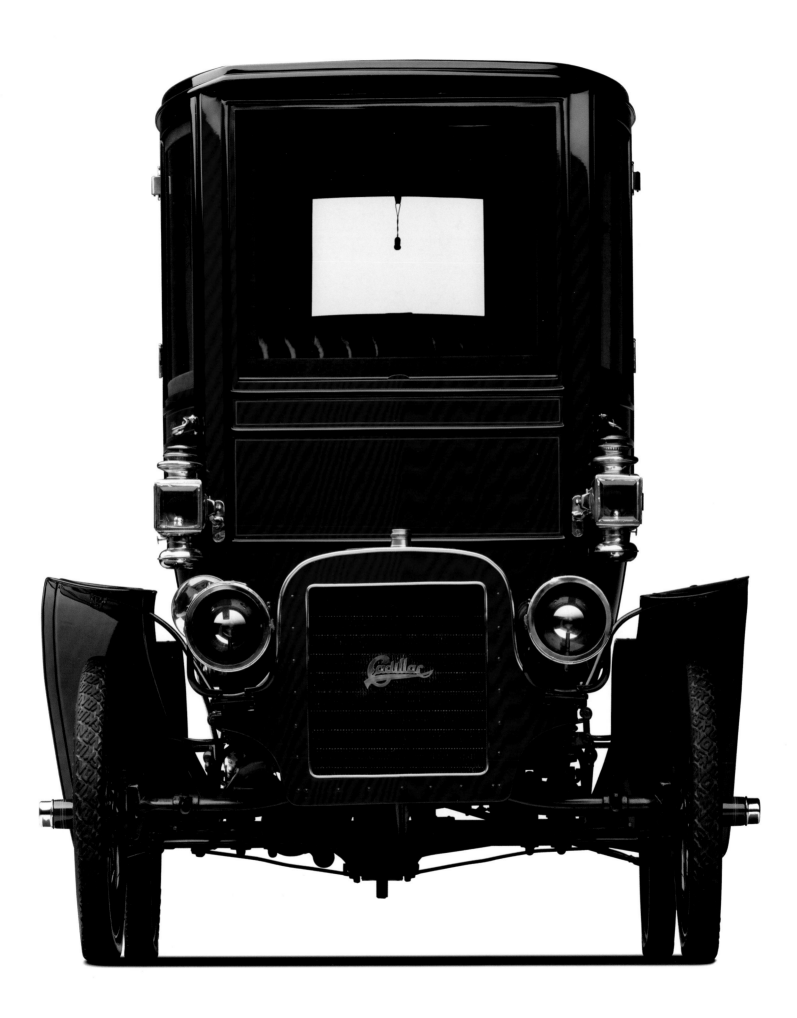

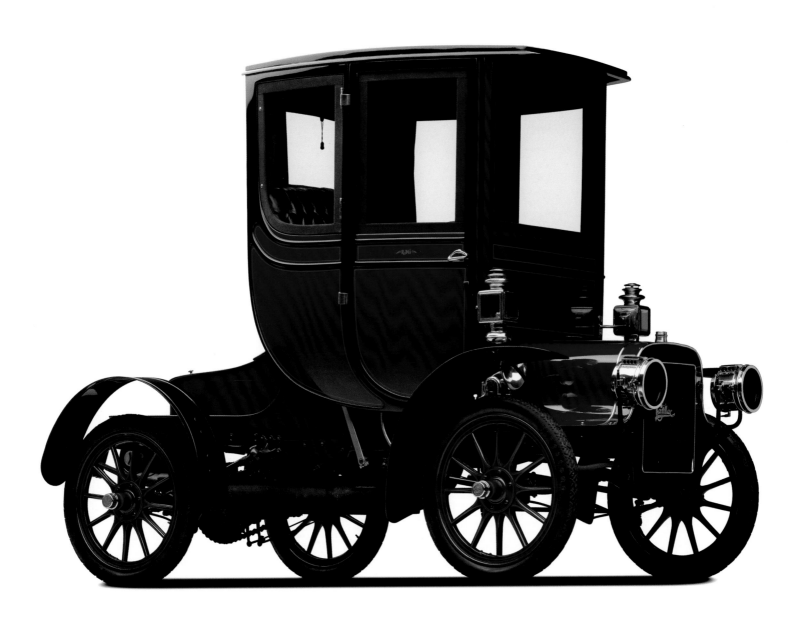

1906 CADILLAC MODEL H COUPE

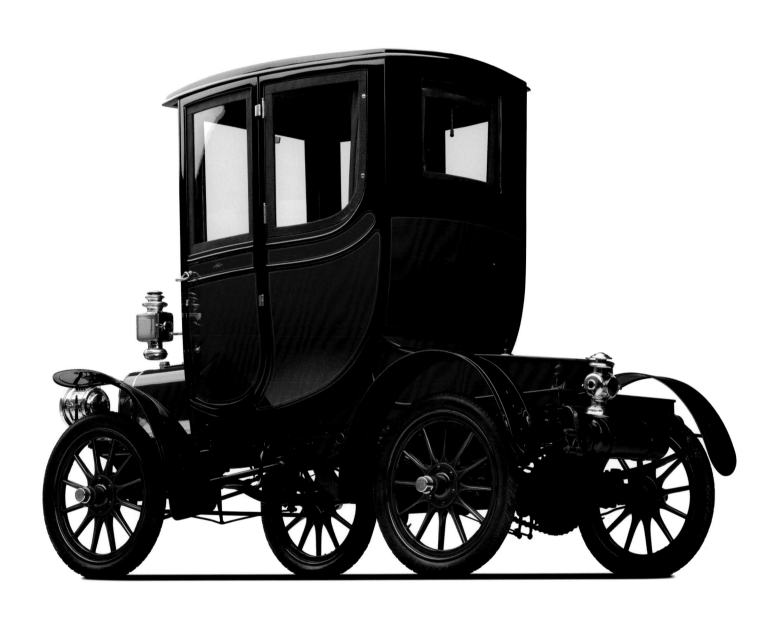

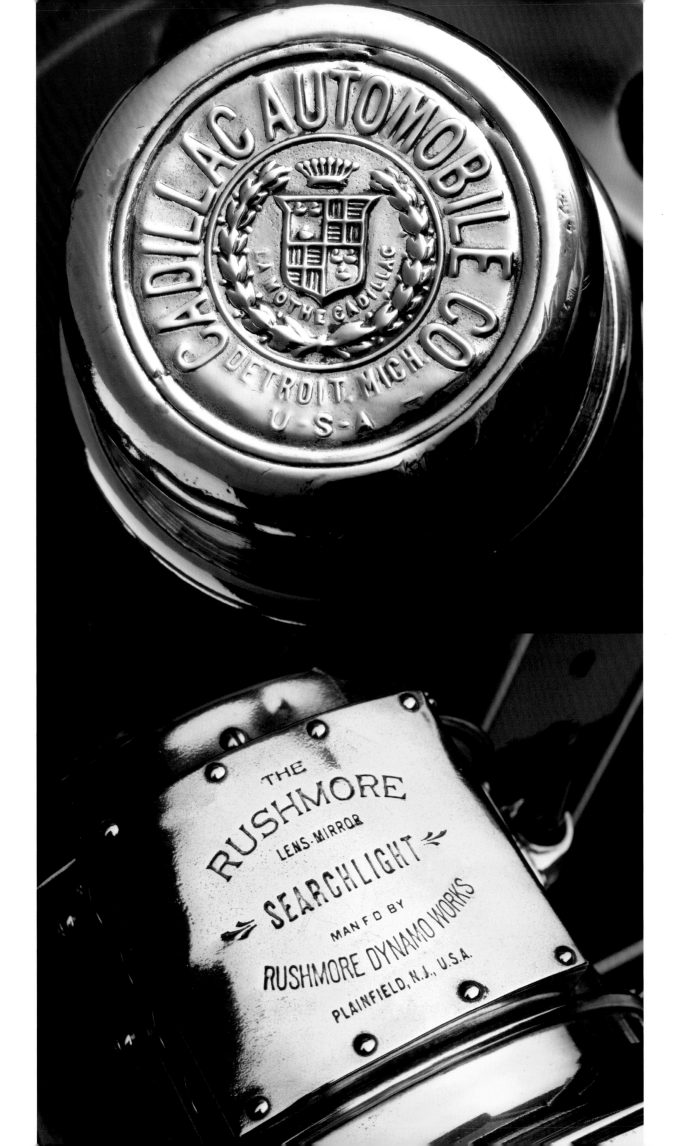

with removable side curtains completed the minimal weather protection.

The Model H, which was also available with touring and runabout bodies, was powered by a 300 cubic-inch-displacement (cid) inline four-cylinder L-head engine rated at 30 brake horse-power (bhp). It was equipped with a three-speed planetary transmission and rear wheel brakes. The wheelbase measured 102 inches and the suspension used 3/4 elliptic leaf springs at the rear. Despite the use of tall 32 x 4-inch tires, the height of the passenger compartment dwarfed the large diameter wheels. Though hardly sleek, the dramatic effect was undeniably reminiscent of a "horseless" carriage.

One of 509 Model H automobiles produced, this lovely two-passenger coupe sold new for a lofty $3,000, which worked out to well over a dollar a pound for this beautifully-crafted car. Like so many early cars, it was offered in a single color scheme. Whether touring, runabout or coupe, the Model H Cadillac livery consisted of "Purple Lake" body panels and "Dark Carmine" running gear. Restored in 2001, it is a rare surviving example of one of the earliest American automobiles offering full weather protection.

Built in an era before nickel or chrome trim were used for bright work, both the wheel center hub (top left) and the lamps (bottom left) of the 1906 Cadillac were crafted of brass.

1912 FORD MODEL T RUNABOUT

MODEL: MODEL T | STYLE: RUNABOUT | SERIAL NUMBER: 9632516

Henry Ford didn't invent the internal combustion engine, the automobile or mass-production, despite being credited with all these accomplishments at various times. However, he recognized significant ideas, knew how to modify them, and made them work in ways that had never been imagined before.

The Model T was not the work of a moment — Henry Ford had been thinking about and experimenting with internal combustion engines and automobiles for well over a decade. He'd built prototypes and race cars and he'd gone through quite a few financial backers and companies. His first true production car was the opposed twin-cylinder Model A of 1903 that came out of the new Ford Motor Company. A small, moderately-priced car, the A was simply the beginning for Ford. Other models came, large and small, modest and leaning towards the grand. But it wasn't until the four-cylinder Model N of 1906 that Ford came close to his goal of an inexpensive and reliable car that could be sold to people of modest means and in significant numbers.

The formula that brought Ford his resounding success included a strong 22 horsepower, 176.7 cid L-Head four-cylinder engine with the cylinders cast en bloc and a removable cylinder head. Power was transmitted to the rear axle via a planetary transmission with two gears forward and one reverse. The chassis was of vanadium steel and featured solid axles front and rear suspended by transverse leaf springs. The foot brake acted on the drive shaft and the rear drums were operated by hand. Considering that a Model T Touring car weighed just 1,200 pounds, it was incredibly strong. It also sold for just $850, and, at that price, Ford was readily able to increase production. The more he produced, the cheaper he could sell them and, therefore, the greater the demand.

There were cheaper cars — like the single-cylinder, 7 horsepower Brush — but nothing offered the value or performance of Henry Ford's new creation. Performance is a funny term to talk about when referring to a Ford Model T. The *Tin Lizzy* wasn't fast or powerful. But it would run steadily, carry heavy loads and climb steep hills, and in 1909

those attributes constituted incredible performance — at a price that hundreds of thousands of people could afford.

Of course there were drivers who wanted a faster Ford. However, if they waited for stubborn Henry Ford to change his car, they would have a very long wait indeed. Nonetheless, added speed could come easily thanks to the use of a carefully-wielded wrench. Devoid of windshield, with less sheet metal and fitted with a pair of bucket seats, the weight of a Ford Model T could drop by as much as several hundred pounds, thus increasing performance considerably.

This yellow Model T is an example of a Ford that was surely faster than the day it left the Dearborn, Michigan, factory. Although every would-be speed demon may have approached the challenge differently, they all found that it cost less to remove weight than to modify the engine or running gear. Ever-increasing sources for speed equipment to fit the Model T eventually fed America's obsession for speed and personalization of its cars. Many lightened and hopped-up Ford Model Ts eventually took to the race track, while others ran on the streets and dry lakes.

This Ford started life as one of almost 70,000 Model Ts built in 1912. The following year, production would leap to more than 170,000 cars, thanks to a newly instituted moving assembly line that virtually changed the automobile industry over night. With millions of cars built from its introduction in 1909 until production ceased in 1927, the Ford Model T — in its many guises — put America on wheels.

This modified Ford Model T was fitted with a fine clock (top right) and a monocle windshield (center right). Like most Model Ts, it rolled on wooden artillery wheels (bottom right).

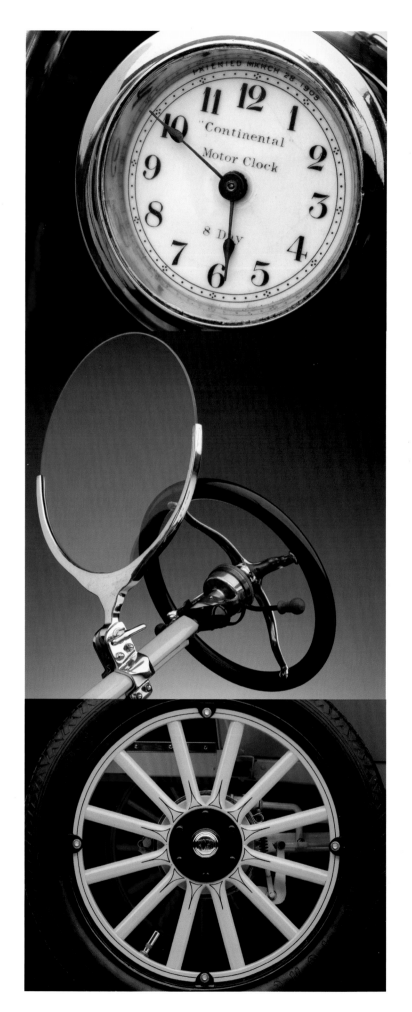

1912 FORD MODEL T RUNABOUT

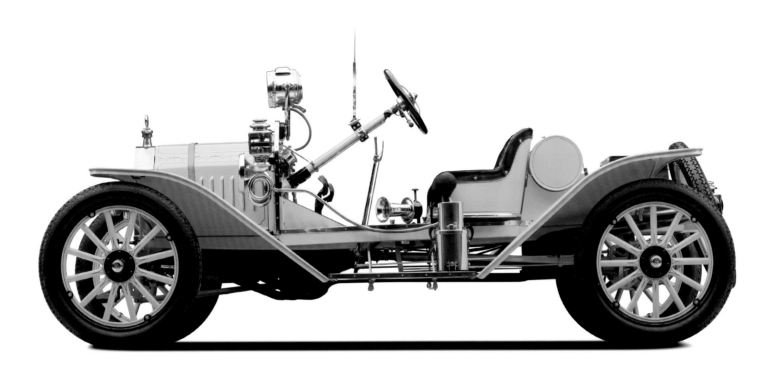

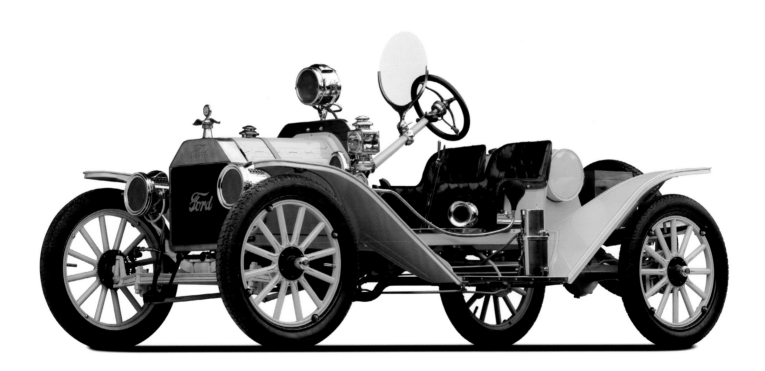

1913 PIERCE-ARROW MODEL 38C BROUGHAM

MODEL: 38C | STYLE: SIX-PASSENGER BROUGHAM | SERIAL NUMBER: 34258

George N. Pierce was a 32-year-old family man in 1878 when he formed the George N. Pierce Company of Buffalo, New York. The new firm manufactured quality household goods including ice chests and bird cages. Soon Pierce branched into building well-designed and affordable bicycles, before entering the modern age with motorcycles and motorcars.

Developed by engineer David Fergusson, that first Pierce automobile was the Model A "Motorette," powered by a 2¼ horsepower, single-cylinder De Dion engine from France. Development was rapid as larger single-cylinder Motorettes soon followed, along with a twin cylinder touring car in 1903, the company's first four-cylinder in 1904 and a truck in 1905. Those four-cylinder engines came with a new model name — Great Arrow — a moniker that the company would use for its big and luxurious fours and sixes until 1909, when the company name was changed to Pierce-Arrow.

Pierce's cars were more than simply luxury cars, though. They were powerful and heavily built automobiles, able to withstand motoring on roads that were awful at best and nonexistent at worst. Between 1905 and 1908, Pierce Great Arrows contested the Glidden Tours. These organized contests over public roads proved both the viability of the automobile and the dire conditions of American roads. Each time they were entered — often at the hands of George Pierce's son, Percy — the Great Arrows bested their competition in both reliability and sheer performance.

More changes than just the name came along for 1909, as George and Percy Pierce had left the automobile side of the business. The Pierce-Arrow model line now included a pair of four-cylinders and three different sizes of sixes. Emphasis was quickly moving towards the smoother six-cylinder engines that were more befitting an expensive luxury car such as the Pierce-Arrow.

For 1913, Pierce-Arrow continued to offer three six-cylinder series: the Model 38C, Model 48B and Model 66A. In each case, the model designation indicated the horsepower rating. As a result, the newly-introduced Model 38C was powered by a 38.4 horsepower six. That smooth six was mounted in

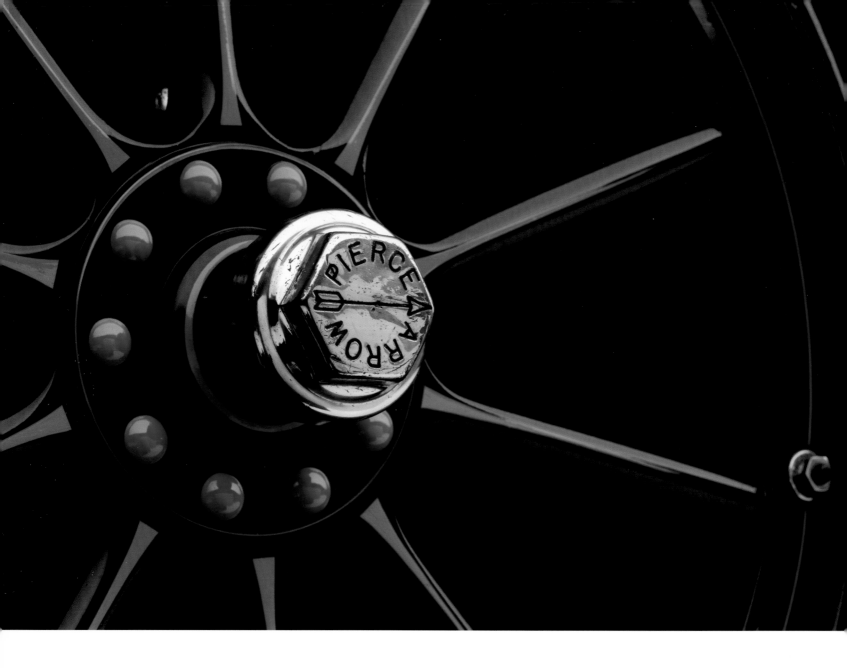

a 119-inch wheelbase chassis that was available with runabout, four- and five-passenger touring, brougham and landaulet bodies. New features for 1913 included a full electrical system and a compressed air starter that would also provide air to inflate the tires. Later in the year an electric starter was added.

Regardless of the body fitted to the Model 38C, this smallest of all Pierce-Arrows was still a very expensive car, with prices ranging from $4,300 to $5,200. By contrast, the most expensive Ford Model T — a Town Car — sold for $850. Top line Model 66A Pierce-Arrows sold for the princely sum of $7,300, which was considerably more than the cost of a new Packard or

Peerless, both of which were considered among the finest of American cars.

This elegant Pierce-Arrow Model 38C Brougham is typical of the company's pre-World War I offerings. Like all of David Fergusson's automobiles, it was carefully conceived, over-engineered and beautifully built. And, like most Pierce-Arrows of any era, it featured restrained styling to appeal to the wealthiest and most conservative Americans.

Distinguishing features of the Pierce-Arrow included the engraved brass wheel center-hubs (above) and the fared-in headlamps (top right). Non-Skid tread tires (right) were common in the brass era. The buckle (far right) secures the spare tire.

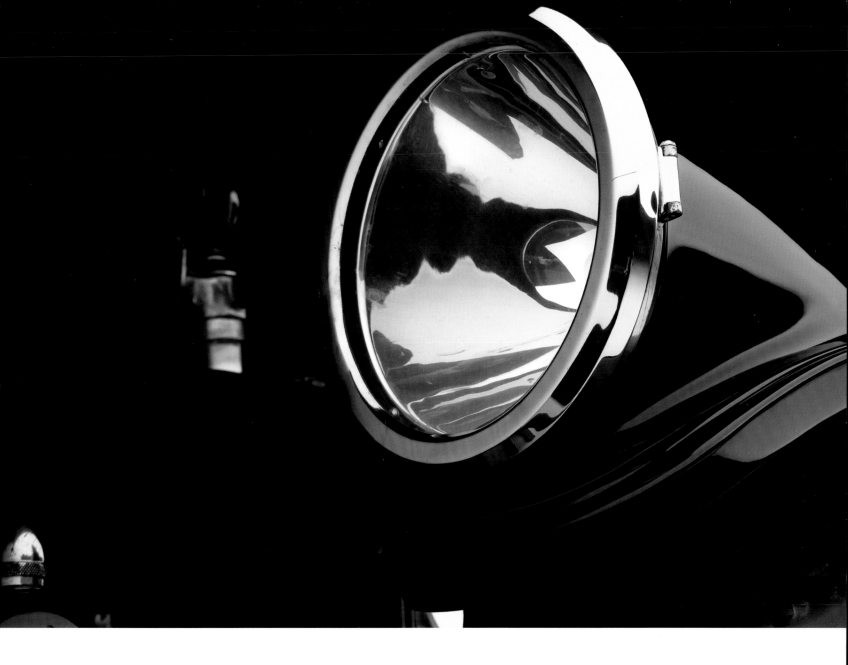

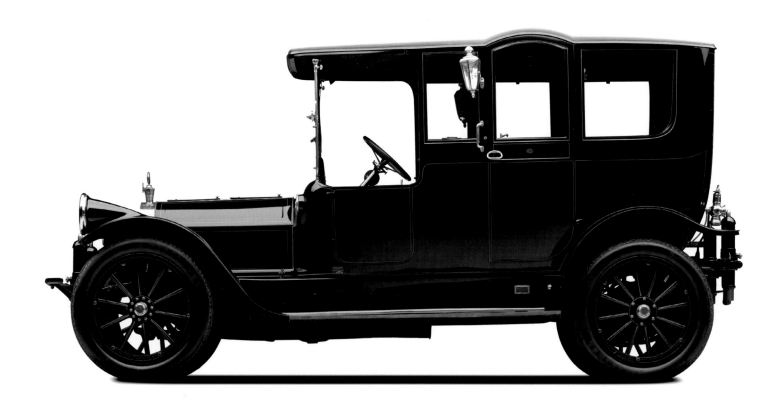

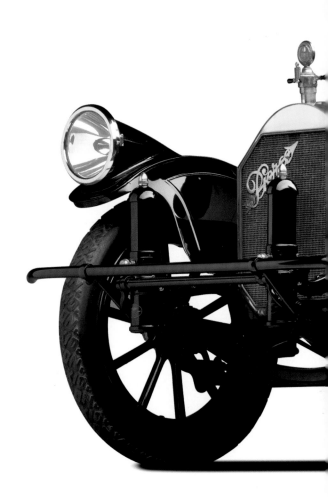

1913 PIERCE-ARROW MODEL 38C BROUGHAM

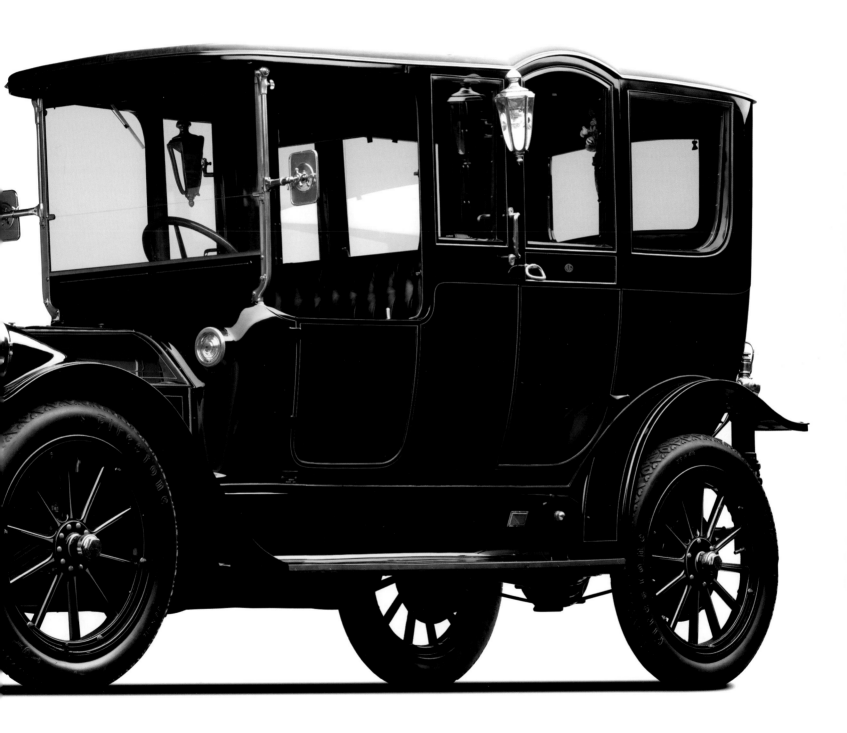

1913 PIERCE-ARROW MODEL 38C BROUGHAM

1914 FORD MODEL T RUNABOUT

MODEL: T | STYLE: TWO-DOOR RUNABOUT | SERIAL NUMBER: 456882

If ever a car came close to being all things to all people, it was Henry Ford's incredible Model T. In 1914, the T was available as a two-passenger runabout, five-passenger touring car, seven passenger town car or a bare chassis. In other words, it was perfect for the traveling salesman, a large family, a successful businessman or someone who needed a truck or delivery vehicle.

What made it so amazing was that Ford's T was incredibly strong and versatile, yet very inexpensive and exactly what the public wanted. By 1914, Ford's Model T had been going strong for five years, with sales totaling more than 300,000. The year was a very important one for Henry Ford and his "Tin Lizzie." Workers were happy and productive, thanks to the revolutionary $5.00 a day wage for 8 hours of labor. Introduced in January, to the joy of Ford workers, it was less well received by other industry leaders. In just one month, Ford production reached 1,000 units a day and kept on increasing from there. Half way through the year, a new Ford rolled off the line every 30 seconds. Production for 1914 eventually

topped 200,000 cars, making the Model T the world's best-selling automobile.

That pay raise may have been seen as a windfall to workers who took home more cash after a shorter day, but it was an even greater windfall for Henry Ford. As worker's wages increased, so did the average person's ability to buy an automobile. And since the Model T cost less than about anything else on wheels, Ford sold more cars. But Ford didn't just sell the Model T in the United States. Canada, England and Australia all took large numbers of his sturdy *Flivver*.

The Model T's basic package of a sturdy and inexpensive car powered by a 22 horsepower flat-head four-cylinder engine mated to a two-speed planetary transmission hadn't changed since the first cars hit the road in 1909. Suspension still consisted of transverse leaf springs front and rear and the stopping was still handled by a contracting band transmission brake and rear drums. Despite the lack of fundamental change, with virtually every passing year the sales volumes had soared and the price had dropped.

At first glance, the 1914 Ford Model T

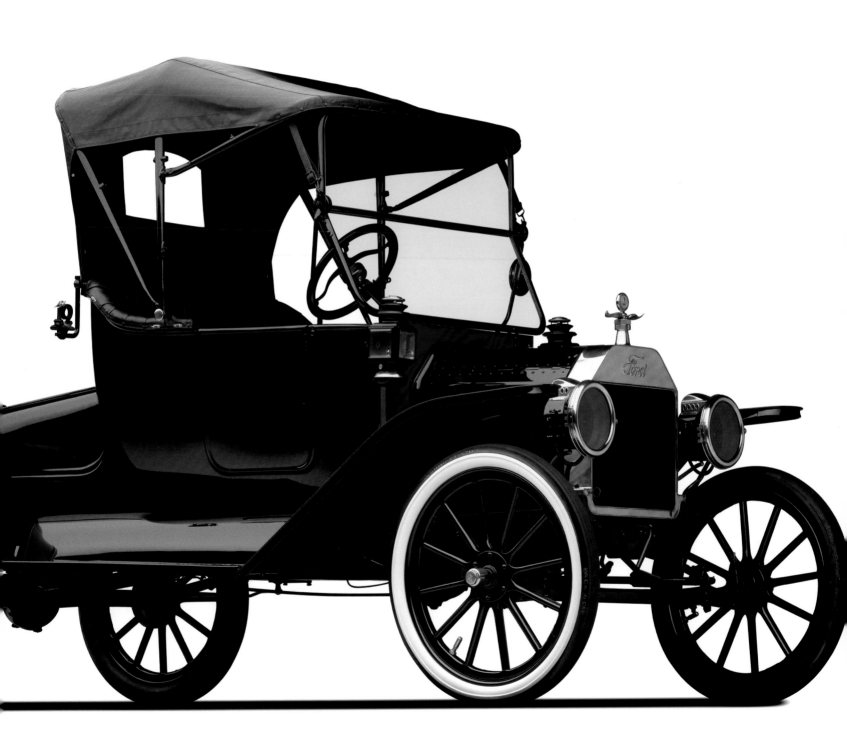

looked just like the 1913 model. Subtle differences included doors that no longer extended to the splash apron, but now had rounded bottoms and were set into the sides of the body. In addition, the body was strengthened by extending the sheet metal across the rear door sills. Both characteristics remained until the end of Ford Model T production in 1927. The second most noticeable change was a windshield that folded towards the driver — an operation that could be performed while driving.

This 1914 Model T Runabout is one of 35,017 built and sold at a cost of $500 — down from $825 in 1909. Through the end of 1913, the Model T was available in several colors. But all that changed for 1914 — and not because black was cheaper. As production speed increased to a breakneck pace, only the quicker-drying black enamel could keep up with production requirements.

Even the humble Ford Model T made use of brass for its radiator shell (right), which is topped by a MotoMeter incorporating a thermometer for water temperature.

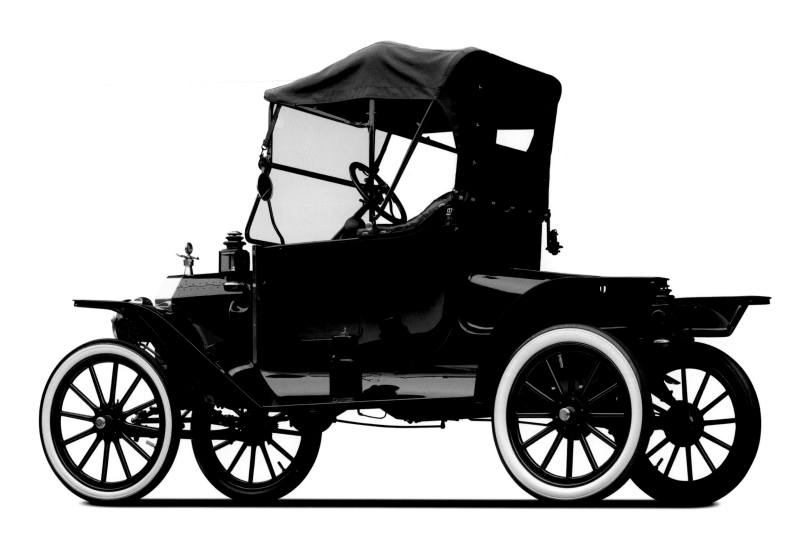

1917 WINTON SIX / SEVEN-PASSENGER TOURING CAR

MODEL: 22A | STYLE: SEVEN-PASSENGER TOURING | SERIAL NUMBER: 32992

According to automotive historian Beverly Rae Kimes, "If any single individual can be credited with lighting the spark which set the automobile industry going in America, it would be Alexander Winton." In 1884, Scotsman Winton immigrated to Cleveland, Ohio. First came the Winton Bicycle Company in 1891, followed six years later by the incorporation of the Winton Motor Carriage Company. Before 1897 was over, Winton had a pair of running horseless carriage prototypes that seated four.

Winton's 10 horsepower twin-cylinder prototype achieved the astonishing speed of 33.64 mph when tested at the Glenville horse track in Cleveland. To prove his automobile's durability and usefulness, Alexander Winton and shop superintendent William Hatcher drove the car from Cleveland to New York City. By the end of 1898, Winton had sold 22 cars, with sales increasing to 100 the following year. Even with such modest numbers, the firm became the largest manufacturer of gasoline-powered vehicles in America by 1900.

While other manufacturers completed automobiles earlier, Winton has been credited as having the first commercially sold automobile built in America. The Curved-Dash Oldsmobile was still three years in the future and Henry Ford continued development of his quadricycle and was several years away from a production automobile. One of those 22 first year cars was sold to a Lehigh-educated engineer. James Ward Packard had numerous difficulties with his Winton and ultimately decided to build a better car — and Packard was thus born.

Fortunately, not all of Winton's customers were so disaffected as to enter into competition with the Cleveland company. According to Kimes, by 1900, production of Winton's 8 and 9 horsepower single-cylinder automobiles had climbed to 700 cars. For 1902, Winton offered a single-cylinder 8½ horsepower runabout and a two-cylinder 15 horsepower touring car with detachable tonneau. By 1905, these high quality cars — the Models A, B and C — all used inline four-cylinder engines for increased performance and refinement.

For 1908, the Winton fours were

relegated to the past and the company relied solely on six-cylinder engines for the remainder of their production. Those six-cylinders also benefited from the use of a pneumatic starter, thus eliminating the need to crank-start a Winton. Alexander Winton was particularly slow to switch to an electric self-starter, which was finally fitted in 1915 due to intense pressure from dealers. The 1915 Winton line included two models: the Model 21 with a 48.6 horsepower engine on a 136-inch wheelbase and the Model 21A with a 31.6 horsepower engine mounted in a 128-inch wheelbase chassis. The big engine was retained unchanged in the 1916 Model 22, which used a slightly longer 138-inch chassis. However, it was joined by the greater performance of the Model 22A, which mounted the 33.75 horsepower engine on a shorter 128-inch wheelbase chassis. These two models of Winton sixes were retained for 1917, the year that this Model 22A seven-passenger touring car was built.

Never one to compromise, Alexander Winton's continued aim for the top of America's motoring market became his undoing. As the 1920s progressed, Wintons were simply too costly and the company failed to produce a less expensive model. In early 1924, the automotive side of the company was liquidated, although it continued to produce Diesel engines and ultimately became part of General Motors.

The Winton was a fine automobile, which featured plated trim (right), a fine time-piece (right center) and steering wheel controls (far right) to advance and retard the ignition timing.

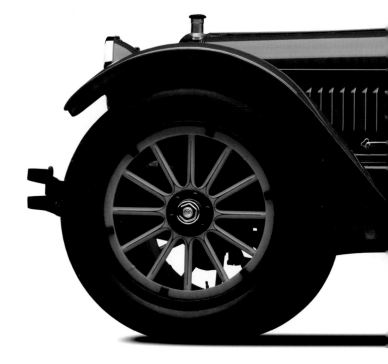

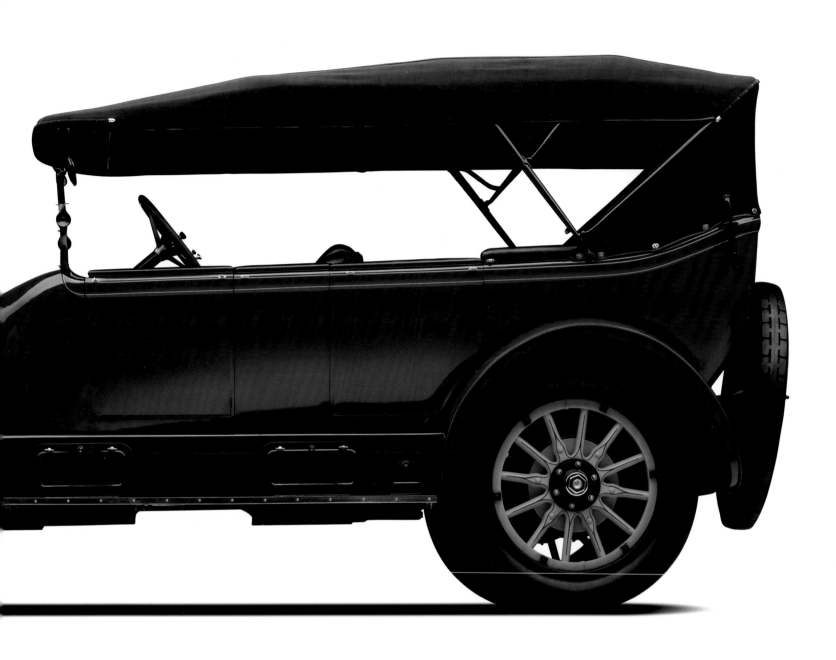

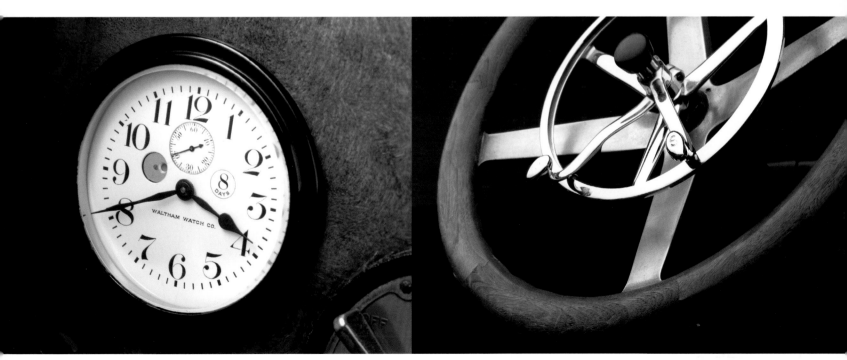

TIMELINE

The American Car Evolves

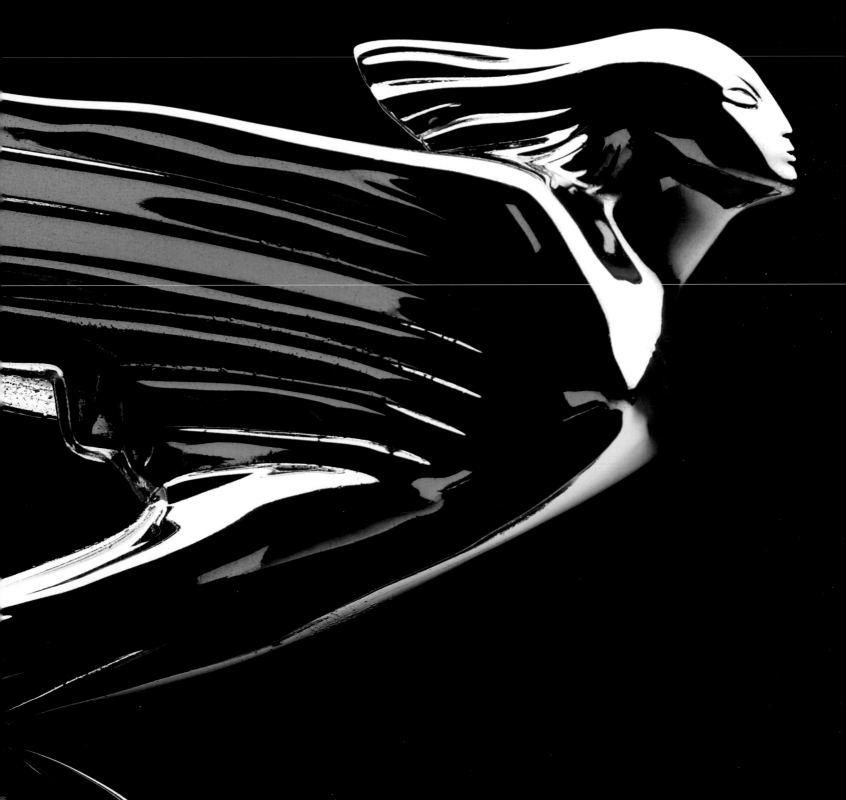

Shortly after the turn of the Twentieth Century, a cross country automobile journey was an arduous trial likely to take two months or more as there were few roads, rivers that had to be forded and no decent maps. In 1923, according to automotive historian John Heilig, an estimated 25,000 cars drove coast to coast. As the 1920s came to a close, America was a prosperous country on the move — literally. Americans were buying automobiles in huge numbers and were taking to the roads.

The single most important factor that made increased long-distance travel viable was also responsible for increased automobile production and sales — more good roads. Without good roads, cars were best suited for intra-urban travel. Those better roads between cities and towns also helped to settle the long-running battle for supremacy contested by steam, electric and internal combustion automobiles. When it came to the long haul, electrics couldn't run far enough on a charge and steamers needed to stop frequently for water. As a result, by the 1920s, internal combustion automobiles ruled the roads.

Initially, the impetus for good roads came from private citizens who began lobbying and fund-raising for roads such as the Lincoln Highway, which would be the first continuous route to link the Atlantic and the Pacific. A major boost for the "Good Roads Movement" came in July 1916 when President Wilson appro-

Henry Leland

priated $75 million dollars for the Federal Aid Road Act. In 1919 when the Army sent a truck convoy across the country, the trip took 56 days — only 7 days less than Horatio Nelson Jackson had required for the trip 16 years earlier. As future president Colonel Dwight D. Eisenhower and virtually every officer in the convoy reported, "Efforts should be made to get our people interested in producing better roads." Eisenhower and his military colleagues realized that good roads were of strategic importance, which was of significant impact in marshalling government support.

It took time, but by the beginning of 1926, roughly 90-percent of the Lincoln Highway was paved. Granted, in most places it was a road that offered a single lane in each direction, but it did allow the steady movement of people and goods East and West through the center of the United States. There were still many unimproved roads all across America that turned to impassable bogs in wet weather, but many major routes now had functional byways and an ever-developing infrastructure to support the increased traffic.

Those roads allowed the development of ever-more competent vehicles. Even small and inexpensive cars, like the 1929 Chevrolet National, were capable

of cruising at 40 miles an hour all day and climbing virtually the steepest grade. There were so many cars to choose from and the prices so low, that people who hadn't dreamed of owning a car in 1908 could have a Ford or a Chevy in their driveway just 20 years later.

Life with roads was even better for people of more substantial means. Gasoline was readily available and cost about $.21 a gallon as the 1920s came to a close. There were plenty of roomy and capable cars from the many faces of General Motors, Chrysler, Ford and other independent automakers. Luxurious American cars from Cadillac, Packard, Lincoln and others offered unimagined comfort and generous power.

Edsel Ford

The climate of comfort and plenty changed on October 29, 1929, with the sudden and devastating crash of the stock market. With the loss of millions of jobs, food, clothing and housing became the immediate goals for a vast number of Americans. A new or even a used car became a luxury far out of reach, and the sales of all cars fell precipitously. Well-established nameplates such as REO, Stutz and Franklin vanished from the automotive landscape. A few new marques were born, but as a rule they were short-lived, like the futuristic Cord or the dramatically-styled Terraplane, which saved the venerable Hudson marque.

As the world in which the automobile existed changed, so did the automobile itself. Six and eight-cylinder engines, which had formerly been the province of luxury cars, became widely-available in modestly-priced vehicles. Front wheel brakes became standard for stopping these more powerful cars, while more effective hydraulic systems were soon adopted by many automakers. Overall, cars had become more mechanically competent and offered reliability only dreamed of at the beginning of the motoring age.

Automobiles entered the 1920s looking like two upright boxes with fenders and wheels — much like their horse-drawn predecessors — and ended the 1930s as sleek manifestations of industrial design. Although very attractive in their own right, the 1928 Chevrolet AB and the Cadillac 341 didn't look fundamentally different from the cars built a decade earlier. However, cars such as the 1937 Terraplane, 1939 Mercury and 1941 Lincoln Continental showed more streamlined shapes thanks to a new breed of stylists who envisioned automobile bodies as more than simply sheet metal to cover the engine and chassis. In fact, those designs became important tools to increase sales and differentiate automobiles that had become conceptually-similar.

1928 CADILLAC SERIES 341 SPORT PHAETON

SERIES: 341 | STYLE: 1172 SPORT PHAETON | SERIAL NUMBER: 319783

When Billy Durant was at the top of General Motors, he'd buy some firms for their patents, others for manufacturing space, some for particular models and still others for reasons impossible to fathom. The brilliant but debt-ridden concept that became GM was replete with overlapping models, product lines and manufacturing capacity. But with the flamboyant and charismatic Durant gone by the end of 1920, and Pierre DuPont and Alfred P. Sloan at the helm, there was a clearly defined place for every company within the General Motors hierarchy.

Over in Dearborn, before Lincoln was added to the Ford family in 1922, the company had a very different philosophy — it was a one model company. If a Ford owner met with financial success and wanted to buy a more comfortable or more powerful car than the Model T, he had to look elsewhere, which played right into the hands of General Motors. At GM, the overall marketing strategy was designed to accommodate every level of the market.

In 1928, a driver could buy a Chevro-let or step up to a Pontiac, Oldsmobile or Oakland. Later, a *General Motors man* could graduate to a Buick, LaSalle or, ultimately, a Cadillac. The prices started with a $495 Chevy and ended with almost $6,000 worth of Cadillac. No other company on earth could offer such a range. With such a tiered product line, the average buyer would never have to consider a car from Ford or Dodge or Studebaker as long as he could climb Mr. Sloan's ladder.

There was wonderful news for Cadillac buyers in 1928. The new Series 341A rode on a longer 140-inch wheelbase and used a bigger L-head V-8 that displaced 341 cubic-inches. Horsepower was a modest 90, but torque was a massive 208 pound-feet, which was useful for eliminating unnecessary shifting of the three-speed manual transmission. That torque was also very helpful for hauling around a car that could easily weigh in at 5,000 pounds, depending upon the body. The chassis was conventional, with heavy side rails and leaf springs with solid axles front and rear. Brakes were drums on all four wheels and hydraulic shock absorbers were fitted.

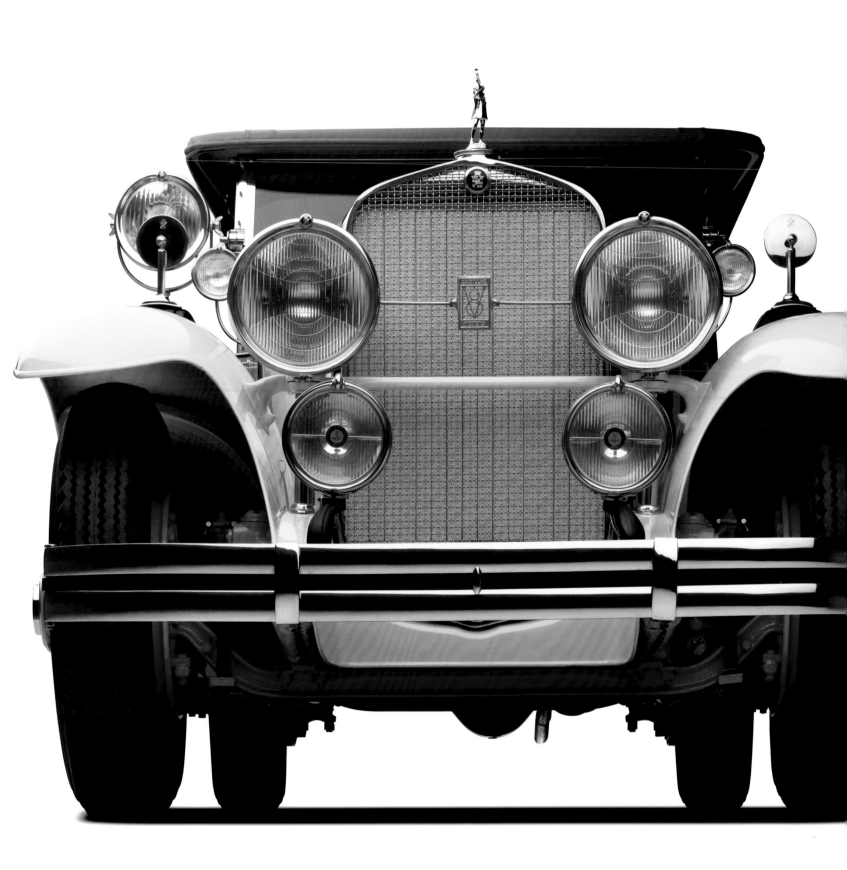

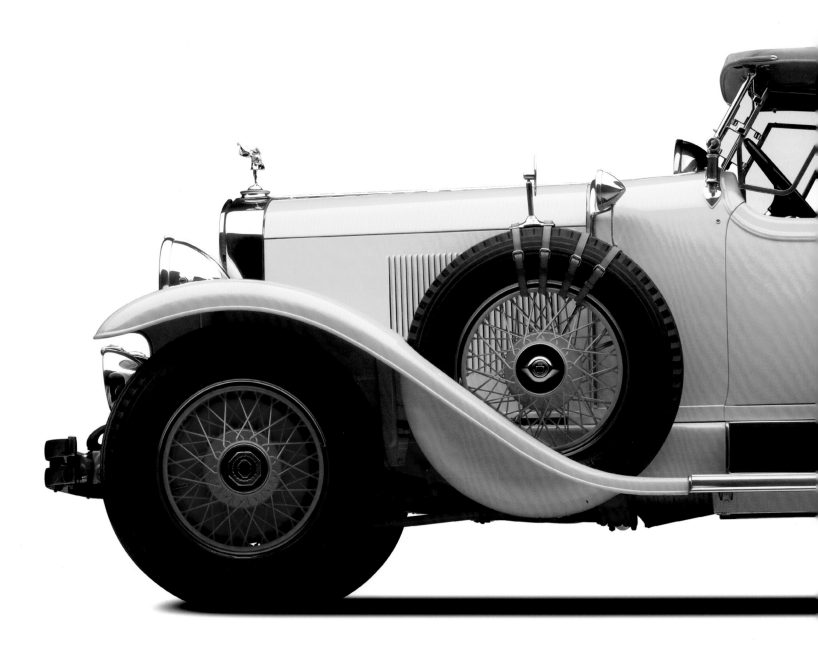

1928 CADILLAC SERIES 341 SPORT PHAETON

Several years earlier, General Motors had established the Art & Colour Department under Harley Earl to oversee styling and bring flare and visual logic to the many car lines within GM. The basic hood and fender lines of the new Cadillac were established by Earl's designers, but one of the things that made the Cadillac so special was the incredible range of bodies offered. There were literally dozens of choices, with virtually every variation of roadster, coupe, sedan or limousine imaginable. Bodies came from Fisher and Fleetwood, both of which were wholly-owned by General Motors and capable of stunning coachwork of very high quality. And if a buyer wanted a body that wasn't on the lengthy list, all he had to do was write a check and wait a few months — virtually anything was possible with a Cadillac 341.

This Cadillac 341A was fitted with a style 1172-B Sport Phaeton body by Fisher. Although a cataloged body, there was nothing plebian about the car, from the long hood and sweeping fenders to the carefully sculpted belt molding. On a less elegant car, the bright colors could have easily made it look gaudy; yet the tall, restrained grille, huge headlamps, dual side-mounted spares and twin folding windshields spread over the long wheelbase ensured that the design worked handsomely in its cheerful livery. Although it's easy to think that the yellow (Curite) and orange paint was the whimsy of the restorer or later owner, GM's "Color Creations of Nature's Studio" of the period depicted a car in the lively colors carried by this grand Cadillac.

The basic design of the Cadillac 341 Sport Phaeton exuded elegance from the tip of the Herald's trumpet (right) and supported the use of bright and cheerful colors (below).

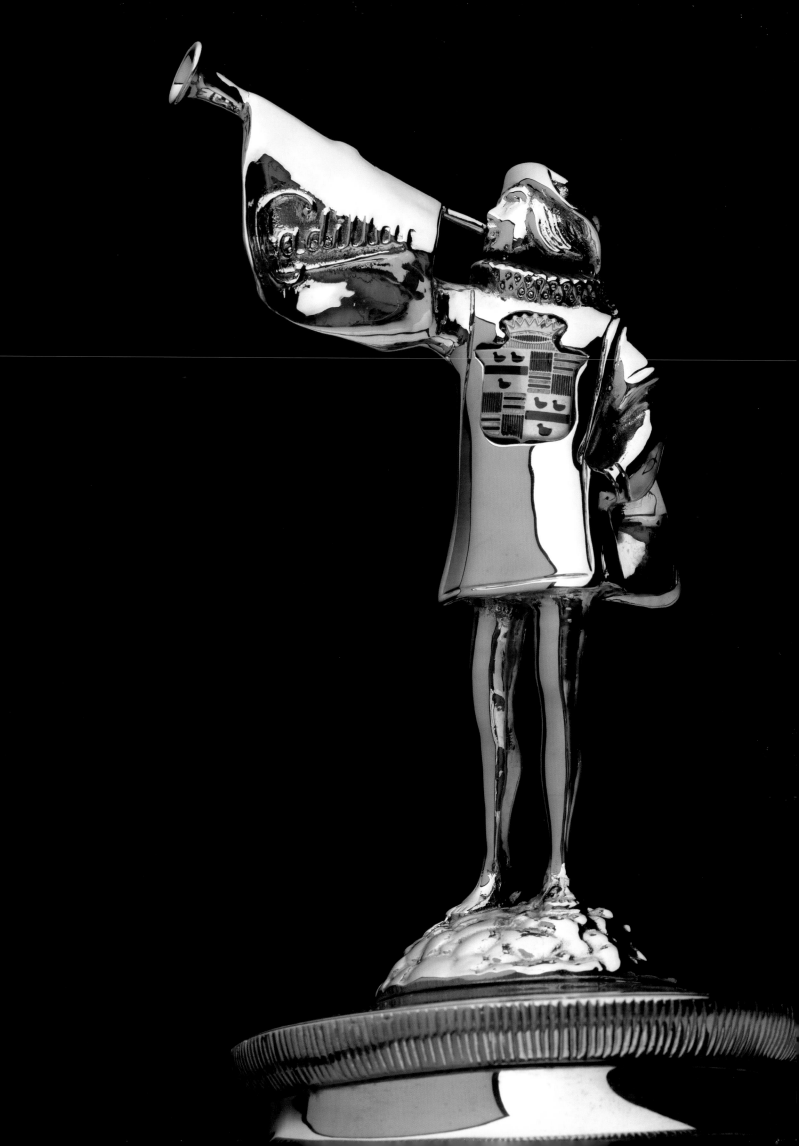

1928 CHEVROLET NATIONAL MODEL AB TWO-DOOR COACH

MODEL: AB NATIONAL | STYLE: TWO-DOOR COACH | SERIAL NUMBER: 3AB32151

When General Motors' Billy Durant took Buick racing in 1909, Swiss engineer, mechanic and driver Louis Chevrolet was the obvious choice, bringing immediate victory. After Durant lost control of GM in 1910, he left the company and turned to Louis Chevrolet to create his own car. Although Durant wanted a "light car," the first model Chevrolet conceived was the large and powerful 299 cid Classic Six. It wasn't what Durant had envisioned. By 1914, Billy also had the Light Six and the four-cylinder Model H in the Chevrolet product line.

But the car Durant really wanted came in 1915 as the Chevrolet 490. First year sales approached 14,000 and would later top 70,000 the following year and 125,000 in 1917. While the Chevrolet Motor Company was quietly building and selling cars, Billy Durant was making money and buying GM stock. By September, 1915, Billy was back in control of the giant automaker, and by the following May he was the majority stockholder. Little Chevrolet had swallowed General Motors whole.

Durant overextended himself and the company, losing General Motors again in 1920 — he would never reclaim it. Chevrolet, meanwhile, had become GM's entry-level brand and was the nameplate most able to take the sales battle to Henry Ford.

Chevy's opportunity came in 1927 when Ford suspended production as it converted assembly lines and tooling from the venerable Model T to the new Model A. With a substantial 678,540 units, Chevrolet's Model AA Series outsold Ford's Model T by a two to one margin. As shrewd as he was, Henry Ford's decision to cease production while tooling up for the new model cost him dearly.

Based on Henry Ford's record and the new Model A Ford, Chevrolet couldn't possibly rest on its laurels. To counter the new 40 horsepower Ford, which was much more sophisticated than the T it replaced, Chevrolet offered the National Series AB. According to *Automobile Quarterly*, "This new model had been designed by General Motors' new Art & Colour Department, headed by Harley Earl. The Chevrolet National

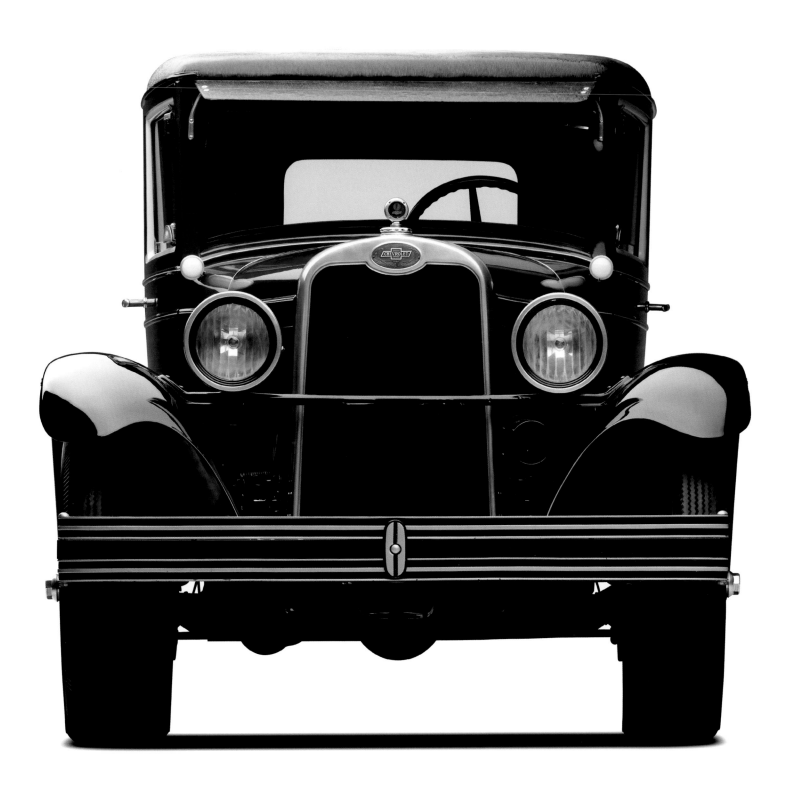

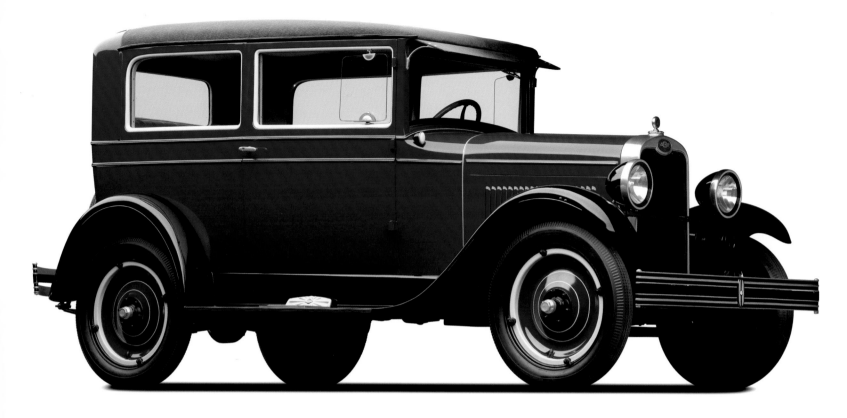

was the unit's second project after designing the new [1927] LaSalle."

The new Chevrolet AB wasn't a startlingly different car, but it was larger, gained power and was significantly more attractive. The wheelbase was stretched from 103 inches in the AA to 107 inches, but the chassis was little changed. The suspension kept live rear axles and leaf springs front and rear. The inline four-cylinder engine remained at 171 cubic-inches, but power jumped from 26 horsepower at 2,000 rpm to 35 horsepower at 2,200 rpm. As with the earlier model, the three-speed transmission was mounted in unit with the engine.

Although the attractive new National Model AB clearly showed a family resem-

blance to its predecessor, the added length and attention from Earl's stylists was apparent — particularly in the car's hood. Open the side panel of that long hood and the four-cylinder looks almost lost. This was neither accident nor folly. Looking ahead, Chevrolet engineers were readying a new straight-six for the following year that would deal Ford a serious blow — until cunning old Henry upstaged everyone with his flathead V-8 in 1932.

In every respect — including price — the new Chevrolet was a serious step up from a Ford Model T, but it still had to contend with a formidable competitor in the Model A. Part of what made the Ford such a tough opponent was a five horsepower advantage, a price range from

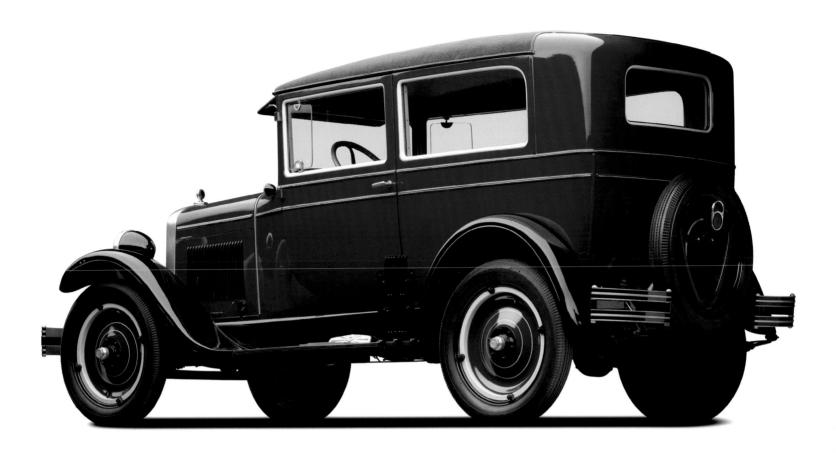

$460 to $585 for passenger models and the stellar reputation of the millions of Model Ts on the road. The Chevrolet had less of a historical legacy and started at a slightly higher $495 and ranged up to $715.

In 1928, Chevrolet sold more than 745,000 examples of the Model AB, of which half were two-door coach models. Ford wasn't that far behind with first full model year sales of the Model A topping 600,000.

This Model AB Chevrolet was built at the company's St. Louis assembly plant. But, most importantly, it is a fine example of the little car that did battle with the formidable Model T and Model A Fords and emerged victorious

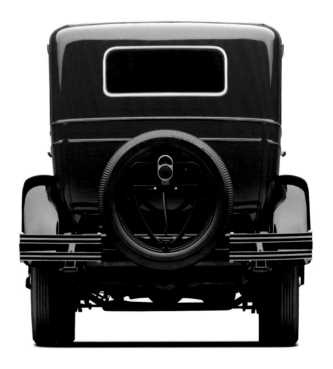

1937 TERRAPLANE CONVERTIBLE COUPE

SERIES: 72 | STYLE: CONVERTIBLE COUPE | SERIAL NUMBER: 7212707

The Great Depression hit Hudson and subsidiary Essex like an unexpected blow in the stomach. Hudson sales fell by half. Meanwhile, Essex sales, which had been at number three in the country, fell in one year from more than 227,000 to 76,000 for 1930. In other words, the companies were in serious trouble, despite having debuted seemingly-affordable new models that year. Unfortunately, those new models took lots of capital to develop and sales simply didn't materialize because of the downturn in the financial climate.

Hudson and Essex were not alone. Millions of people were out of work and in danger of losing their homes, so a new car became anything but a priority. Those who hadn't been devastated by the stock market crash of October 1929 were much less likely to make a significant purchase because of the extreme uncertainty and weakness of the economy.

Hudson had to take action and it did. It developed the new Essex Terraplane to slot in well below the middle-class Essex sixes and Hudson eights already in the catalog. The car they came up with was

created to do battle against such low-price leaders as Ford and Chevrolet. But designing a car to sell for 30-40 percent less without accelerating a company into bankruptcy was a big challenge.

That challenge was met by a team that included engineer Stuart Baits and designer Frank Spring. The result was a car with a light and innovative chassis that gained strength by being bolted to the body at 23 points. It weighed substantially less than prior Essex or Hudson models and had a terrific power to weight ratio, thanks to the 193 cubic-inch six that made 70 horsepower. Introduced in 1932, model for model, the Essex Terraplane had more power, cost less and was lighter than the popular new Ford V-8s. With only 50 horsepower, greater weight and higher prices, the Chevrolets were simply outgunned in every way.

Terraplane's partial year sales proved it was a winner and, for 1933, the standard Essex was eliminated and a 90 horsepower eight-cylinder Essex Terraplane model was added. For 1934, the Essex name was dropped altogether as was the eight. By 1935, sales topped

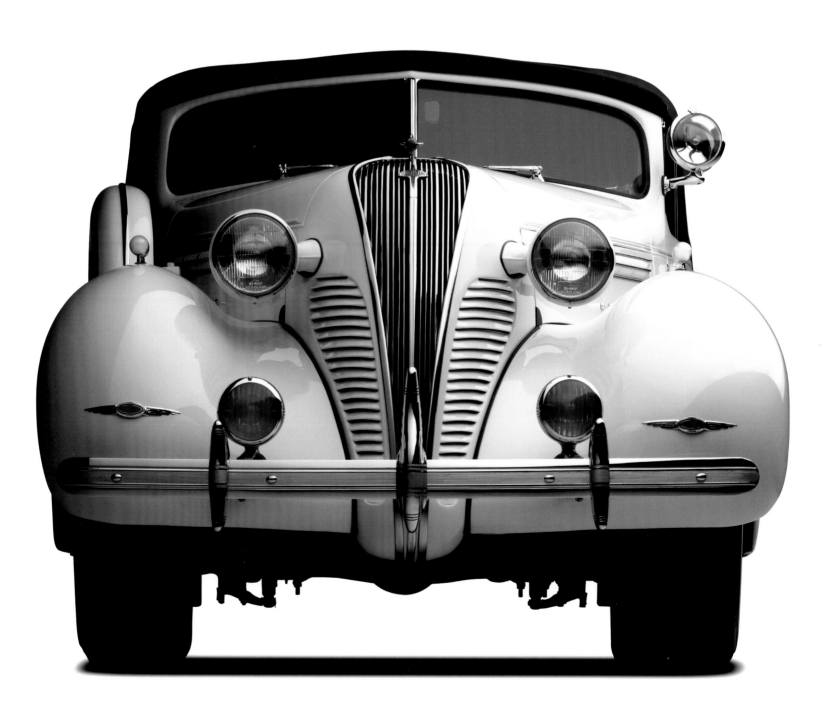

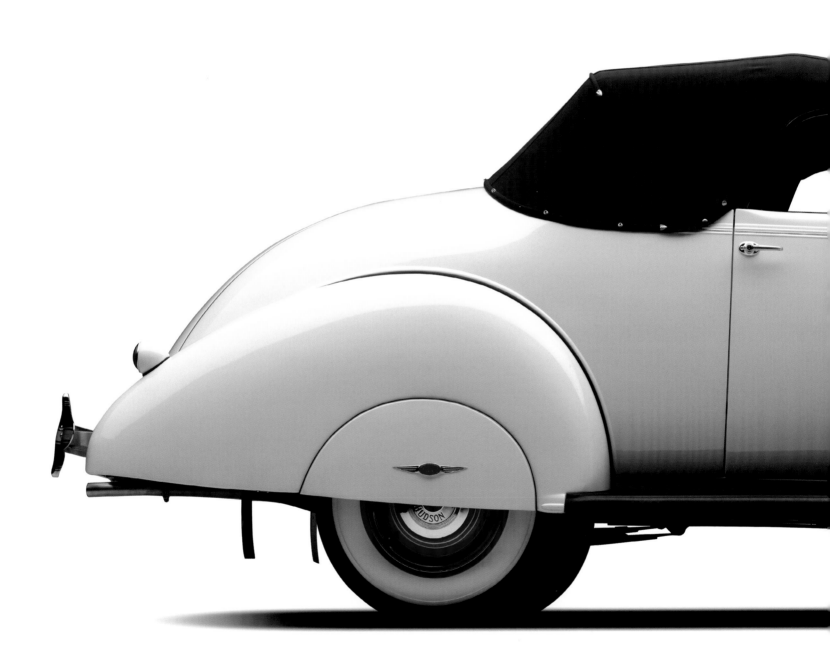

1937 TERRAPLANE CONVERTIBLE COUPE

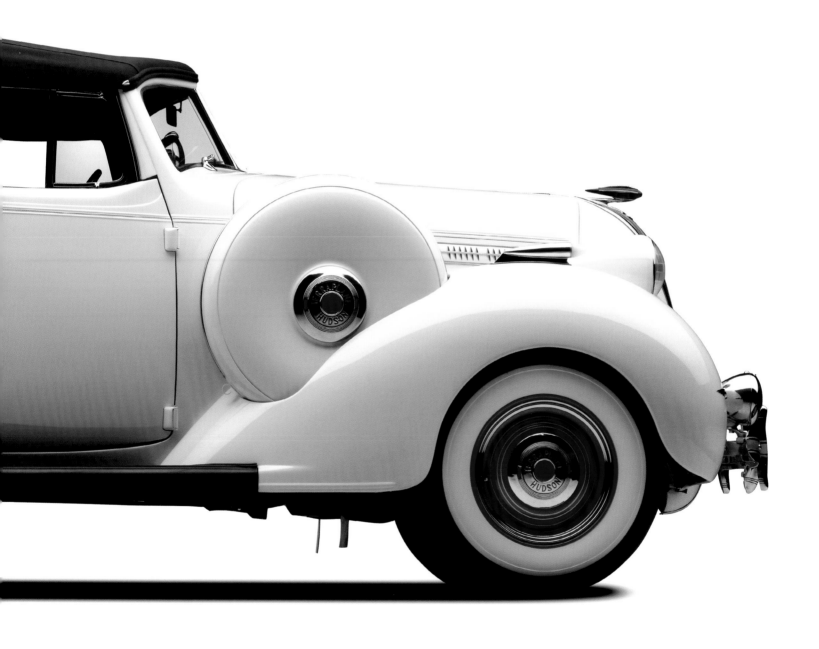

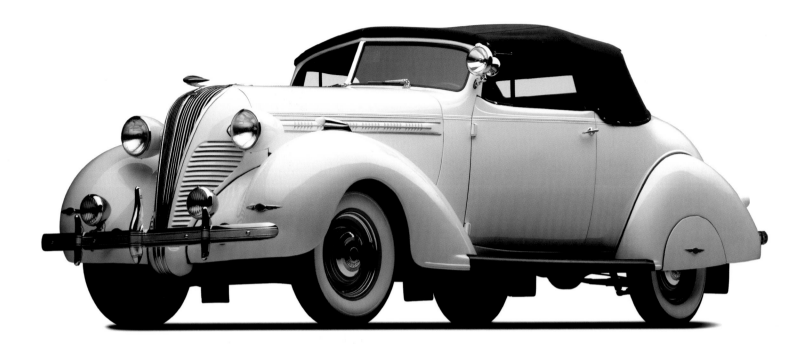

70,000 Terraplanes and almost 30,000 Hudsons, which meant that the parent company had regained profitability.

Big changes afoot for 1936 included hydraulic brakes and an all new, more rounded and streamlined body with a slanted waterfall grille. There were two trim levels on the 115 inch wheelbase chassis — Series 61 and Series 62.

The striking new appearance propelled Terraplane sales up to almost 98,000 units. Visually, the 1937s looked liked the prior year's car with a few minor changes. In truth, they were lower, longer, wider and afforded a much more comfortable passenger cabin. Again, there were two levels of Terraplane, the Series 71 (with nine models) and Series 72 (with eight versions). The standard engine was an alloy-block straight six displacing 212 cid and producing a healthy 96 horsepower. The optional version was no larger, but had higher compression, a chrome alloy block and was rated at 107

horsepower. Both versions were generously endowed with 170 foot-pounds of torque. With weights ranging from about 2,300 to 2,900 pounds, performance was quite good for the day. The cost of the Terraplane started at $595 for a Series 71 business coupe and topped out at $880 for a Series 72 three-passenger coupe.

This Mandalay Ivory Series 72 convertible coupe originally sold for $770 and seated four people. For that price, it offered terrific performance and very high style. After 1937, Terraplane became the "Hudson Terraplane" for one year before it vanished completely, leaving Hudson to stand on its own four wheels. But, had it not been for the light, fast and stylish Terraplane, Hudson would never have survived the Depression.

The Terraplane was fast, good-looking and elegant. Despite its moderate price, the attention to design details is apparent, particularly in the grille and radiator mascot (right).

1937 TERRAPLANE CONVERTIBLE COUPE

1938 CADILLAC V-16 FIVE-PASSENGER TOWN SEDAN

SERIES: 38-90 V-16 | STYLE: 9039 FIVE-PASSENGER TOWN SEDAN | SERIAL NUMBER: 5270052

Years after the precision-minded Henry Leland had left Cadillac, GM's top-of-the line marque was still considered one of the very finest of all American automobiles. Cadillac didn't rely on ordinary fours or sixes — every one of the company's cars used a Vee-engine of 8, 12 or 16 cylinders. The cars were smooth and capable; they also made a visual and social statement just as powerful as their engines.

By the time Cadillac engineer Owen Knacker was developing the mighty V-16, the cylinder race was in full force. The company was aiming to displace Packard at the top of the luxury car market, where Lincoln and Marmon had also been turning to more cylinders. However, by the time the Cadillac Series 452 V-16 was introduced, the stock market had crashed and even many of America's most substantial families were now more concerned with weathering the storm than keeping up with the Rockefellers.

Despite the crash, the response to the V-16 far exceeded Cadillac's expectations. The 16-cylinder engine was finished in glossy enamel, porcelain, polished aluminum and chrome. Valve covers were polished and detailed to such a level that Cadillac started marketing its cars with photographs of just the engine, with the caption: "works of the modern masters." Though the Series 452 Cadillacs could attain speeds of up to 100 mph, the V-16 was best known for its massive torque, smooth acceleration and quiet ride.

With wheelbases stretching from 141.25 to 154 inches and that long hood and tall radiator grille, the V-16 Cadillacs were splendid platforms for some of the finest coachbuilders of the day. More than 70 different styles were offered by Fleetwood and Fisher and many bodies remained one of a kind. Like many other fine cars, the model 452 was available as a rolling chassis to accommodate full-custom bodies designed and supplied by major coachbuilders throughout the United States and Europe.

Although Cadillac offered the V-16 for a decade, in 1936 the model designation was changed from Series 452 to Series 90. A later car, this Cadillac Series 90 was built in 1938, the first year of the new L-head version of the V-16. The style 9039

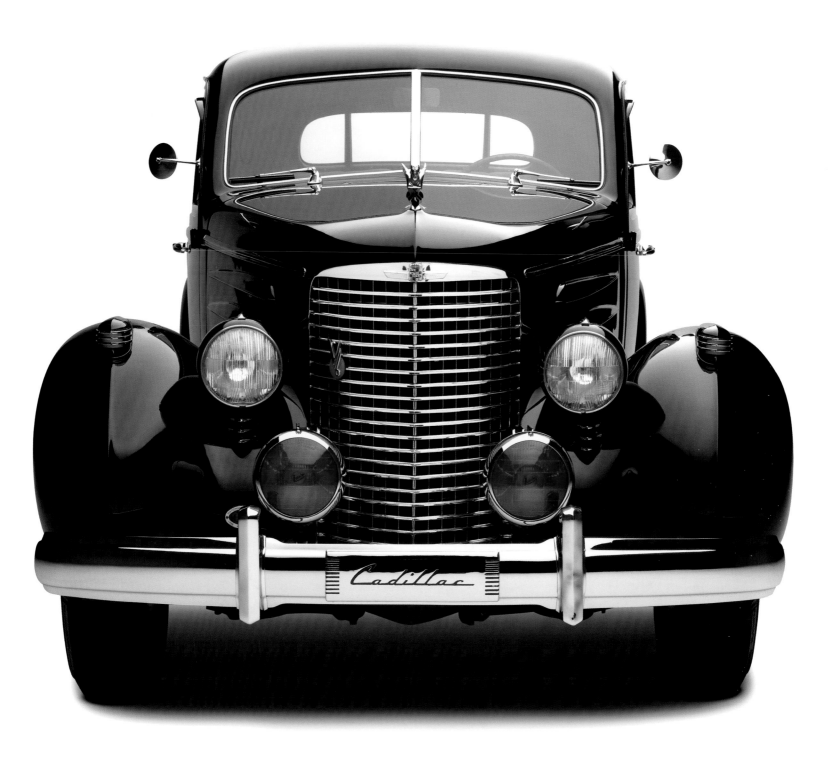

1938 CADILLAC V-16 FIVE-PASSENGER TOWN SEDAN

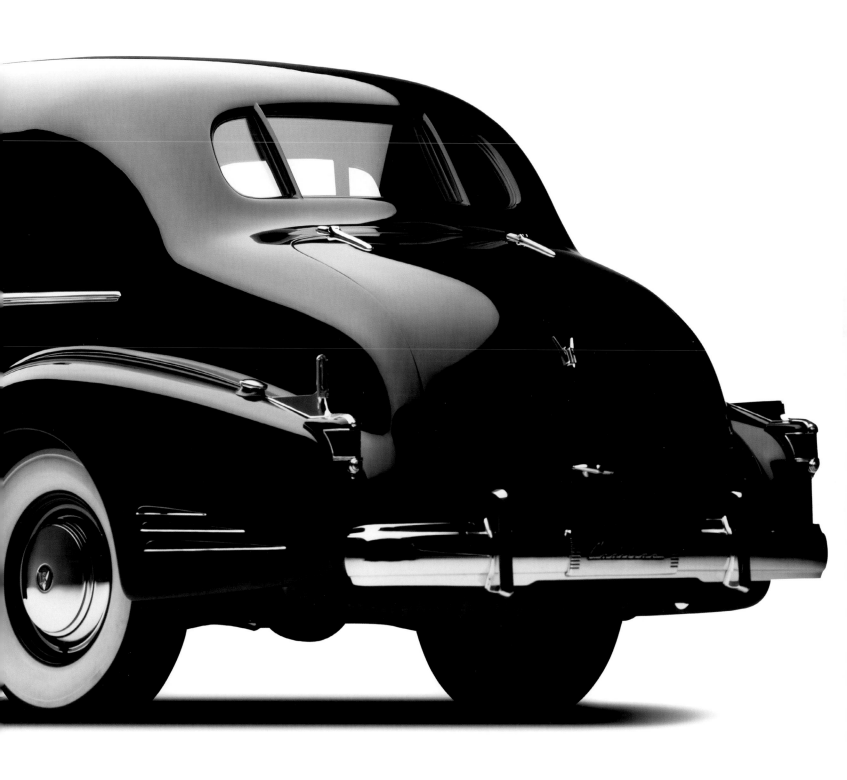

Town Sedan was mounted on the 141.25 inch chassis and was produced for three years, until the V-16 was discontinued after 1940. Total production of this style was limited to approximately 20 cars. This multiple award winning five-passenger town sedan is one of only two known to exist. Unique features include a custom trunk fitted with a spare tire, along with many original options such as the cat eye lighters and vanity mirror.

Cadillac's mighty 16 was the most enduring of all the multi-cylinder clas-sics, outlasting Packard's 12 by a year. By the time the last Cadillac V-16 was sold, Auburn, Duesenberg, Cord, Marmon and Peerless were all memories. It is unquestionably one of the greatest cars of the classic period in terms of luxury, elegance and performance.

Everything about the V-16 Cadillac suggested power, including the grille badge and stream-lined headlight nacelles (top right) and the long hood (below). The main passenger compart-ment (right) was a very comfortable place.

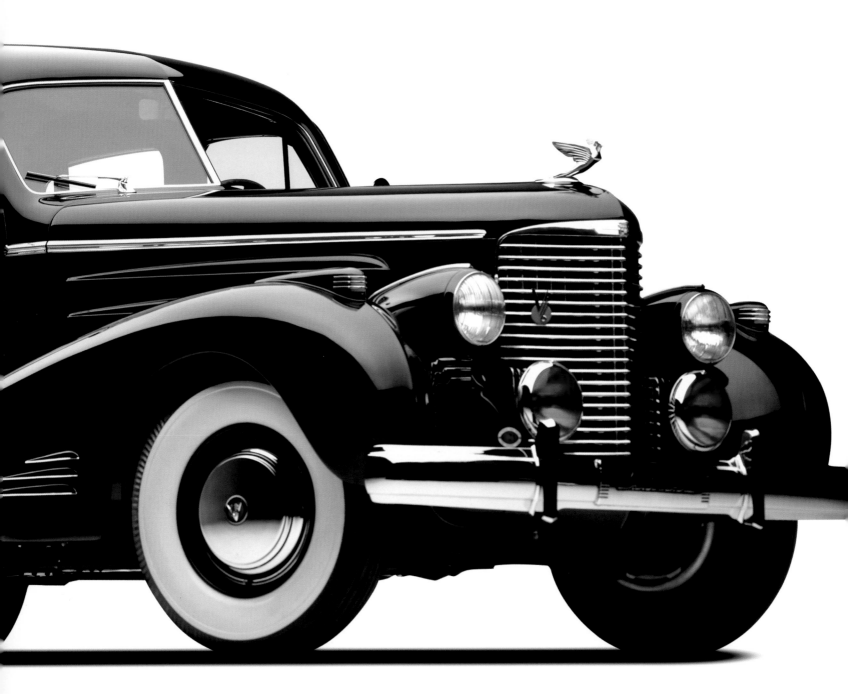

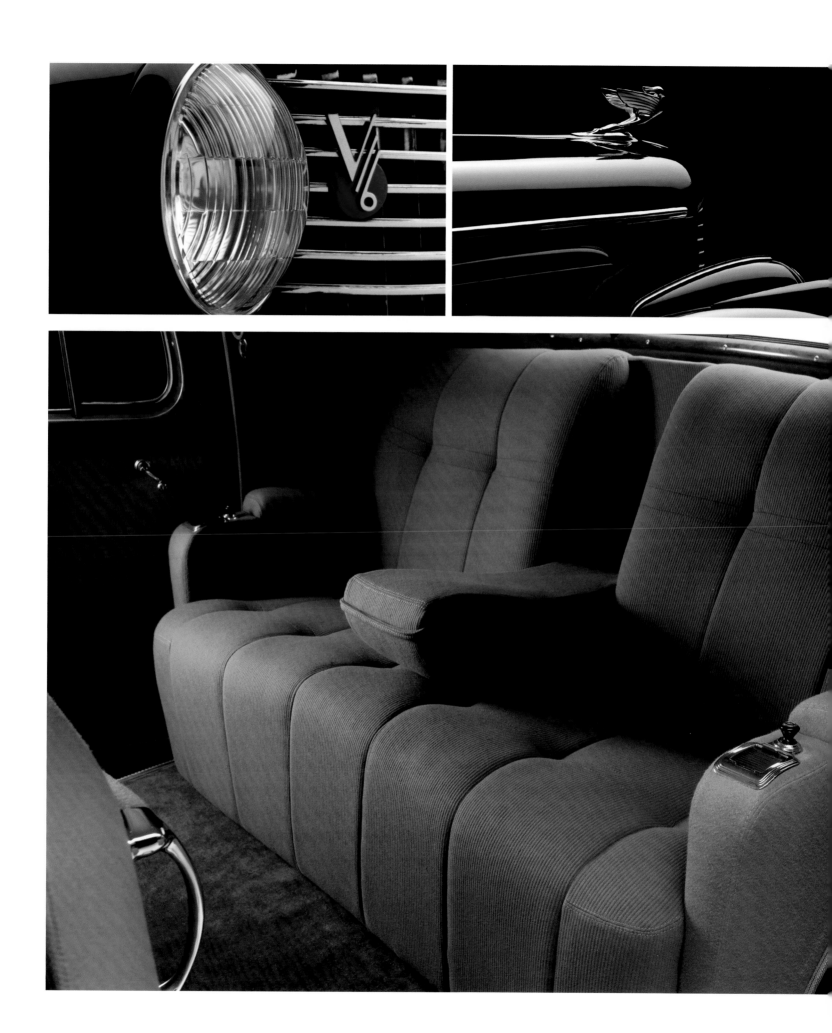

1939 MERCURY SERIES 99A SPORT CONVERTIBLE

SERIES: 99A | STYLE: CONVERTIBLE COUPE | SERIAL NUMBER: 99A7039

In the ancient Roman Empire, Mercury was the winged messenger to the Gods. And when the Ford Motor Company launched its new brand to fall above the bread and butter Fords and beneath the stylish Zephyrs and Lincolns, they looked to the fleet messenger God as inspiration and namesake.

The name was apt. The Mercury was sleek, powerful and something very special. It also filled a gaping hole that had long existed in the Ford product line. For years, Ford had its model for everyman and its Lincolns for wealthy customers. As an effort to narrow the void in the range, Ford had created the lovely Zephyr in 1936. As late as 1938, if a driver wanted something more powerful or luxurious than an 85 horsepower Ford Deluxe convertible sedan for $900, it was a bit of a step to the least expensive Zephyr at $1,355. It was an even steeper climb to the senior Lincolns which spiraled *upward* from about $5,000 Depression dollars.

Ford's son Edsel, however, knew that their company would have to offer a medium-priced car to survive; it just took him awhile to convince stubborn old Henry. Finally, in 1939, Edsel rolled out the Mercury as a competitor for the Dodge, Oldsmobile and Buick. The auto-buying public responded by snapping up more than 50,000 examples in four body styles priced at $916 for the two door sedan, $957 for the four door sedan and coupe and $1,018 for the attractive, yet affordable convertible coupe.

The styling by E. T. Gregorie — with close consultation from Edsel Ford himself — showed a strong resemblance to the Ford. Additional design cues were picked up from the Lincoln Zephyr, specifically the grille and headlights completely molded into the front fenders. In a departure from previous company practice, the Mercury was the first Ford design developed from a full-sized clay model.

The enlarged 239.4 cubic-inch, 95 horsepower flathead V-8 engine gave the Mercury great performance and it was recognized as one of the fastest stock cars of the day. The reliable and powerful eight sent its power aft through a three-speed manual transmission. The chassis was typical Ford, with transverse leaf springs and a 116-inch

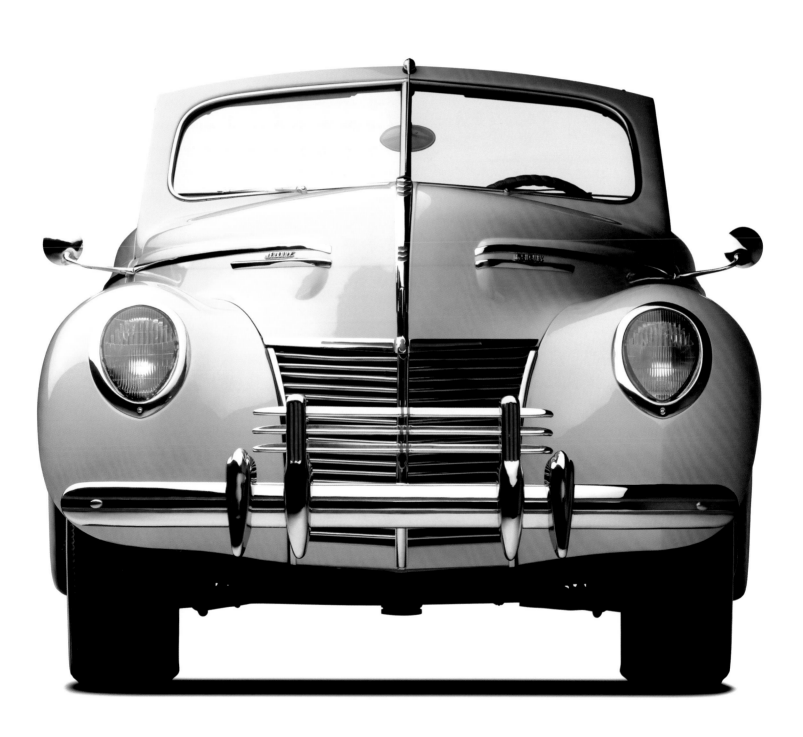

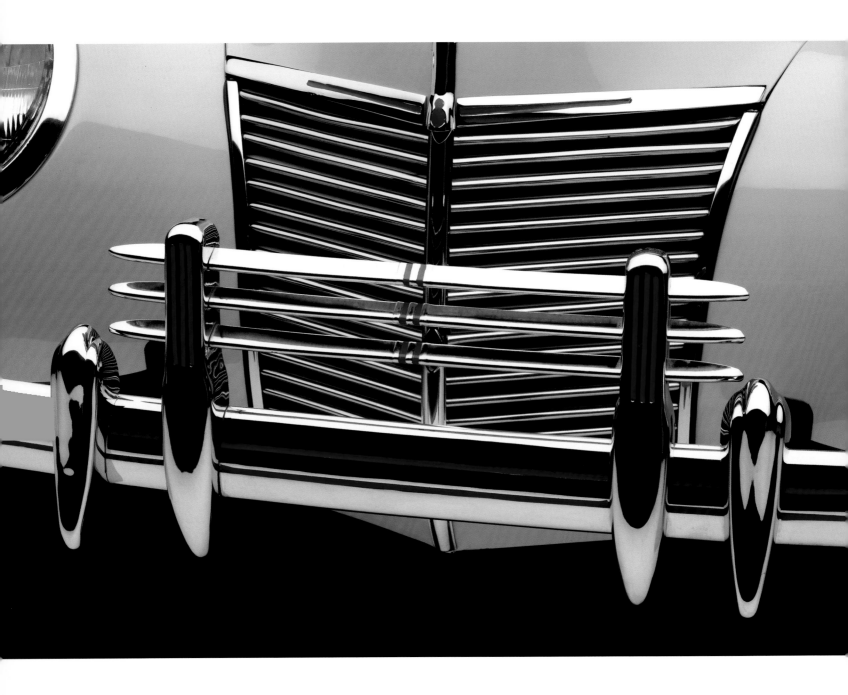

wheelbase. Stopping was handled by hydraulic drum brakes on all wheels. Featured at the 1939-40 World's Fairs in New York and San Francisco, the Mercury helped keep upwardly-mobile Ford drivers in the Dearborn family.

The convertible coupe was clearly the most elegant and stylish of the first-year Mercurys. It's easy to imagine a young aspiring starlet signing a contract at one of the Hollywood studios and going out and buying a Lustrous

Ivory convertible coupe just like this one. It was beautiful, showed excellent taste and was just flashy enough — but wouldn't absorb the entire signing bonus.

All new for 1939, the Mercury showed a distinct family resemblance to the Ford and Lincoln Zephyr. The most noticeable cues came from the grille (above) and headlamps (top right), although the basic shape retained a similarity to Ford's more established lines.

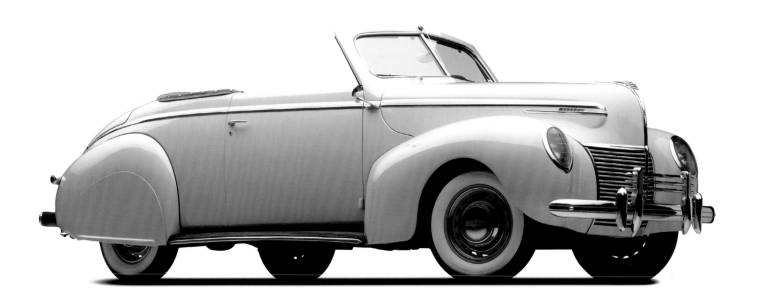

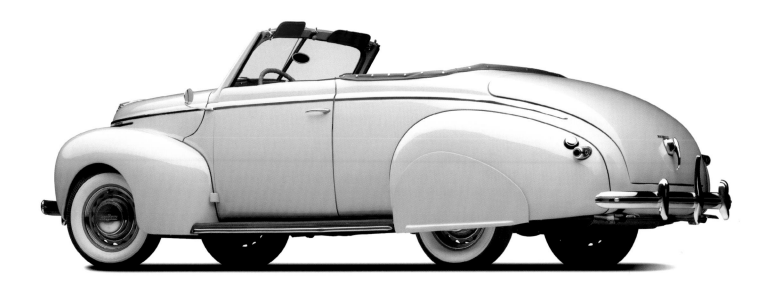

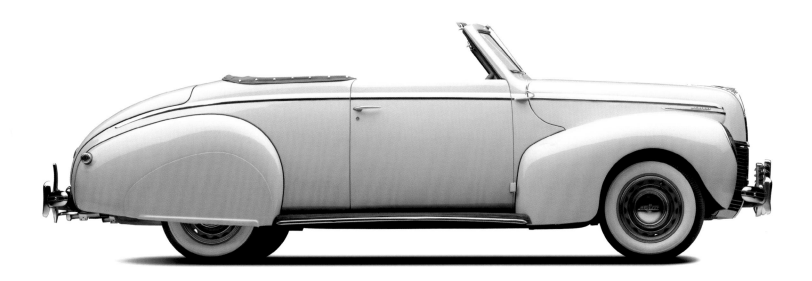

1939 MERCURY SERIES 99A SPORT CONVERTIBLE

1941 LINCOLN CONTINENTAL COUPE

MODEL: 57 CONTINENTAL | STYLE: TWO-DOOR COUPE | SERIAL NUMBER: H128506

Lincoln was founded by Henry Martyn Leland and his son Wilfred. They had left Cadillac — of which the senior Leland was co-founder — because of a significant difference with GM founder and leader William Crapo Durant. Apparently the Lelands wanted to promptly convert Cadillac production to manufacture Liberty aircraft engines during World War I. Durant didn't agree.

The Lelands, particularly Henry, had been responsible for the engineering precision and standardization for which Cadillac had become known. Their products tended toward the conservative, but the high manufacturing standards were consistently met.

Shortly after their departure from Cadillac, GM and Billy Durant, the Lelands established Lincoln — with the help of government money — to turn their considerable energy and talents to the production of those Liberty engines. But with the end of World War I, the Lelands were left with a plant, employees and a mountain of debt. The solution to their situation was to do what they had always done before

— design and build a quality automobile.

The first model L Lincolns were completed in September, 1920, but production started slowly and investors were anxious to see a profit. In early 1922 those shareholders insisted on filing for bankruptcy after only 3,407 cars had been completed. At son Edsel's urging, Henry Ford acquired the company. The inevitable conflict between Ford and the company founders soon came and the Lelands soon went.

Mechanically, there was little wrong with the Lincoln. Stylistically, it was old fashioned and stodgy. And, that's where new company president Edsel Ford stepped in. The antithesis of his father, the younger Ford had an innate sense of style and elegance. He also knew how to work closely with talented designers. Soon, the Lincoln appearance was as good as the smooth and powerful V-8 under the hood. Before long, Lincoln was one of the grandest of all American cars, with models including the elegant Model K and the stunning Zephyr of 1936.

Inspired by some of the great coachwork appearing on fine European

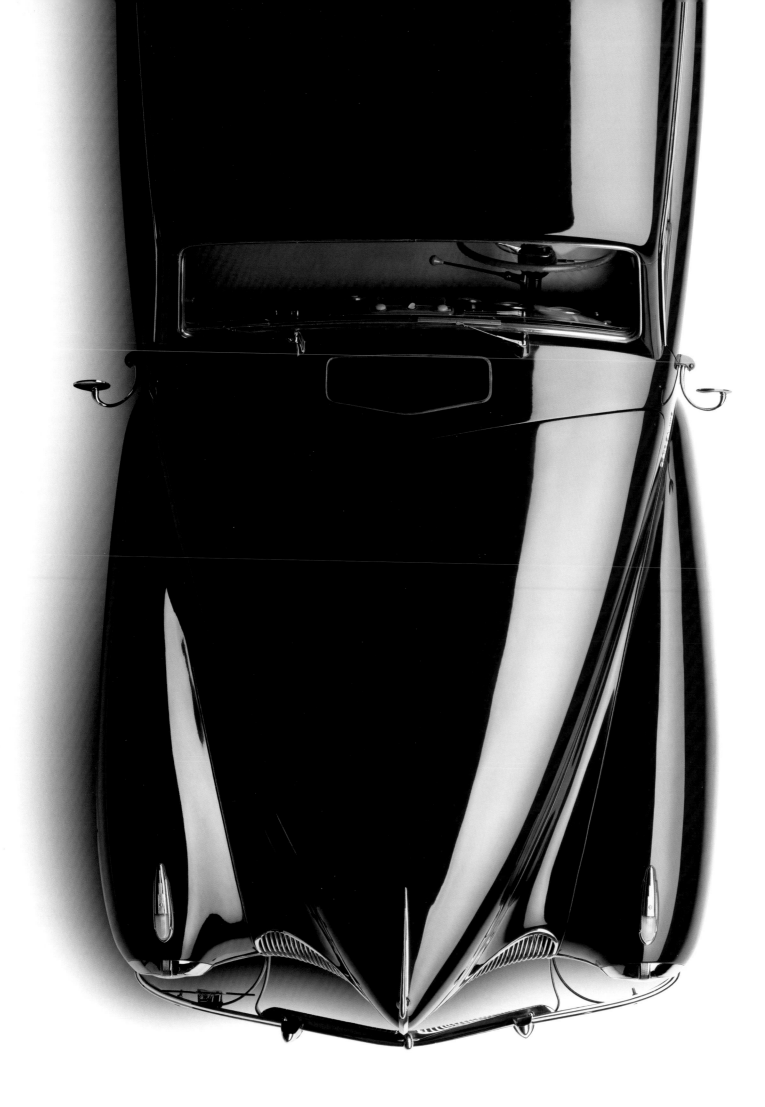

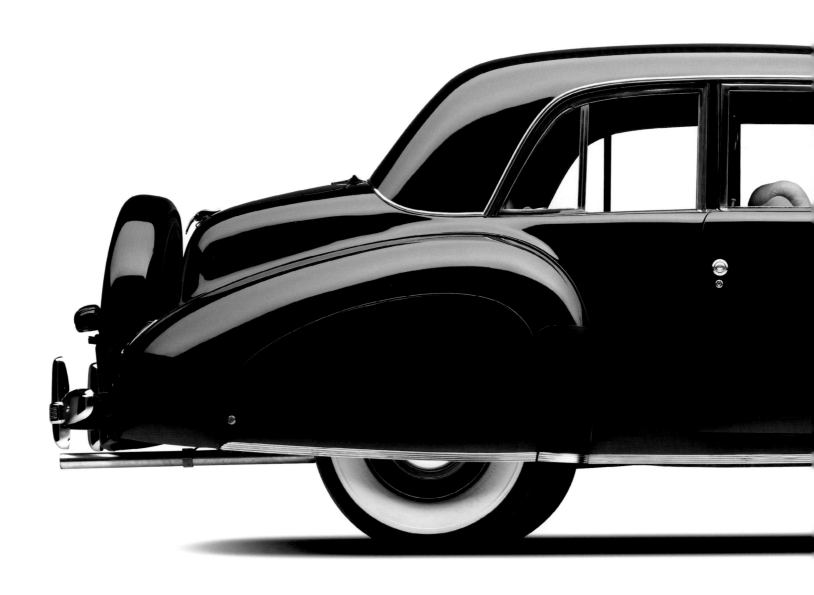

1941 LINCOLN CONTINENTAL COUPE

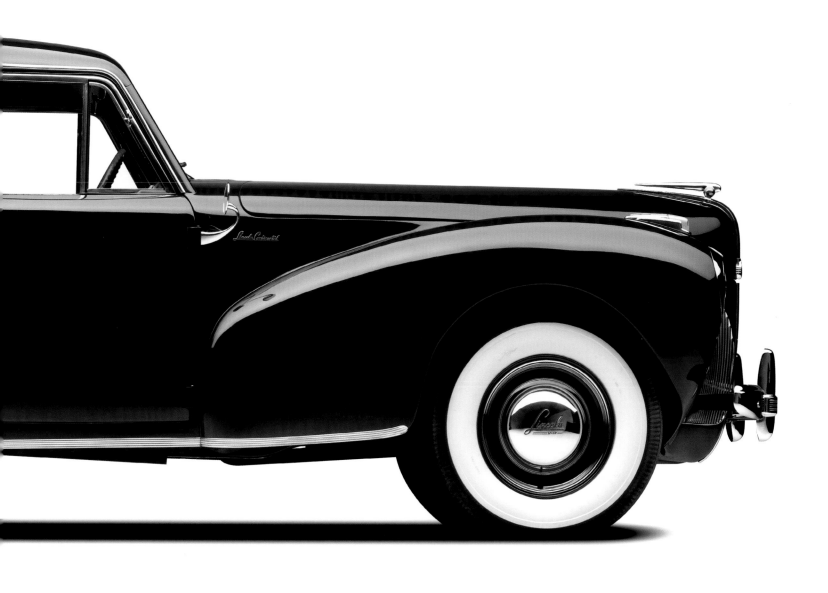

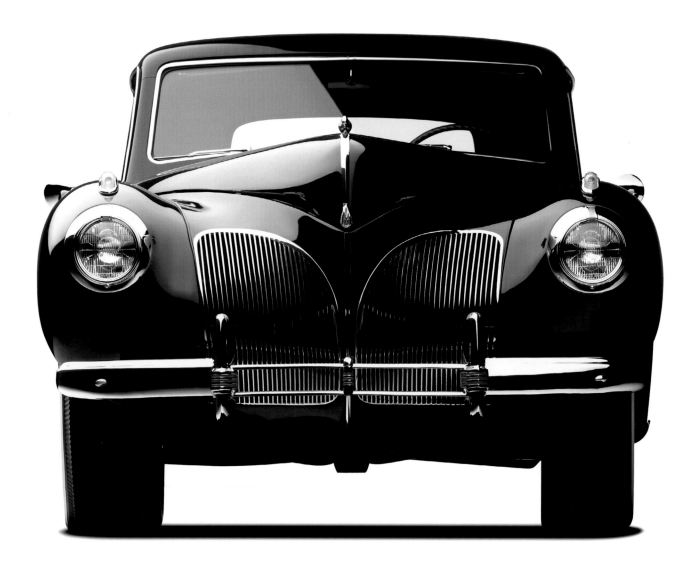

chassis, Edsel Ford asked designer E. T. "Bob" Gregorie to build him a personal car that looked "Continental." The result was a custom cabriolet built on a 1939 Zephyr chassis. In 1939, Edsel used his new "Continental" while vacationing in Boca Raton, Florida. The response to the unique car was overwhelming and Edsel decided to put the car into production. In May, 1940, it appeared in both cabriolet and coupe forms using a modified Zephyr chassis, as well as that car's V-12 engine and three-speed transmission. Production totaled just 350 of the cabriolet, with a mere 54 coupes.

Originally sold as a special version of the Zephyr, the 1941 models were spun off as a separate Continental line for Lincoln. With only detail changes from the original 1940 models, the supremely elegant 1941

Continentals were trimmed with the finest materials. Though hardly a high production model, the second year quantity increased markedly to 1,250 units, 850 of which were coupes like this one.

Manufacturers constantly proclaim that their new models are "instant classics," but that really was true with the elegant and beautifully proportioned Continental. Few cars have aged so gracefully; more than 60 years after it was first introduced, the styling is still stunning and a fitting tribute to the collaboration between Bob Gregorie and Edsel Ford.

From every angle, inside and out, the Lincoln Continental was a model of elegance and styling restraint. Though unique to the Continental, the grille (above) clearly spoke of a family connection to Lincoln Zephyr, Ford and Mercury.

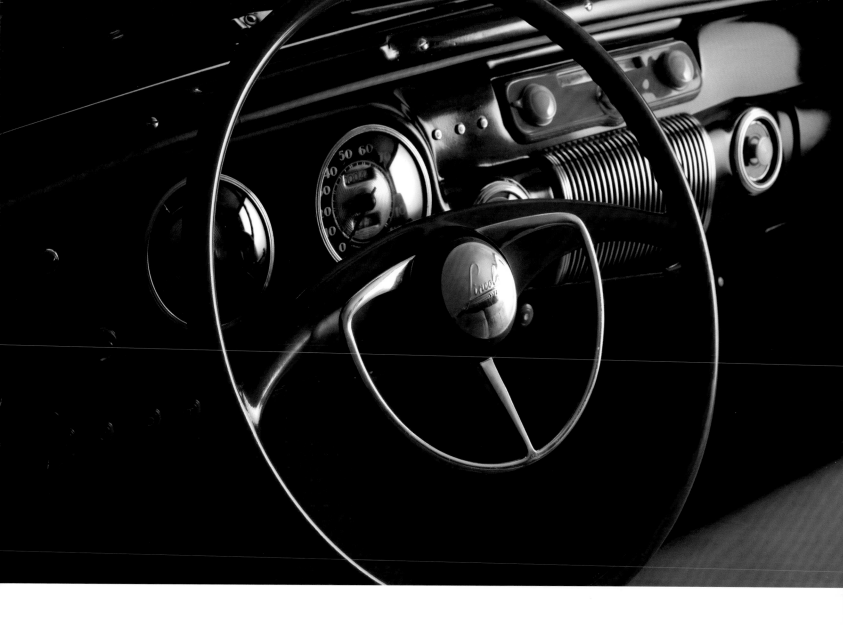

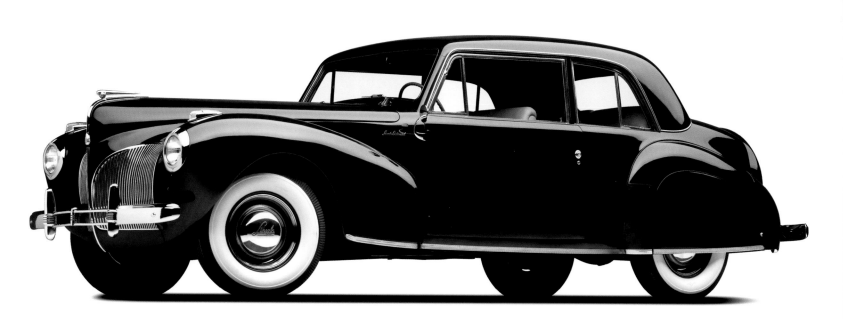

1941 LINCOLN CONTINENTAL COUPE

HOLLYWOOD HIGH STYLE

American Automotive Icons

During the Great Depression, America and Americans

needed Hollywood more than anyone could imagine. Millions were out of work as the breadlines snaked along the streets of most cities. People lost their homes by the thousands, but still, the sun shone on the Hollywood Hills.

Those fortunate enough to have 15 or 25 cents to spare, could escape from life and head to the movies. The stories were magical, the leading men handsome and the starlets beguiling. For almost two hours, all that mattered was up on the flickering screen. It was easy for a young shop girl to imagine herself holding hands and singing with Dick Powell. For a young man out on his own it was just as easy to dream that the lovely Carole Lombard was staring wistfully into his eyes.

The studios knew about selling movies and they knew just as much about packaging stars. Studio press offices helped with fabricating biographies, carefully-leaked information and creating dashing names — Clark Gable's real first name was Billy, Cary Grant was born Archibald Alexander Leach, and Harlean Carpentier became Jean Harlow. And when Gable or Harlow went out on the town, they couldn't very well be seen in an old Hudson or Maxwell. No, only the best would do.

Oddly enough, many of the most extravagant automobiles ever seen coincided with the greatest financial calamity of the Twentieth Century. The commitment to design and develop these marvelous motor cars had been made during the boom years of the mid- and late-1920s. Only the wealthiest few could afford Duesenbergs and Cords, V-12 and V-16 Cadillacs and other top chassis from Lincoln and Packard. However, most of the conservative and wealthy Americans who had weathered the worst of the financial storm were reluctant to showcase their continued affluence with these rolling billboards of plenty.

But all bets were off in Hollywood. If a movie star made it big, he or she drove a flashy and expensive car. Gable had a pair of Duesenbergs; so did Gary Cooper, while actresses Billie Burke and Marion Davies had one each. Jean Harlow had an L-29 Cord, while movie cowboy Tom Mix had a later Cord 812. Like the name, the makeup and the clothes, the car was part of the packaging. The public expected it. They wanted their stars to be larger than life and they wanted to be able to live vicari-

E. L. Cord Dutch Darrin Fred Duesenberg

ously through their exploits, both on and off screen. And exploits — as the studio publicity mavens knew — were good for selling tickets to the movies.

By the middle of the 1930s, there were fewer fancy cars for the very wealthy to choose from. Victims of the deepening Depression, Marmon, Peerless and Pierce-Arrow, were gone. And by 1937, so too were the highly visible Auburn, Cord and Duesenberg. Fortunately for those with the money, taste and desire, Cadillac, Lincoln and Packard still remained. The senior Cadillac and Lincolns were usually big cars with room for five or six people; however they had limited appeal to a box office hero. Packard was also known for its staid styling and conservative engineering, but every now and then there was a glimmer of excitement from East Grand Boulevard, even if it came out of Hollywood. Right in the shadows of the studios, stylist Dutch Darrin was turning the banker's Packard into low, sleek machines any monarch of the marquee would covet.

By the time the 1930s ended and the war in Europe helped the United States economy recover, the American automobile had evolved. Study the massive and mighty Duesenberg J or Cadillac V-16 and compare them to the Auburns or the Darrin Packard. Automotive design was changing and becoming more integrated. The custom body was also losing its place on American streets as mass production took over at all levels. Even the custom Darrins, which first came from a small shop in southern California, soon ushered forth from an old Auburn factory in Indiana.

Clark Gable and Gary Cooper continued to make movies into the 1940s and 1950s, but they no longer pulled at the box office quite the way they had when they were young and dashing and drove Duesenbergs. The great era of Hollywood was gone and so, too was the great era of the grand American car.

1929 PACKARD MODEL 645 DELUXE EIGHT RUNABOUT

MODEL: 645 DELUXE EIGHT, SIXTH SERIES | STYLE: RUNABOUT | SERIAL NUMBER: O5418C

Born in Warren, Ohio, James Ward Packard was the son and brother of successful businessmen. After receiving a degree in mechanical engineering from Lehigh University, Packard spent six years working with the Sawyer-Mann Electric Company in New York. In 1890 he then returned to his home town to establish the Packard Electric Company with older brother William Doud. The new company would manufacture dynamos and incandescent lights.

By the mid-1890s the Packard brothers were interested in far more than manufacturing electrical components. William Doud visited Europe and examined several automobiles, ultimately ordering a de Dion-Bouton. James Ward was fascinated by the automobile in general and spent much of his mechanical aptitude and energy on exploring the new device and other developments in the field. The second Packard-owned motorcar was a Winton James Ward purchased in August 1898.

Mr. Packard's enthusiasm for his new motorcar couldn't have been long-lived, considering his 65-mile maiden trip was concluded behind a team of horses. Numerous repairs and more failures occurred and the Winton was returned to its manufacturer several times. In June, 1899, James Ward Packard is said to have suggested several improvements to Alexander Winton, who would have none of them. The discussion — or possibly confrontation — was the final catalyst that convinced Packard that he could, indeed, build a better automobile than the troublesome Winton he had been running since the prior summer.

The first Packard automobile was completed in November, 1899 and used a single-cylinder engine credited with 9 horsepower. The Ohio Automobile Company was organized the following September. Meanwhile, an additional four examples of the Model A were built and were priced at between $1,200 and $1,325, depending on the body style. The Packard was continuously developed and production increased. One fairly early customer was Henry Joy of Detroit, who was so delighted with his Packard automobiles that he soon invested in the venture. Joy

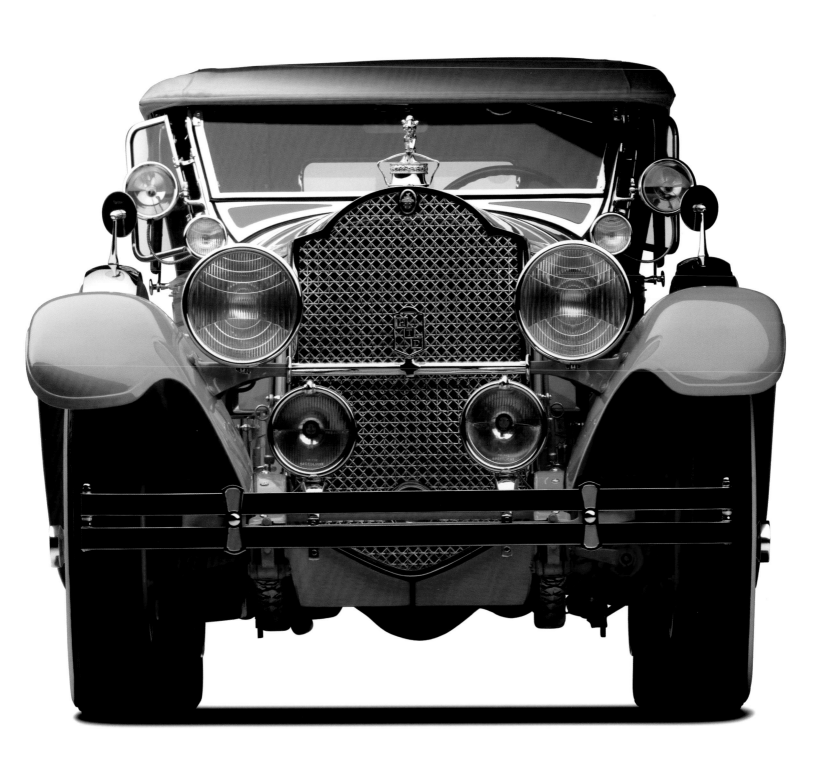

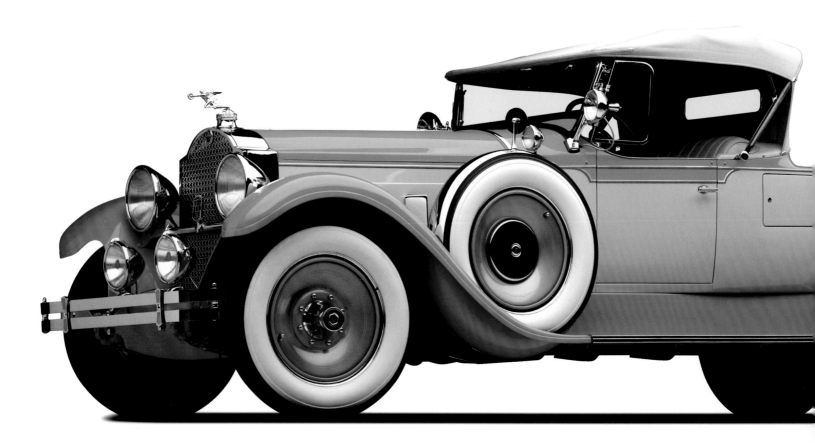

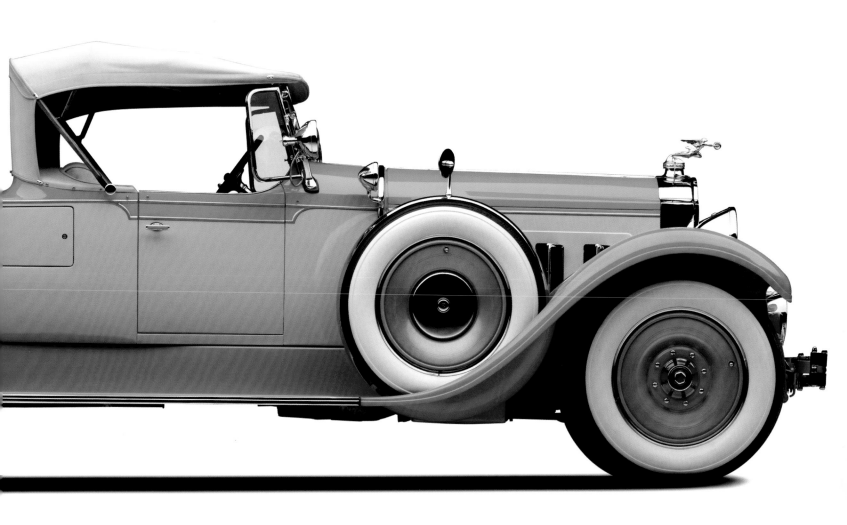

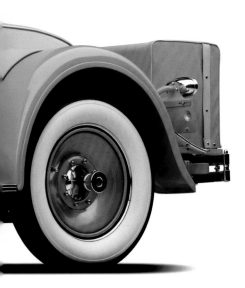

1929 PACKARD MODEL 645 DELUXE EIGHT RUNABOUT

was instrumental in both bringing in significant outside investment and moving the company to Detroit in 1903.

Packard prospered in Detroit. The single-cylinder engine had yielded to the twin, then the four and the six, also to be joined by the straight-eight and the 12-cylinder Twin-Six. Packard, quite simply, rose to the top of any market segment it entered.

By the end of the 1920s, Packard was very well-established as a manufacturer of carefully engineered and properly built cars for the discerning — and prosperous — owner. Throughout most of the classic era, the Packard outsold all its competitors — including Lincoln, Cadillac, and Pierce-Arrow — combined. In 1928, production totaled an all time record 49,698 cars. Nonetheless, the market was changing. The vast majority — more than 41,000 cars — were the less expensive six-cylinder models.

In 1929, the Model 645 "Deluxe Eight" was introduced. This chassis was specifically designed for the extravagant custom and semi-custom bodies of the time.

Regarded by collectors as the ultimate examples of Packard's sixth series, these 145-inch wheelbase cars featured long hoods cloaking their strong and silent 106 horsepower straight-eight engines.

The vehicle offered here is fitted with its original and highly desirable runabout body. Considered the sportiest coachwork offered on the chassis, the lines of this true roadster are remarkable, with a long hood, low beltline, and rakish rear mounted spare. Although the runabout was priced at the bottom of the range when new, the style is highly-prized today. Such sporting bodies were in stark contrast to the conservative coachwork for which Packard was usually known. The runabout was lighter than the more prevalent phaetons, sedans and limousines. And, for the knowledgeable buyer, that equated to improved performance from a car that was already incredibly civilized and comfortable.

This Packard 645 is all about the details, from the carefully designed color breaks (below) to the moldings and door handles (right).

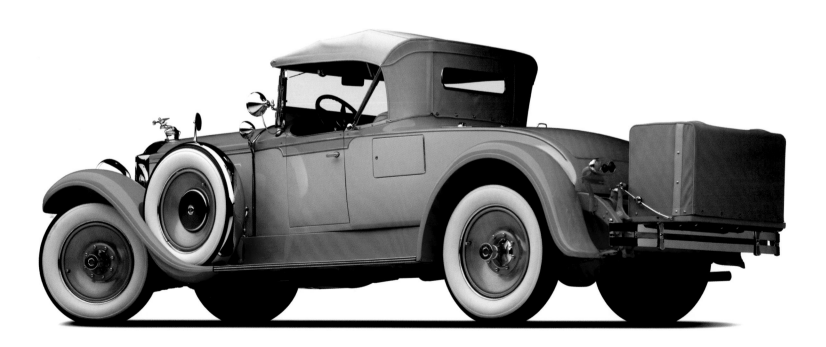

1930 MODEL J DUESENBERG LWB HIBBARD & DARRIN TRANSFORMABLE CABRIOLET

MODEL: J | STYLE: TRANSFORMABLE CABRIOLET | SERIAL NUMBER: 2329, ENGINE NO. J-319

Fred and Augie Duesenberg lived the American dream. Born in Germany, they left their native country for Iowa as young boys. After working for others — generally repairing machines of some type — avid cyclist Fred opened his own bicycle shop. Several years later, when Fred was running his second cycle shop, Augie joined him. As Duesenberg historian Randy Ema wrote: "They made an unbeatable team: Fred the designer and Augie the fabricator."

From bicycles, it was a logical step to the automobile. As was often the case, Fred took the first step and Augie followed later. Before long they were up to their necks in designing and building automobiles — preferably racing cars. Although the Duesenberg brothers loved racing and built some cars that were fierce competitors on dirt, boards and bricks, they eventually found themselves back in the business of building production automobiles. Fred and Augie began work on a new passenger car in their Newark, New Jersey, building. However, in early 1920, a new firm, Duesenberg Automobile and Motors Company Inc,

was founded to produce the car in Indianapolis. By 1922, the Model A Duesenberg was rolling out of the factory.

Just like the latest Duesenberg racing cars, the Model A was powered by an overhead cam straight-eight engine. The displacement may have been a relatively small 260 cubic inches, but Fred's efficient OHC engine was good for 88 horsepower and provided the power needed for the company's new high-quality cars. Model A production continued through 1927, by which time about 650 had been built. It was followed by an updated, more powerful car called the Model X, but only 13 were produced.

One of the most important events in the history of great automobiles had taken place a year before the Model A ceased production; Auburn president E. L. Cord had stepped in and purchased the financially shaky Duesenberg Motors in October, 1926.

He had great plans, but they didn't include Augie Duesenberg. Cord wanted to harness the engineering skill of Fred Duesenberg and the well-known Duesenberg name. Together, they were

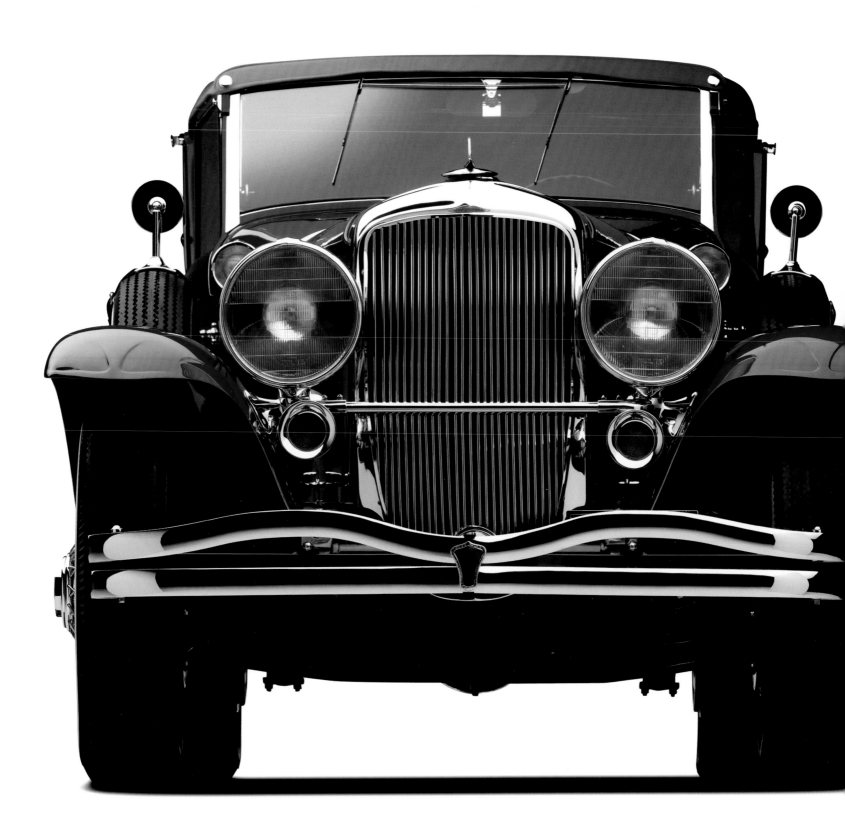

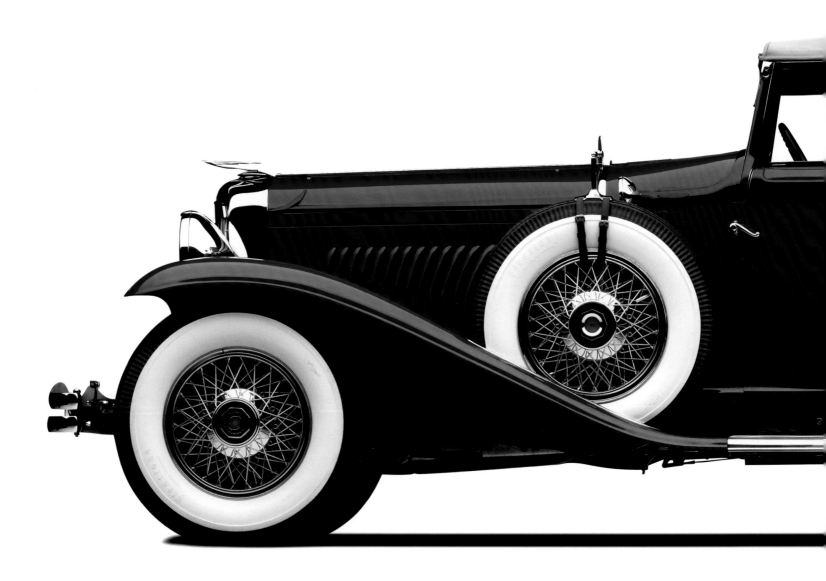

1930 MODEL J DUESENBERG LWB HIBBARD & DARRIN TRANSFORMABLE CABRIOLET

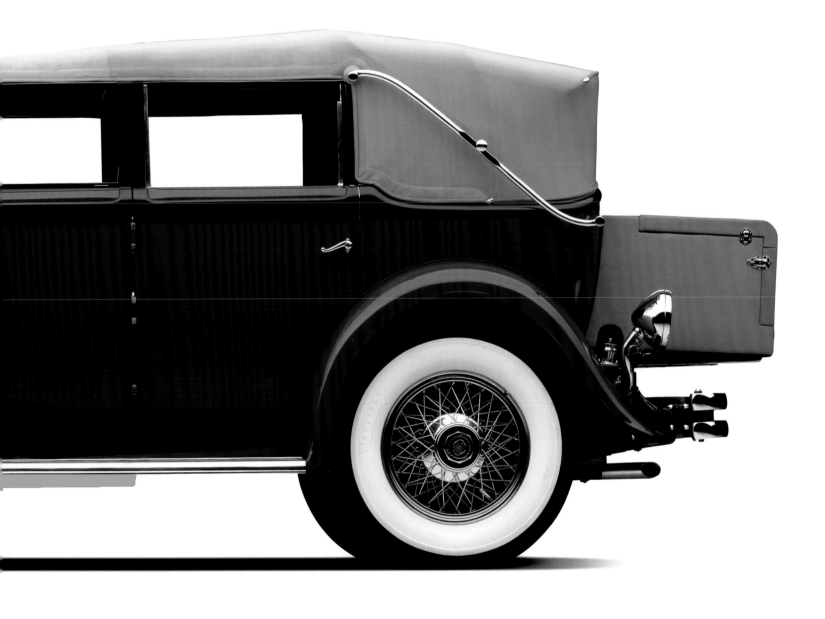

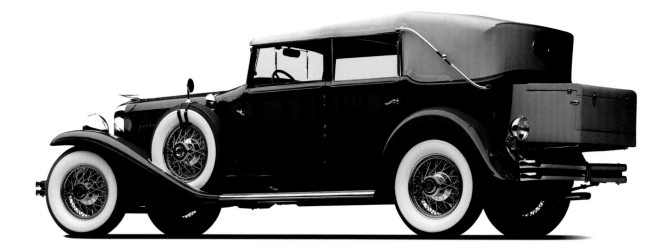

going to build the grandest car ever seen. In that sense, Cord's lofty ambitions may have been realized. Many consider the Duesenberg Model J to be the epitomy of the classic American luxury car. It was big, it was powerful, and with virtually any body style it was spectacular.

The Duesenberg Model J debuted at the New York Automobile Salon of 1928. The J was built on a conventional leaf-sprung ladder frame powered by 420 cubic-inch double-overhead camshaft straight-eight producing 265 horsepower. A chassis alone — stretching either 142.5 or 153.5 inches — cost $8,500 before it was clothed by the finest coachbuilders of the day. Every aspect of the new car was of the highest quality and they were owned or driven by some of the biggest names in America: Wrigley (as in chewing gum), Clark Gable, Gary Cooper, movie director Howard Hawks, and multi-millionaire Howard Hughes. Scores of powerful business figures and scions of old families also gravitated towards the Duesenberg Model J. The company also offered a 320 horsepower supercharged version known as the SJ.

The Paris coachbuilder, Hibbard & Darrin, bodied seven Model Js on both long and short wheelbase chassis. Two of the long-wheelbase cars were bodied as Transformable Cabriolets — at a cost of $3,002 unmounted. One of them,

known by its engine — J-319 — was first displayed at the Paris Salon in October 1929. The folding fabric top could be configured to provide fully-closed accommodations, a town car style with open driver's compartment or as a fully open touring car. The opulent rear passenger compartment was equipped with jump seats, a cigarette lighter and radio.

Originally owned by the Marquis Luis Martinez de Rivas of Paris and Madrid, in October, 1932 it was acquired by Lucius O. Humphrey, who brought it to New York. After leaving Humphrey's ownership, the car passed through a variety of American hands, including noted Duesenberg specialist Jim Hoe, who owned it twice.

Everything about the expansive Hibbard & Darrin body asserts its elegance: from the tall chrome radiator grille and its graceful mascot, to the long louvered hood side panels and the functional landau irons. This was a car for royalty, whether they were the kings and queens of nations, finance, industry or Hollywood.

Few cars are more elegant than this Hibbard & Darrin Duesenberg. The woodwork , instruments and dashboard (top right) are beautifully conceived and executed, while the delicate mascot and vertical grille louvers (bottom right) suggest the power of the big straight-eight.

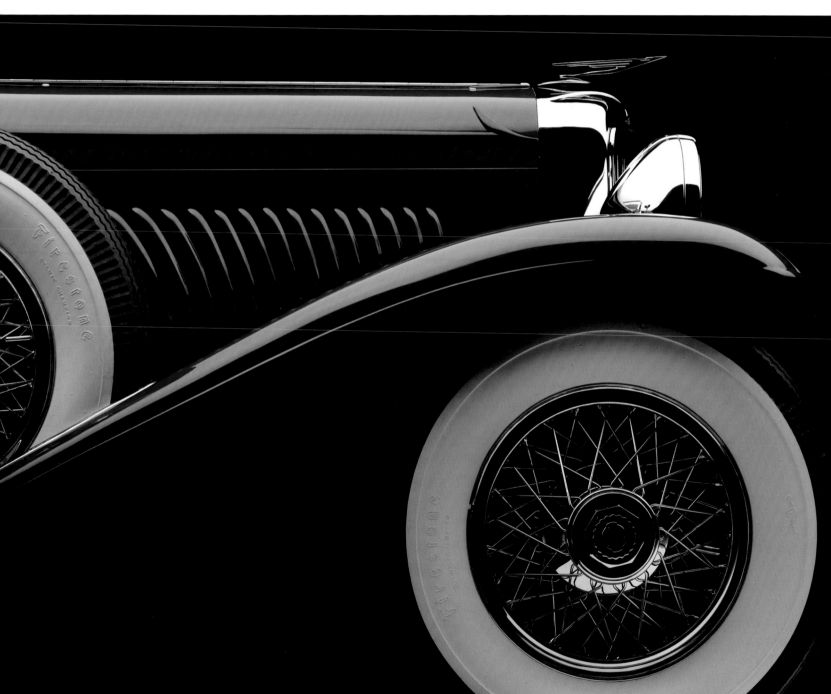

1930 MODEL J DUESENBERG LWB HIBBARD & DARRIN TRANSFORMABLE CABRIOLET

1936 AUBURN MODEL 8-852 SUPERCHARGED CABRIOLET

MODEL: 8-852 SUPERCHARGED | STYLE: CABRIOLET | SERIAL NUMBER: 35263M

When E. L. Cord was born in July 1894, it wasn't to wealth or privilege, but to an ordinary family which had both good and hard times. When the family store in Missouri failed, the Cords moved first to Joliet, Illinois, and then to Los Angeles. Although young Cord attended Los Angeles Polytechnic High School, he never completed his education.

After leaving school, he held a variety of jobs, which involved selling cars, construction work, modifying Model Ts and driving a truck. He also drove in a few contests on dirt as far North as Tacoma. By the time he reached the Windy City in 1919, he'd run through many jobs in a very short time and had little in his pocket. But in Chicago he found his calling selling Moon cars, though he soon moved on in search of his ever-elusive fortune.

Cord left Chicago, but returned at the request of the newly-established Quinlan Motor Company, distributor of Moon cars. The incentive for Cord was a stake in the business, which would come out of his sales commissions. Moon, Quinlan and the Cord family soon benefited from Cord's extraordinary sales skills.

Cord's success selling Moon Cars and the lessons he'd learned about business and finance prepared him for his adventures at Auburn. In 1924, the Auburn Company was ailing when Cord met Auburn board member Ralph Bard, who worked for the bank that was a large creditor of the automaker. Although his fellow-directors didn't agree at first, Bard eventually sold them on E.L. Cord as the one man who just might be able to turn the company around.

It wasn't long before Cord was sprucing up the unsold inventory and moving them out the door. Meanwhile, he was building a formidable sales organization and planning stylish and more powerful models. A series of increasingly good-looking and strong performing cars brought Auburn back to life. For a while, the books were healthy and Cord began to build an empire that included Duesenberg, the front-wheel-drive Cord, the Lycoming Motor Corporation and other companies in the automotive and aviation fields.

In 1932, Auburn had Standard and Custom versions of both its eight- and twelve-cylinder models. Those ranges

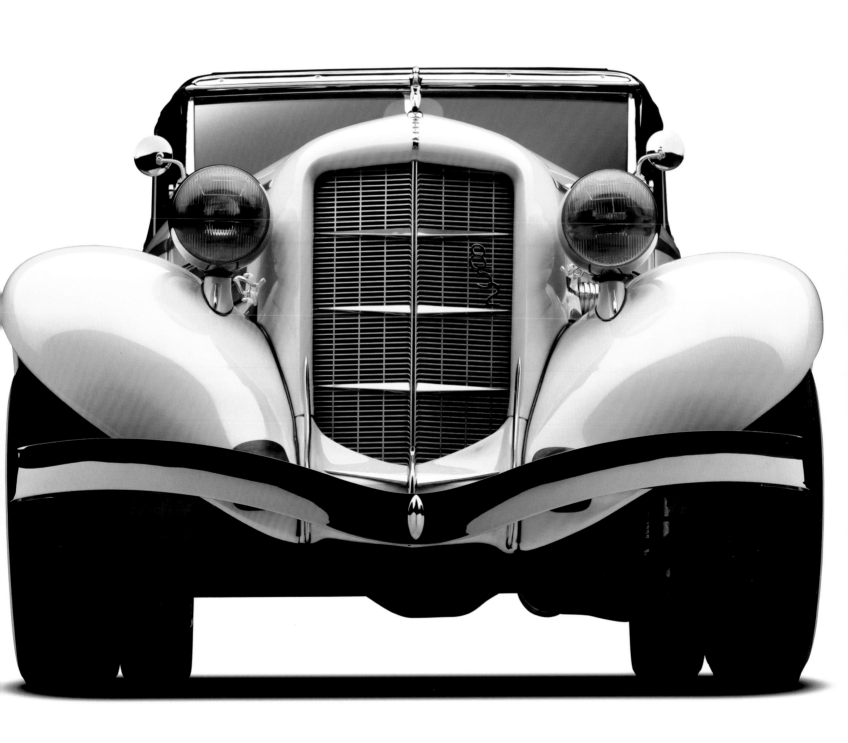

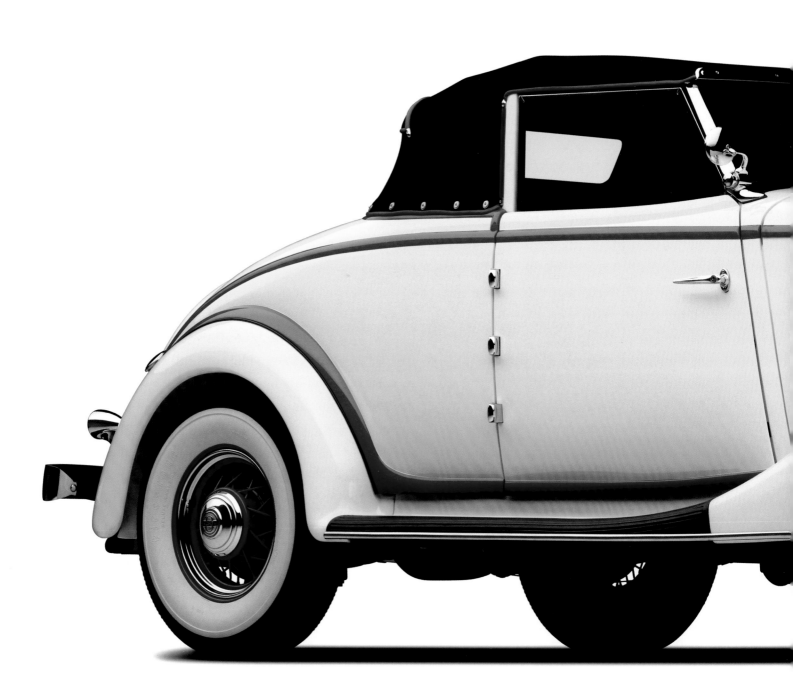

1936 AUBURN MODEL 8-852 SUPERCHARGED CABRIOLET

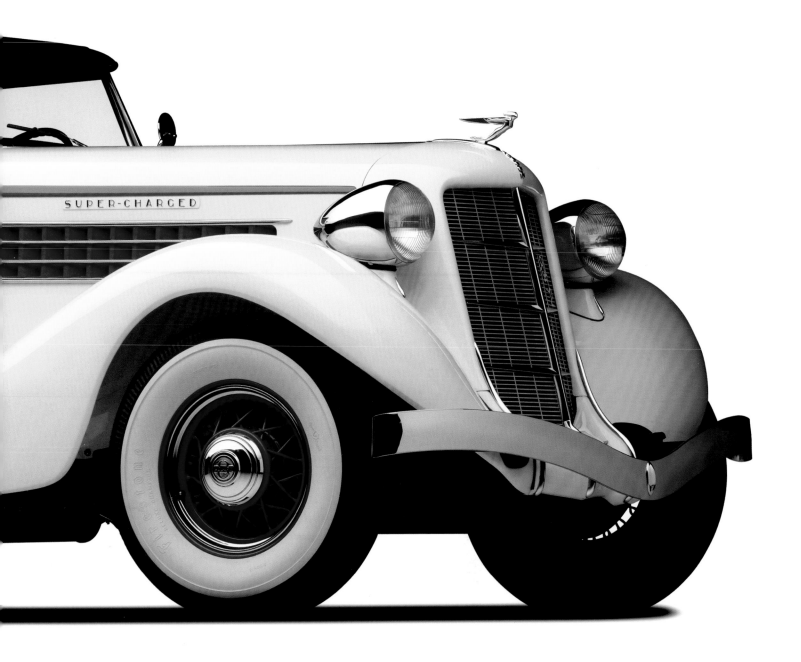

SUPER-CHARGED

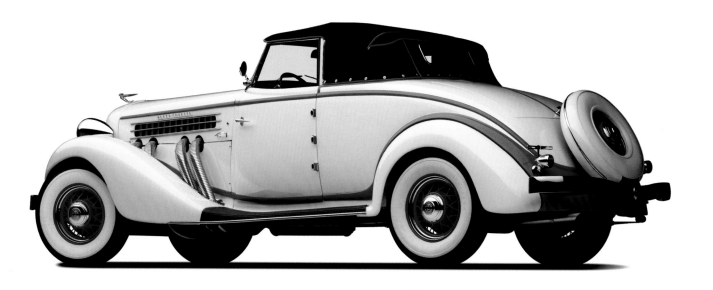

were even broader in 1933 as sales plummeted, the profits vanished and the company was in real trouble again. By the following year, Auburn was again a company of sixes and eights trying to hold down prices and boost sales.

One effort to increase sales was to increase power at a modest cost. That came thanks to a supercharger fitted to the straight-eight engine of the Model 851. The new car had much going for it. It also combined stunning Gordon Buehrig styling — which used minimal new tooling. The 851 Supercharged model also had 150 horsepower and the equivalent of a six-speed transmission thanks to a three-speed gearbox and a dual ratio rear axle. Starting at less than $1,450, the new Auburn offered superlative performance and looks. There was no question that the car could really move — a 1935 Supercharged Speedster broke 70 speed records at the Bonneville Salt Flats and was crowned the world's fastest stock car.

In 1936, the final year for the Auburn, owner E. L. Cord found himself the focus of federal investigations for stock manipulation and fraud, and just 2,418 cars were produced by the Indiana-based company. Although there were essentially just two lines of chassis and two basic engines, many bodies, options and combinations of features were available. Such a proliferation of models with sales so limited clearly told its own story.

But at the very top of the 1936 model range was the 852 Supercharged model offered in six body styles. From the front, the cabriolet and coupe are clearly related to their Speedster stablemates and share the same radiator grille. However, unlike the Speedster, the coupe and cabriolet have a back seat and more room for luggage. Under the skin, the cars were the same, from the supercharged Lycoming straight-eight to the fully-hydraulic drum brakes. This example started life as a coupe. Later in life its top was removed and it was subsequently converted into a cabriolet.

After 1936, there was no more Auburn, Cord or Duesenberg. E. L. Cord sold his automotive holdings and moved on to other ventures, most notably real estate. Cord ended his days in Nevada, where he finished a vacant term in the legislature and became a noted elected official in his own right.

The styling and detailing of the Gordon Buehrig-designed 852 Cabriolet combined power and elegance, from the exposed exhaust pipes (above right) to the tidy spare tire treatment (above left) and the finely-sculpted mascot (left).

1939 PACKARD SUPER EIGHT
CONVERTIBLE VICTORIA BY DARRIN

MODEL: SUPER EIGHT, SEVENTEENTH SERIES | STYLE: DARRIN CONVERTIBLE VICTORIA | SERIAL NUMBER: EC501612

American Howard "Dutch" Darrin was trained as an electrical engineer, started a pioneering American airline and ended up in Paris where he set up Hibbard & Darrin with fellow American Tom Hibbard. At first the company held a Parisian Minerva agency, but later concentrated on designing and building custom coachwork. When the American partners lost financial backing in 1931, Hibbard returned to the United States. With funding from South American J. Fernandez, Darrin regrouped and Fernandez & Darrin continued as a top coachbuilder in Paris.

Chassis brought to Paris for Darrin designs included the greatest of the day: Mercedes-Benz, Packard, Duesenberg, Delage, Rolls-Royce and Hispano-Suiza. Coachwork designed by Darrin graced cars owned by film stars, royalty and industrialists. But by the middle of the 1930s, business wasn't all it could be in Paris and Fernandez & Darrin closed shop, while Dutch Darrin set sail for the United States. Although he chose to leave for greener pastures, the meadows in which he had been grazing must

have been sufficient to provide the de Haviland airplane that was also part of the ship's cargo. Upon reaching New York, Darrin, who was an avid pilot, flew the de Haviland to Los Angeles.

In 1937, Darrin set up a shop on Sunset Boulevard in Hollywood. According to historian J. M. Fenster, Darrin's first "Hollywood" effort was "a convertible Victoria on a 1937 Ford V-8 chassis." It was followed by a long, low and sensuous Darrin body on a Packard 120 that was sold to film star Dick Powell in 1938. Within a year Clark Gable, Tyrone Power, Errol Flynn, Ann Sheridan and Carol Lombard, among others, all had cars built by the charming, polo-playing Dutch Darrin.

Darrin's Packards were considerably different from the cars coming directly from the factory. Rear fenders were removed, slightly stretched and then remounted with a forward slant, while front fenders were restyled and skirted to fit a body without running boards. The radiator was cut down by three inches and the hood was sectioned, while the Darrin-bodied cars were fitted with cus-

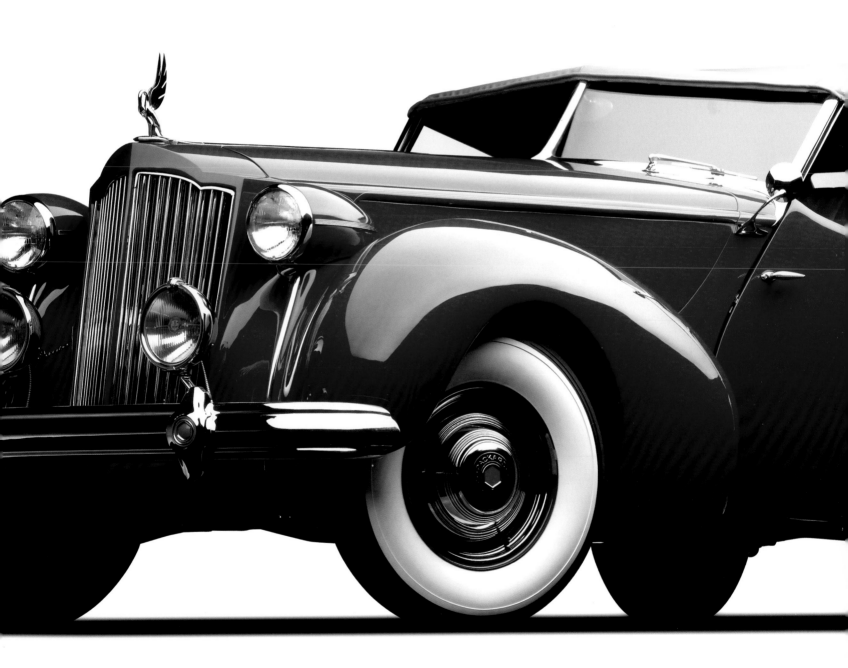

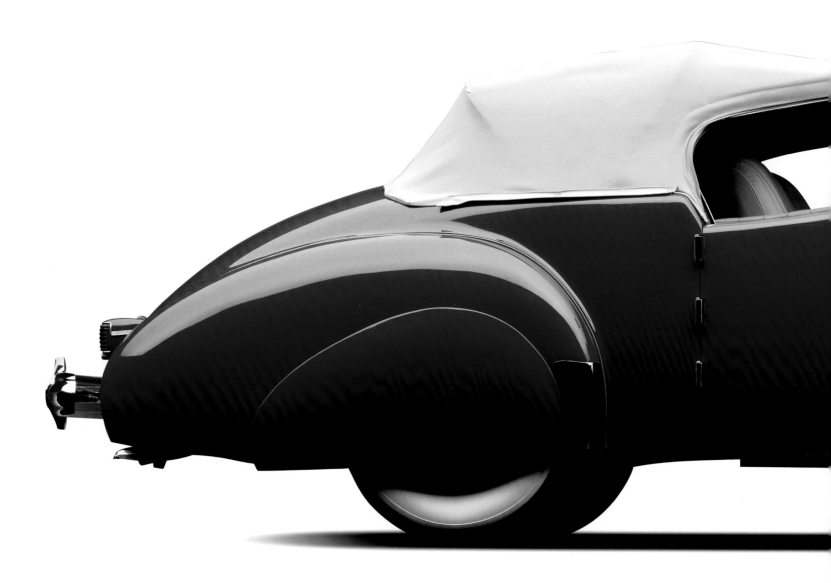

1939 PACKARD SUPER EIGHT CONVERTIBLE VICTORIA BY DARRIN

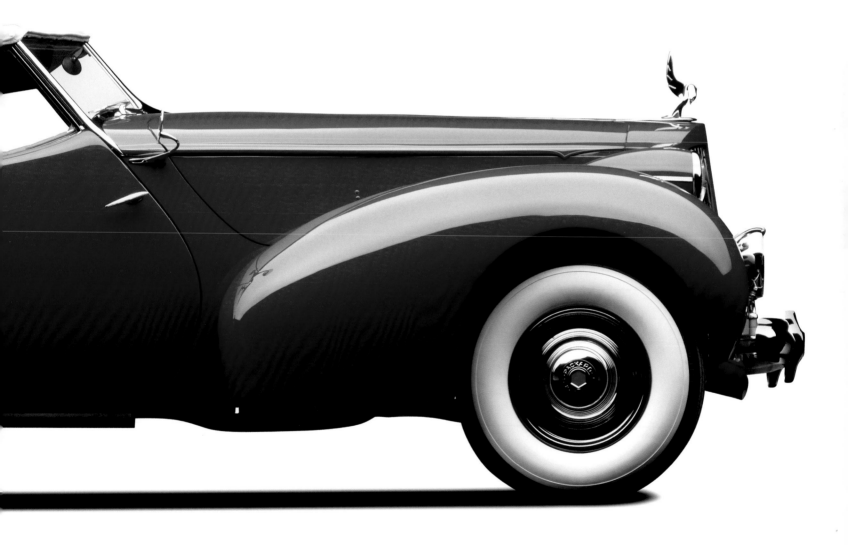

1939 PACKARD SUPER EIGHT CONVERTIBLE VICTORIA BY DARRIN

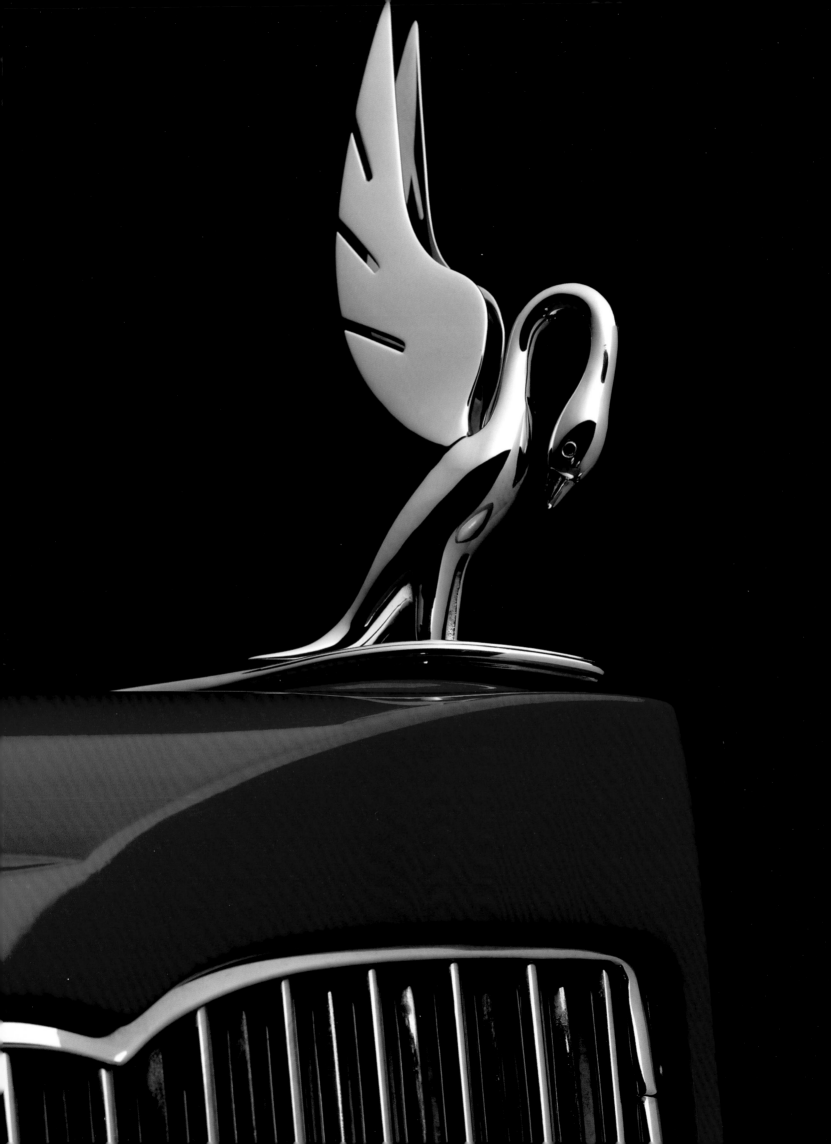

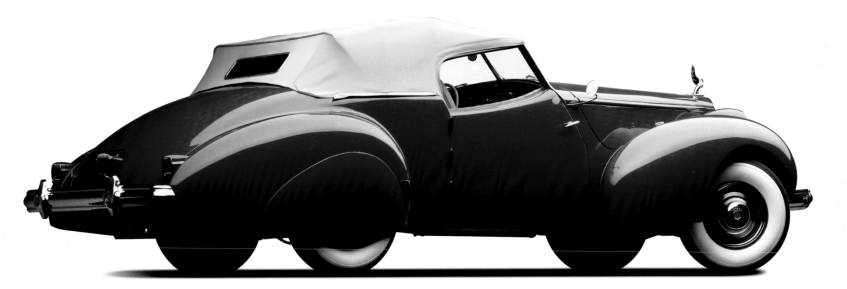

tom-built windshield frames and his favorite modification: cut-down, suicide doors.

Darrin certainly had Hollywood's attention, and it wasn't long before the men at Packard's Grand Boulevard headquarters in Detroit were noticing Darrin's work on Packard chassis as well. At first, the Darrin-bodied cars were built in Hollywood, but eventually volume was too great for demand. For the 1940 models, production was moved to the former Auburn plant in Connorsville, Indiana. There, the Victoria was built on the 127-inch wheelbase and was joined by the elegant Sport Sedan. Although rolling on the longer 138-inch chassis, the four-door car lost none of the drama of the smaller Darrin, despite the extra length and room to accommodate five or six people comfortably.

The 1939 Packard Darrin Super Eight Convertible Victoria displayed here is much like any other 1939 Packard — under the skin. The engine was an L-head straight-eight displacing 320 cid and producing 130 horsepower. Drive reached the rear axle via a three-speed manual transmission and was available with optional overdrive. Brakes were hydraulic drums all around. The one significant change from the standard Packards was that a front brace was removed during the process of lowering the radiator shell. Once Packard was responsible for distribution of the Connorsville-built Packard-Darrin Super-Eights, the company's engineers recognized that, without the brace, the car's handling was much less secure. To improve the feel and make the car safer, a retrofit kit was developed and installed at Packard's expense.

This Hollywood Darrin is one of only about 24 Darrins built before production moved east to Connorsville and the convertible Victoria and sport sedan model became part of the official Packard catalog.

The Darrin Packards were sporty and rakish beyond anything coming out of the Packard factory, yet the grille and traditional cormorant mascot (left) made it clear that the car was undeniably a Packard.

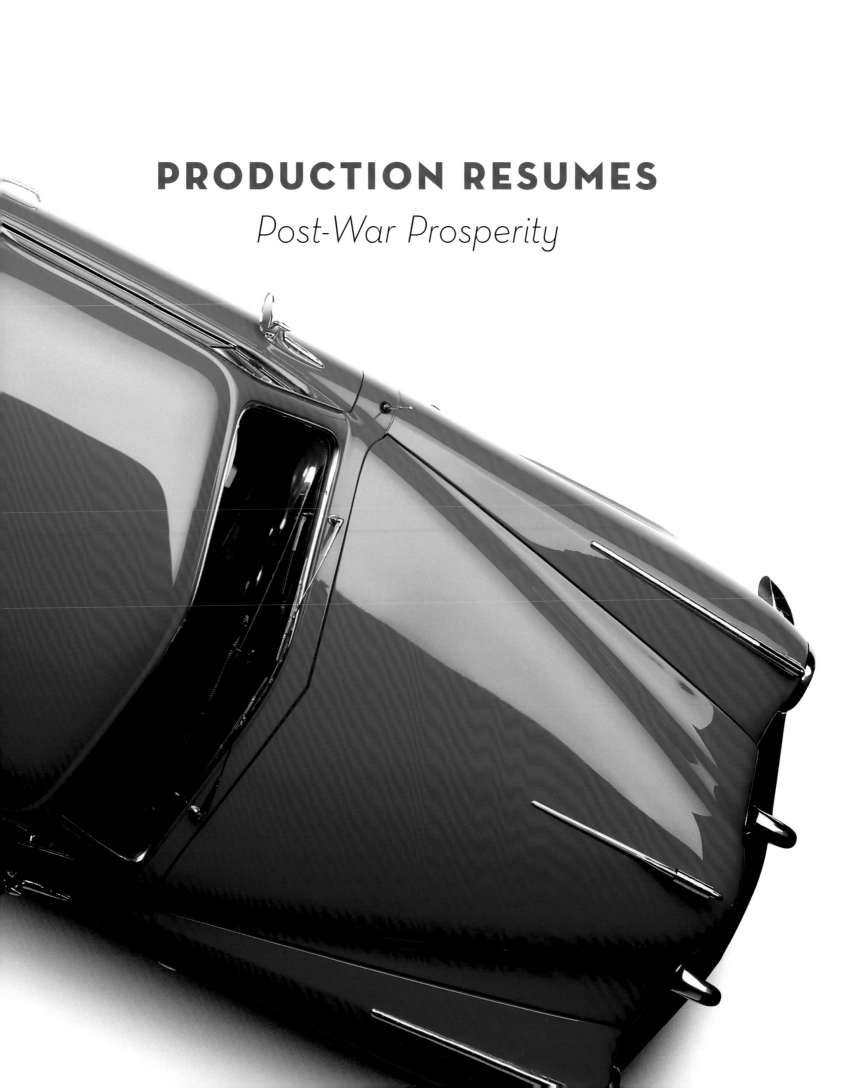

PRODUCTION RESUMES

Post-War Prosperity

Neither America's citizens or automakers

had wanted to go to war. The memory of the terrible loss caused by "The War to End All Wars" was still fresh. But with the advance of Germany, war appeared inevitable. In 1940, President Roosevelt appointed General Motors president "Big Bill" Knudson as director of the newly-created Office of Production Management to allocate resources and oversee the conversion of a peace-time manufacturing economy to the production of war materiel.

The automakers controlled a huge chunk of the United States' production capability and their cooperation was essential to the war effort. Appointing a major automotive executive to manage the process was a shrewd move. Following the Japanese bombing of Pearl Harbor on December 7, 1941, the United States entered World War II. In response to a government directive in January, 1942, American automakers suspended production of passenger vehicles and began the arduous job of converting their full industrial and manufacturing might to the war effort.

Soon Cadillac was producing tanks and Buick was building airplane engines, as were Packard and Studebaker. Ford and Willys were building Jeeps, while Chrysler was hard at work on military trucks, anti-aircraft guns and tanks. With only a few automobiles built for military purposes, all of Detroit's manufacturing capability went into the tools of war.

With the surrender of Japan on August 15, 1945, it was time to convert back to automobile production. That meant moving out tooling and assembly

lines for tanks, airplanes, aero engines and guns and dusting off and reinstalling the machines needed to build cars. Amazingly, the first civilian automobiles were rolling out of plants by autumn 1945, as first one automaker then another resumed limited production.

Return to civilian production had been anticipated for some time. But much of the machinery was either worn out from war work or had deteriorated from $3\frac{1}{2}$ years of storage. To a car, the products rolling out of the plants were 1942 models that had been quickly freshened with new grilles, badges and minor interior changes. Engines, drive trains and body stampings remained largely unchanged — and it made perfect sense. There was a ready market for any car Detroit could build and the 1942 body tooling was hardly used. As a result, costs saved on tooling could be applied toward the

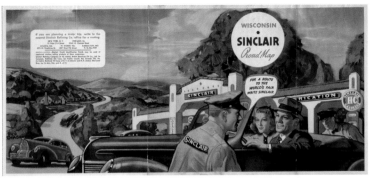

development of a truly new model for a time when buyers could afford to be more particular about the new cars they chose.

Mechanically, those postwar cars all had something in common — prewar technology. Lincoln, Cadillac, Chrysler and Studebaker all used L-head engine designs which, while not particularly efficient, were inexpensive to build.

For five years, Americans had been saving their money. People at home were making good wages and had virtually nothing to buy in the wartime economy. Soldiers and sailors stationed overseas had several years of wages they hadn't touched. Suddenly they were home with cash in their pockets, with the prospect of shiny new cars, washing machines and other manufactured goods. But, supply was limited in what was clearly a seller's market.

Studebaker was one of the first of the automakers to offer new 1947 models, which were ready for sale in the spring of 1946. The cars were well-received, but so, too, was anything on wheels.

Many of the major automakers didn't have their all-new models ready until 1948 or 1949. Ford and Mercury had a fresh shape for 1949, but still relied on the venerable flathead V-8. Cadillac, ever the leader, had a new car that same year, but it was equipped with an all new overhead-valve V-8, which helped the GM Division to resume its place at the top of the hierarchy.

Most American cars built from late 1945 through 1948 sold simply because any *new* car was a *good* car. Hundreds of thousands of orders went unfilled because of a shortage of raw materials, limited production capacity and sporadic labor disruptions that swept the country as workers wanted their rewards for winning the war.

Those first postwar cars were also important because they generated the cash essential to develop new chassis, body designs, tooling and engines. In the seller's market immediately following the war, the independents, such as Packard, Hudson and Studebaker, sold every car they could build. The profits from these boom years extended their corporate lives only into the 1950s and early 1960s, as competition and economies of scale became such important factors.

1947 CHRYSLER TOWN & COUNTRY CONVERTIBLE

SERIES: NEW YORKER TOWN & COUNTRY | STYLE: C39N CONVERTIBLE | SERIAL NUMBER: 7402328

The first postwar Chryslers didn't trickle out of the plants until the last few months of 1945. With very few changes, the cars in the showrooms were essentially the same as the 1942 models. With the advent of war, very few of the 1942s had actually been sold, so warmed over as they were, any new models were very welcome. Some were certainly more welcome than others.

During the 1940s and 1950s, Chrysler was known for high-quality engineering; it was not renowned for styling excellence. There were exceptions to that rule, the most notable of which was the elegant Chrysler Town & Country that first appeared in 1941. The concept for the stylish steel and wood-bodied wagon was initiated by Paul Hafer of Pennsylvania's Boyertown Body Works. Although Boyertown never landed the contract to build bodies for Chrysler, the Town & Country name suggested by Hafer was adopted.

Initially, the Town & Country was available in 6 and 9 passenger wagons on the long-wheelbase six-cylinder Windsor chassis. A 6-passenger version of the eight-cylinder Saratoga line was offered as well, but only one is known to have been built. What set the Town & Country apart was its external wood body framing and paneling. Approximately 1,000 buyers signed up for the gracious and utilitarian Town & Country in the first year of production. Changes were few for 1942 and sales were fairly constant from the prior year.

Chrysler had seriously considered a complete line for the Town & Country nameplate, which would have included a brougham, roadster, hardtop, sedan and convertible. But when the new 1946 Chryslers came out, Town & Country offerings were limited to a four door sedan for the Windsor line, with sedan and convertible versions for the eight-cylinder New Yorker series. The '46 Chryslers were more extensively face-lifted than many of the other automotive offerings returning to the market. Changes included front fenders faired into the body sides and an elaborate "harmonica" grille. The glamorous Town

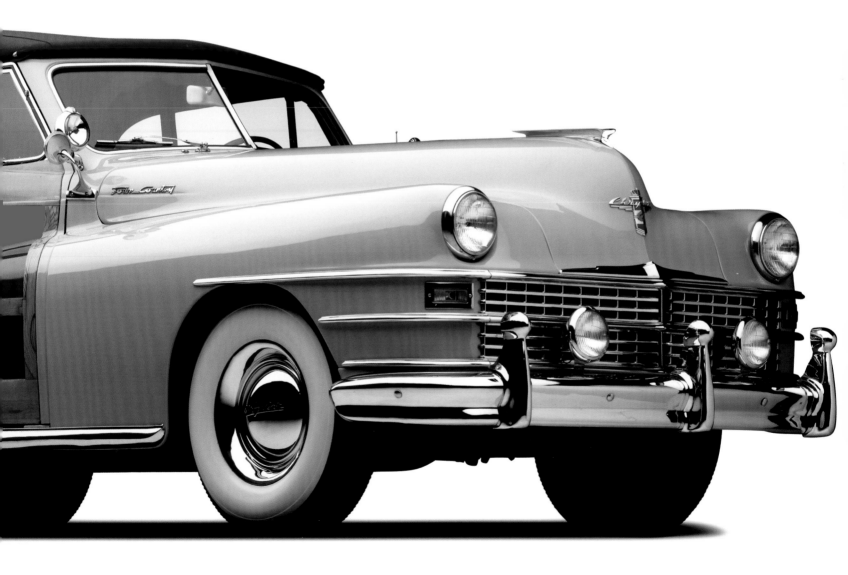

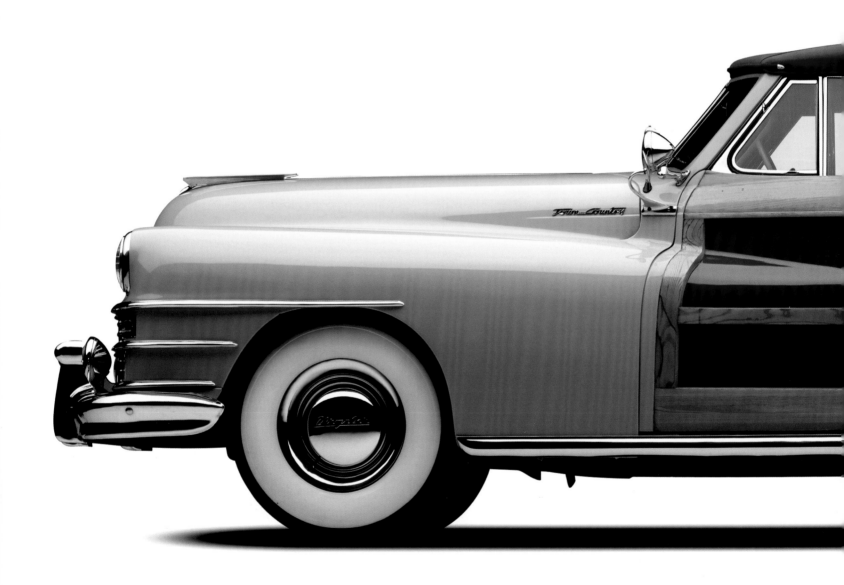

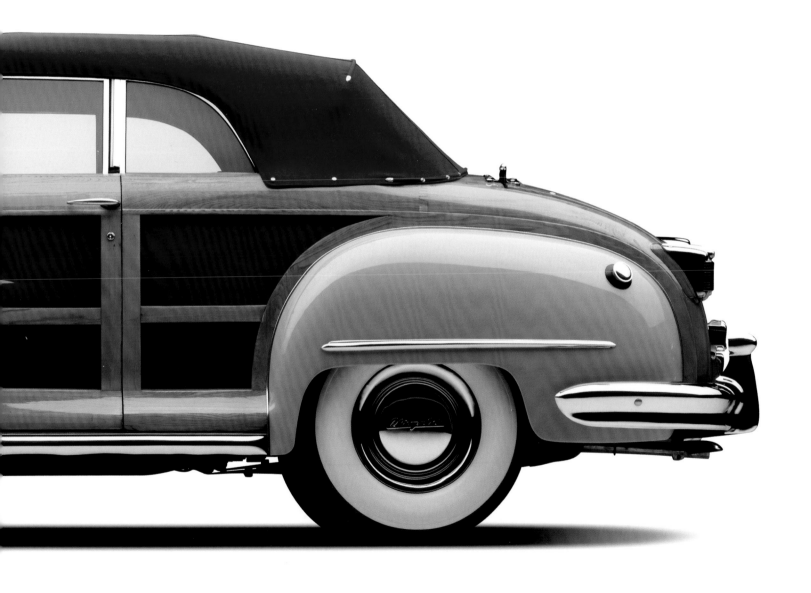

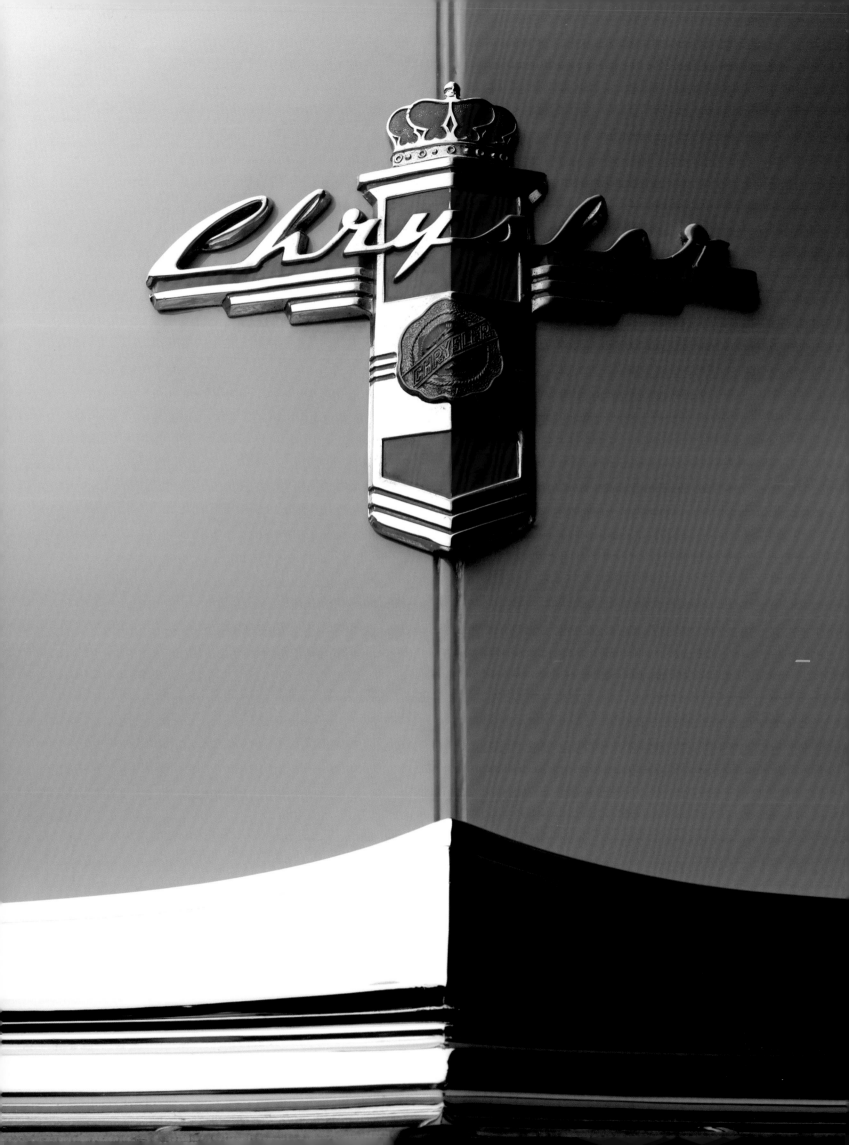

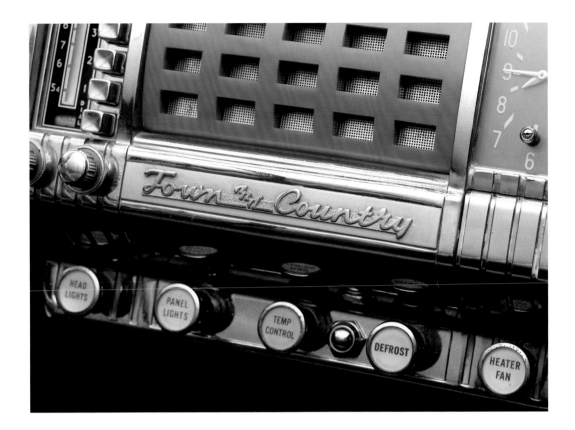

& Country convertible was the showroom draw for Chrysler. Priced $600 above the standard open New Yorker, the Town & Country soon became the choice car for Hollywood stars. It was also the car often cast in films to take city-dwelling movie characters to their weekend homes in Connecticut.

The Town & Country was little changed for 1947, although the six-cylinder Windsor was available only as a four-door sedan and the eight-cylinder New Yorker came solely in two-door convertible form. At $2,743, the Town & Country New Yorker cabriolet cost almost $1,000 more than the base New Yorker. But for that extra spending, the owner received one of the last hand-built cars to come out of Detroit.

This exceptional 1947 Chrysler Town & Country convertible is as lovely inside as it is on the outside. The interior is impeccably finished with wood paneling

and options on this car include radio, heater, dual spotlights and fog lights. Ash was used for the structural wood framing and mahogany veneer for the contrasting inserts on the exterior of the car. Later in 1947, although the wooden framing remained, the paneling was replaced by a "dinoc" decal over a steel stamping. The approach was certainly less traditional, but was less costly to build and much easier to maintain.

One of the first postwar cars to achieve true collector status, interest in Chrysler's Town & Country remains strong. The Town & Country was continued through 1954 but wasn't picked up for the new 1955 model line.

The Town & Country was the top model in the Chrysler line. As a result, every feature of the car from the stylized badge (left) to the ornate dashboard (above) showed elegance and extreme attention to detail.

1947 CADILLAC SERIES 62 CONVERTIBLE

SERIES: 62 | STYLE: CONVERTIBLE | SERIAL NUMBER: CG680887

The story of the 1947 Cadillacs — like that of so many cars of the immediate postwar era — really starts with the 1941 model line. Although Cadillac styling had been gradually evolving, for the first time a full-width grille tied the front end together and served to integrate the fenders with the car. Those fenders were still not fully-flowing into the front or rear body section, but the effect was much more modern than in the past.

Based on a quick glance, it's easy to think that the Cadillacs were all new again for 1942, but the body shells were essentially unchanged. GM's stylists, under Harley Earl, had cleverly extended the bullet forms of the front fenders back into the front doors. Meanwhile, the rear fenders also stood partially-proud of the main body shell, but echoed the shape of the front fenders. A clever design feature was a running board that was hidden when the door was closed and became a useful step for climbing in and out of the elegant new Cadillac. The overall shape was harmonious and gave the impression of an entirely new design.

The first postwar Cadillac rolled off the assembly line on October 17, 1945. This time there was little attempt to hide the fact that the 1946 models were hastily warmed-over 1942 models with revised grilles, parking lamps and other detail changes. The object hadn't been to create something fresh — but to get cars into production as rapidly as possible; change could come later. By the time the 1946 model year ended, 28,144 cars had been produced. Sales more than doubled for 1947, despite minimal changes that included revised badging and trim as well as a new grille. Due to the high demand for steel, and limited production capacity, 90,000 orders for 1947 Cadillacs couldn't be filled.

The Series 62 Cadillac was the best selling 1947 model for GM's luxury car division. With any new car difficult to come by, those few who managed to take delivery of a Cadillac were very fortunate indeed. The Series 62 accounted for two-thirds of Cadillac's production in 1947, with 6,755 of those being convertible coupes.

All Cadillacs for 1946 and 1947 were built with the company's venerable

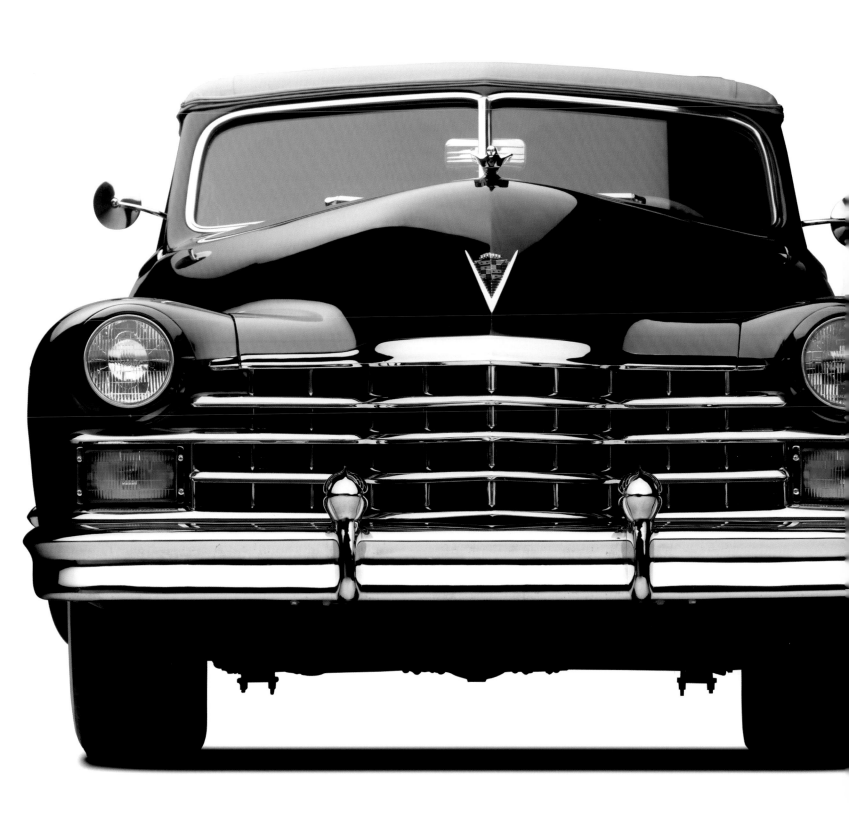

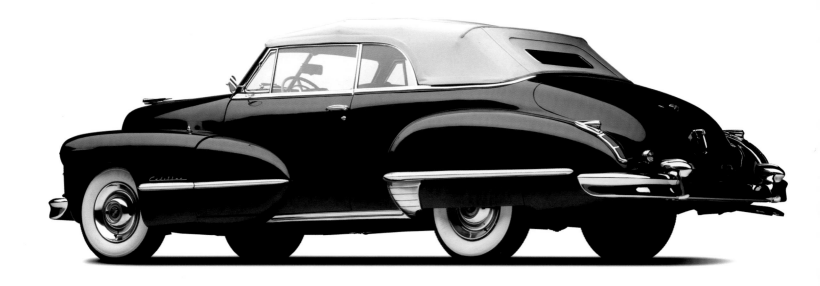

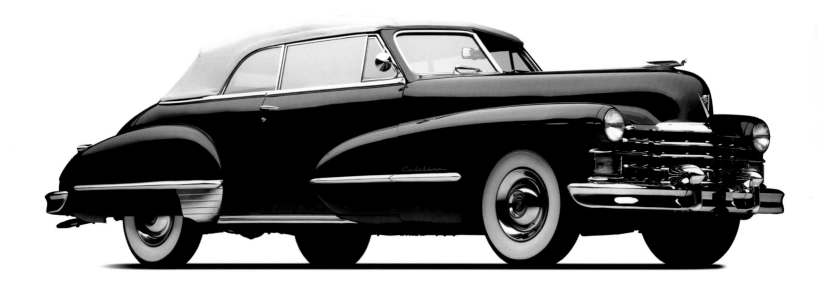

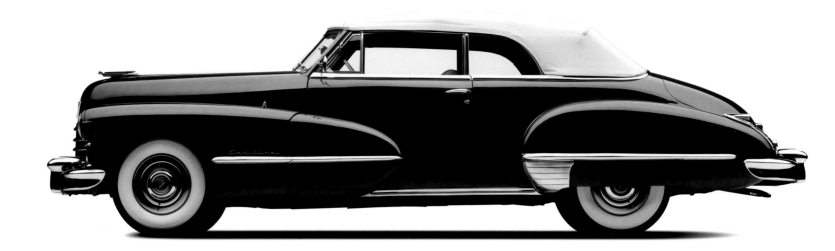

1947 CADILLAC SERIES 62 CONVERTIBLE

L-head V-8 engine, which produced 150 horsepower and 125 pound-feet of torque. The standard transmission was a three-speed manual unit with column shift, but many buyers opted for General Motors' fine Hydra-Matic automatic transmission, which was ideally-suited for use with the slow turning, high-torque engine. A coil-spring independent suspension was used up front, with a live axle in the rear. Stopping was handled by four-wheel hydraulic drums.

This 1947 Cadillac Series 62 Convertible Coupe is finished to original specifications with the correct maroon exterior and tan leather interior. Original optional equipment fitted to the car includes the Hydra-Matic transmission

— a $186.00 option — as well as power seats and windows, white wall tires and the stylish and popular full wheel discs that cost the lucky buyer an additional $25.00. Although the manufacturer's list price of a new Series 62 Convertible was listed as $2,902, by the time all the options were totaled up, this lovely car would have cost in the neighborhood of $3,200 — if an unscrupulous dealer didn't insist on even more to ensure timely delivery of this hot commodity.

From any angle, the 1947 Cadillac Series 62 Convertible was a handsome car that made a statement of success and good taste. The side trim and grille (left), as well as the taillights (above) were sculpted just like fine jewelry.

1947 LINCOLN CONTINENTAL CABRIOLET

SERIES: 76H LINCOLN CONTINENTAL | STYLE: 76 CABRIOLET | SERIAL NUMBER: H147325

In the beginning, there was the Lincoln Model L. It was a meticulously designed automobile built to the most exacting tolerances. Lincoln founder Henry Martyn Leland would have it no other way. The L-head V-8 was strong and smooth and the chassis was conventional, but again built to the highest standards. However, all this excellent new hardware was clothed in some incredibly dull and uninspired coachwork designed by Leland's son-in-law. The lackluster styling — along with production delays while Leland perfected his design — meant that sales were slow to materialize in the post-war recession and the investors became impatient.

In came the receivers in early 1922, followed closely by Henry and Edsel Ford who — after acquiring the firm — now held the keys to the Lincoln kingdom. Although it was impossible to keep father Henry far away, the responsibility of running Lincoln fell upon Edsel. Where Henry Ford was a rough-hewn, self-made sort of a man, his son was a man of taste and refinement. He also had a gifted eye when it came to any kind of art, particularly automotive styling.

Although the Lelands had feared that the Ford regime would cut cost and impinge on quality, the opposite was true. Mechanical improvements were accompanied by more modern and appealing bodies from a variety of coachbuilders. The Leland-inspired Model L continued through the end of 1930. It had proven to be a very fine — if conservative motor car.

The Model K that replaced it was even better and a truly fitting platform for the finest American coachwork. Like its predecessor, the Model K was powered by a 60-degree V-8, which was continued in the KA. However, a 12 came along with the advent of the KA V-12 and larger KB of 1933. The senior Lincolns used a 67 degree V-12, displacing a massive 414 cid. In 1936, those big and luxurious K-Series were joined by the teardrop-shaped Lincoln Zephyr.

Although V-12-powered, the Zephyr's 75-degree engine was derived from the flathead V-8 and, at 267.3 cid, was substantially smaller than the K engine. The sleek, streamlined Zephyr was essential to the development of the magnificent Continental of 1940. Edsel Ford desired a personal vehicle for use in Florida and

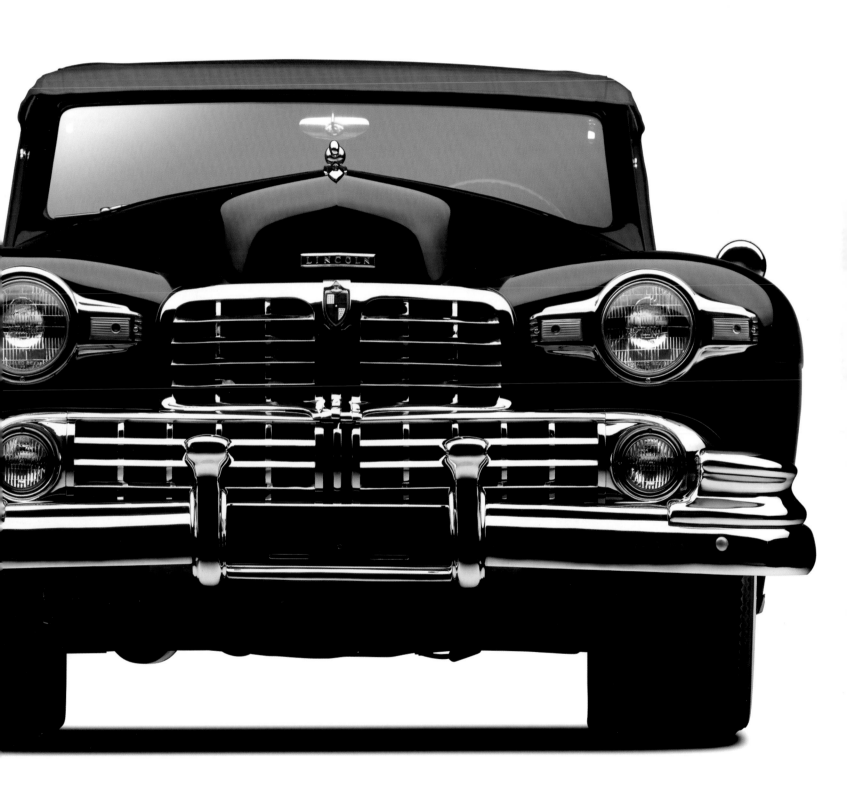

turned to designer Bob Gregorie to come up with an elegant new vehicle using Zephyr chassis and running gear. The result was a long, low and phenomenally elegant Lincoln Continental. Although a very limited production vehicle, it was Lincoln's flagship for the new decade, which was interrupted by war.

Lincoln announced in March of 1946 that there would be no 1947 model year cars offered. But the company reversed its decision and announced a new model year as of February 19, 1947. The Continental returned to production with only a minor facelift including slightly updated trim. The front-end was revised from 1942 and the resulting double tiered grille gave the Continental a much more massive visage. Equipped with a 292 cubic inch V-12 engine, Lincoln was at the top of the list when it came to luxury and style.

In 1947, when the Indianapolis 500 was first run again after World War II, the Continental was there as its pace car. However, Edsel Ford was not behind the wheel, having died of stomach cancer during the war. Instead, Edsel's beautiful Continental was driven by his son, Henry Ford II, who had been recalled from the military to join the Ford Motor Company upon his father's death. Whether on the track at Indianapolis or in the country club environment for which it had been conceived, the 1947 models lost none of the grace and style of the original car built in 1939 for Edsel Ford.

The original Lincoln Continental was possessed of a simple and undeniable beauty, and the 1947 Continental followed suit. Where other cars relied on ornate trim, Lincoln stylists were reserved when it came to applying chrome. The lines were just right and needed little ornamentation. The same principles of restraint were applied to the interior (right), instruments (far right) and the hood ornament (center right).

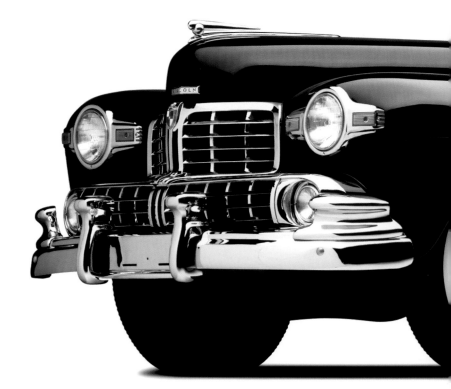

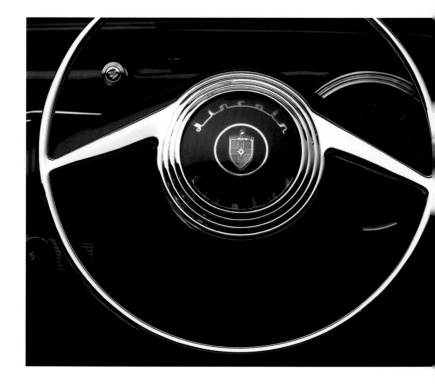

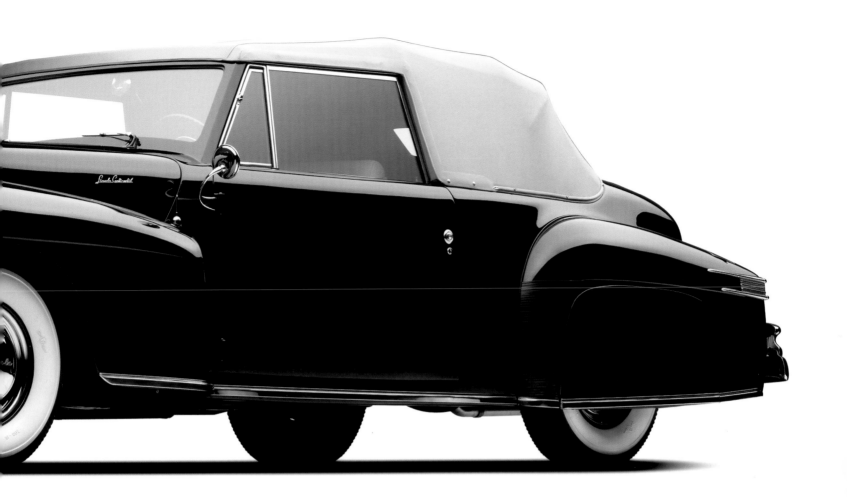

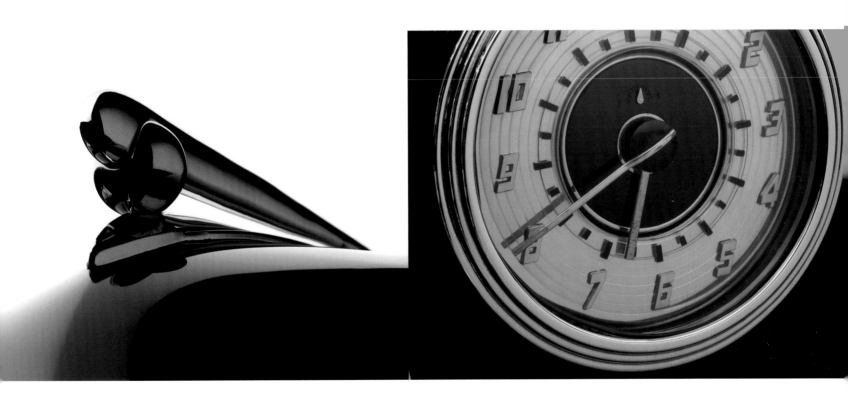

1947 LINCOLN CONTINENTAL CABRIOLET

1948 STUDEBAKER COMMANDER COUPE

SERIES: COMMANDER | STYLE: STARLIGHT TWO-DOOR COUPE | SERIAL NUMBER: 4349601

The Studebaker Manufacturing Company could trace its roots back to Henry and Clement Studebaker who opened a blacksmith shop in 1852. Before long, wheelbarrows and horse-drawn vehicles of many kinds were coming out of the Studebaker workshops. The company built and sold an electric automobile in 1902 and was producing gasoline motor vehicles just a few years later.

Showing its heritage as a maker of wagons capable of withstanding hard and heavy use by both the military and west-bound settlers, Studebakers were strong and reliable. However, they were somewhat stodgy in appearance. Once firmly established, Studebakers were aimed at the middle of the market. They were bigger and better equipped cars than those produced by Ford, Dodge Brothers or Chevrolet. At the same time, they made no pretense to be sports or luxury cars. At first, gasoline-powered Studebakers used a horizontal twin-cylinder engine, but the company's first four came along in 1905 and ruled the roost until 1913 when it was joined by a six.

Studebaker went further up-market in 1928 with the introduction of the FA Series President, which used the company's first straight eight. Although a big and powerful car, it was more akin to a Buick than a Stutz, Lincoln or Cadillac.

In 1933, Studebaker had a close call when long-time company president Albert Erskine banked on the Depression being short-lived and continued paying out substantial dividends. With company reserves depleted, Studebaker slid into receivership. Thanks to Paul Hoffman and Harold Vance, the company recovered in time to join the age of streamlining in 1936. A sleek, modern look was applied to both its six and eight-cylinder lines and the company was able to secure its future.

During World War II, Studebaker was dedicated to producing materiel for the war effort, all the while preparing to resume production at the end of hostilities. Thanks to Hoffman and Vance, Studebaker was in a position of strength as soon it was time to build cars again. By December, 1945, an interim six-cylinder Champion model was produced, but continued only

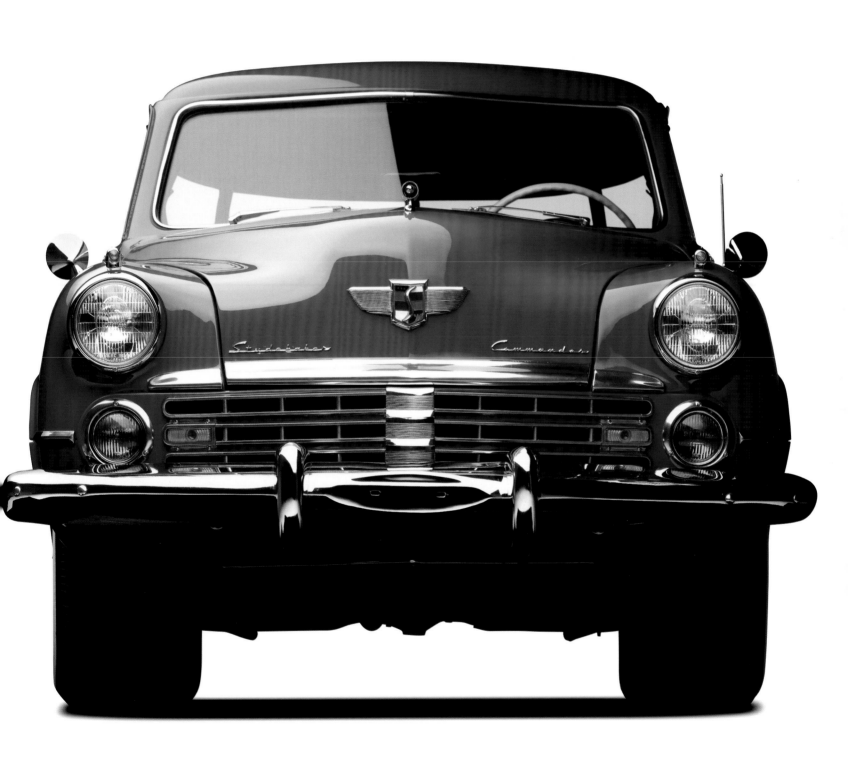

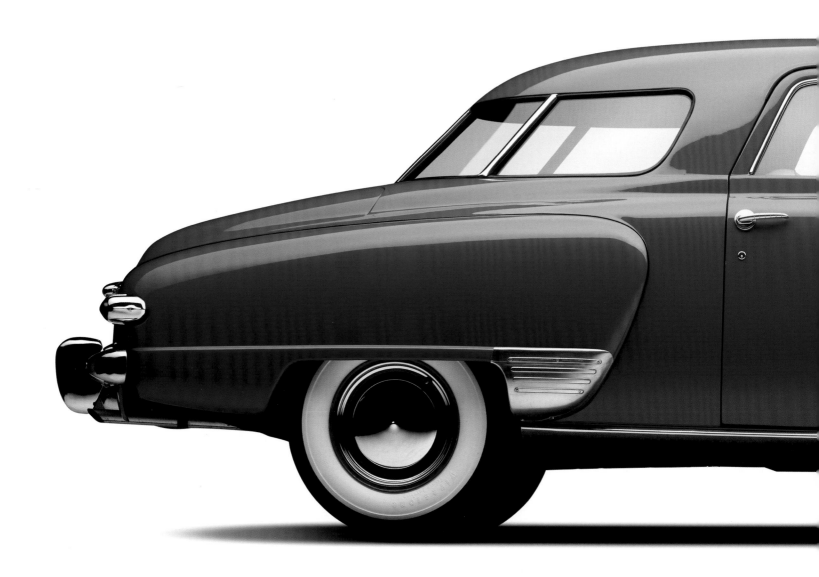

1948 STUDEBAKER COMMANDER COUPE

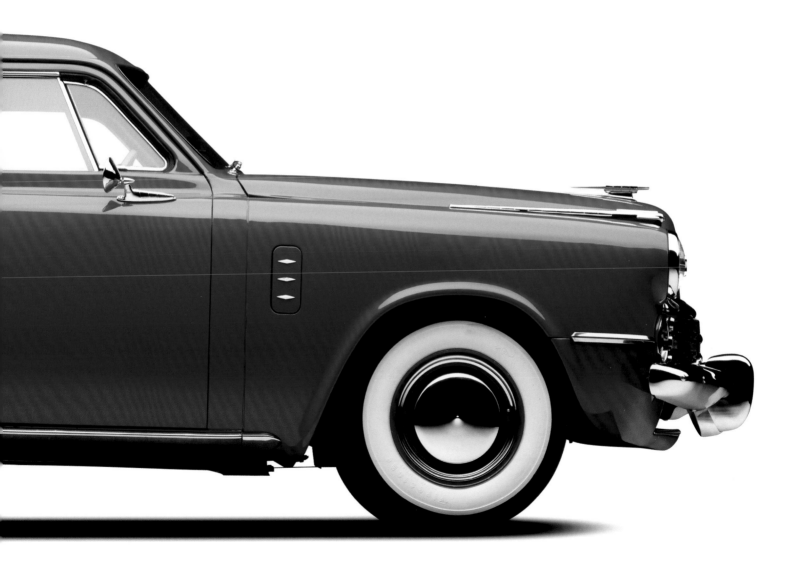

1948 STUDEBAKER COMMANDER COUPE

until March, 1946. In those few months, Studebaker built approximately 19,000 cars in four body styles. By sticking with the single, low-cost model, production could be resumed quickly in what was clearly a seller's market. At the same time, energy and the cash generated from the Champion sales could be used to ready an all-new model.

Those all new Studebakers came out early as 1947 models, while most other automakers were selling prewar models that had been gussied up and warmed over. This time, there were two complete lines, both of which were powered by six-cylinder L-head engines. The Champion used a 169.6 cid engine, while the Commander used a bigger 226.2 cid unit. The only transmission was a three-speed on the column, although overdrive was optional. Both lines had a similar new look with a short hood and long rear deck. People joked that you couldn't tell whether one of the new Raymond Loewy-designed Studebakers was coming or going because the front and back looked similar. Despite the teasing, Americans bought 161,500 Studebakers during the long 1947 model year.

Studebaker had no need to change the Champion and Commander series significantly for 1948. Only the obligatory grille and trim revisions marked the new models. Sales remained strong, with more than 186,525 units for the model year. When new in 1948, this lovely Peacock Green Commander Starlight Coupe sold for approximately $2,000 and was one of more than 11,000 five-passenger coupes built. Although neither revolutionary nor particularly fast, tens of thousands of sturdy Studebakers like this helped to keep the company alive in the immediate post war years.

Studebaker had a jump on most other automakers when it came out with an all-new car in mid-1946. Although a handsome car, the Studebaker was often accused of having a rear view that mirrored the front. Hence people joked that you couldn't tell if a Studebaker was coming or going.

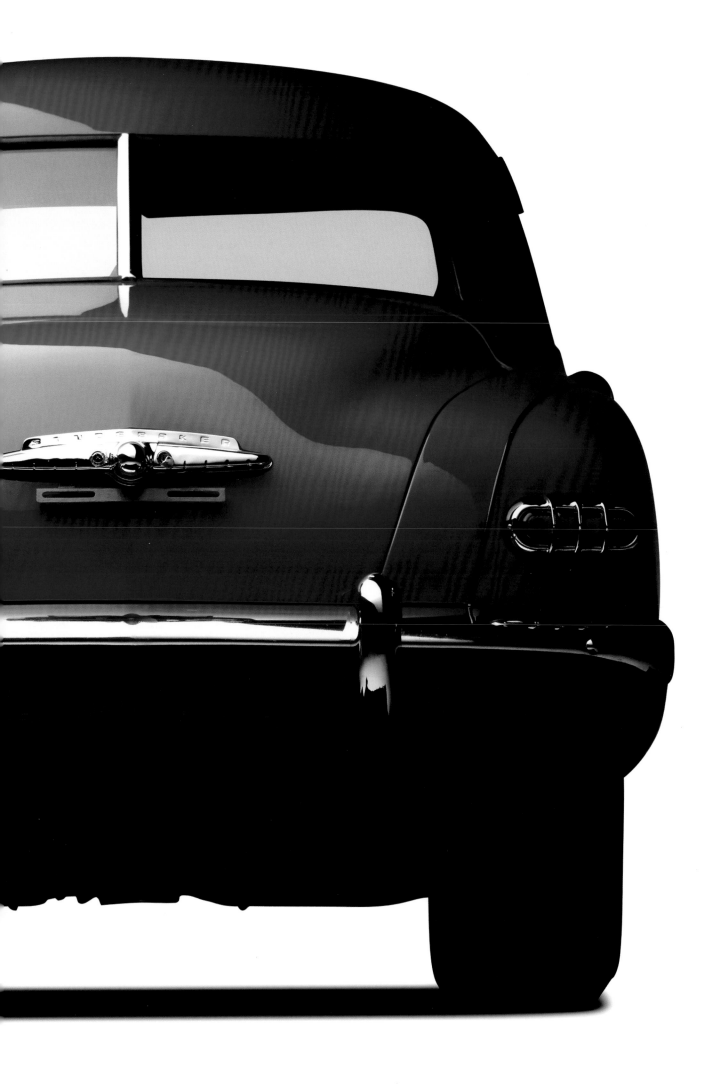

1950 PACKARD SUPER EIGHT VICTORIA CONVERTIBLE COUPE

SERIES: TWENTY-THIRD SUPER EIGHT | STYLE: CONVERTIBLE | SERIAL NUMBER: 237952853

When the dust settled and World War II was over, Packard, like most automakers, was facing many challenges. Although it had completed military contracts for hundreds of millions of dollars, the profit on that work was less than if the company had simply invested in war bonds and watched its money grow. In spite of this, in 1945, Packard was debt-free and had $35 million in working capital.

However, before any new cars could be built, Packard had to clear its warehouses of millions of dollars of the governments' raw materials, It also had to replace the machine tools for military production with the aging Packard tools that had been stored for the duration. Packard president George Christopher also had to find sources for rolled steel and sooth labor unrest.

The first postwar Packard was completed in October 1945 and by year's end just 2,722 cars had been completed. As with all other automakers, the 1946 models were simply 1942s with detail changes. Those updated prewar Packards also had to do double duty as the 1947s until the replacements were ready.

Packard's all-new postwar cars didn't come along until 1948. The three lines shared similar styling, which was often compared to an "inverted bathtub." The base Packard Eight line was available in Standard and Deluxe trim. Either way, it was powered by a 288 cid L-head straight eight rated at 135 horsepower. One level up, the Super Eight was powered by another L-head straight-eight, although this one measured 327 cid and generated 150 horsepower. At the top of the catalog sat the Custom Eight, which used a bigger-still 356 cid straight-eight producing 165 horsepower.

Although Packard's catalogs showed three lines, several wheelbases and a good variety of body styles, the Packard of 1948 to 1950 was hardly the Packard of 20 years earlier. The Packard was a very good car, but it was no longer the exclusive carriage of the upper classes. During the Depression, the company had leveraged its reputation for quality cars to bring out a much less expensive line. As a result, sales increased and Packard survived a decade that killed many an automaker. Some would also say that the move down market compromised

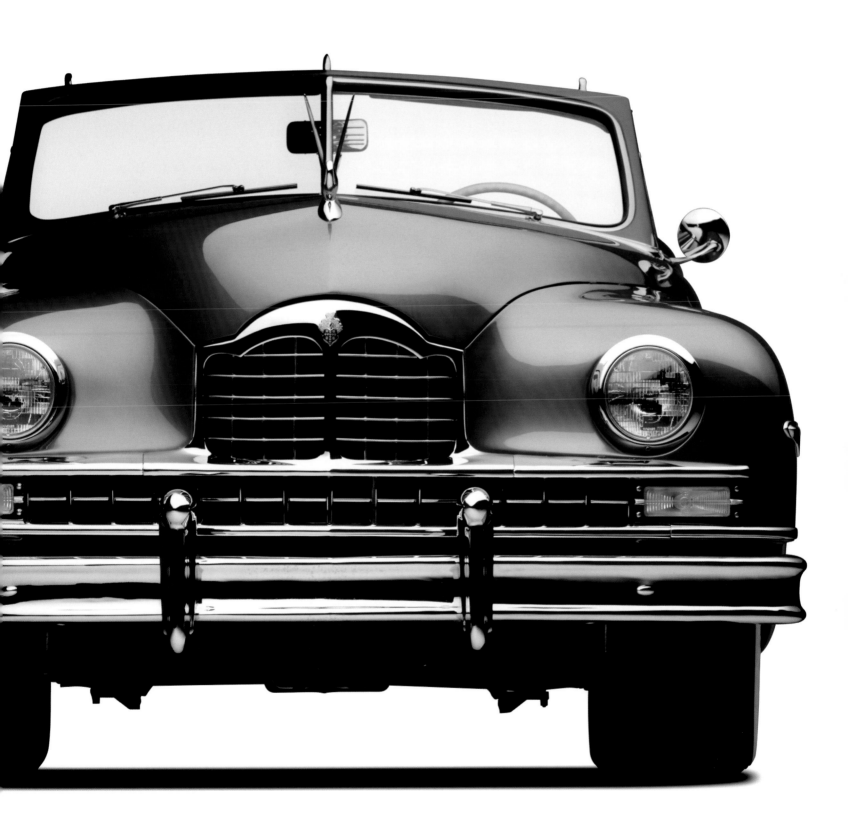

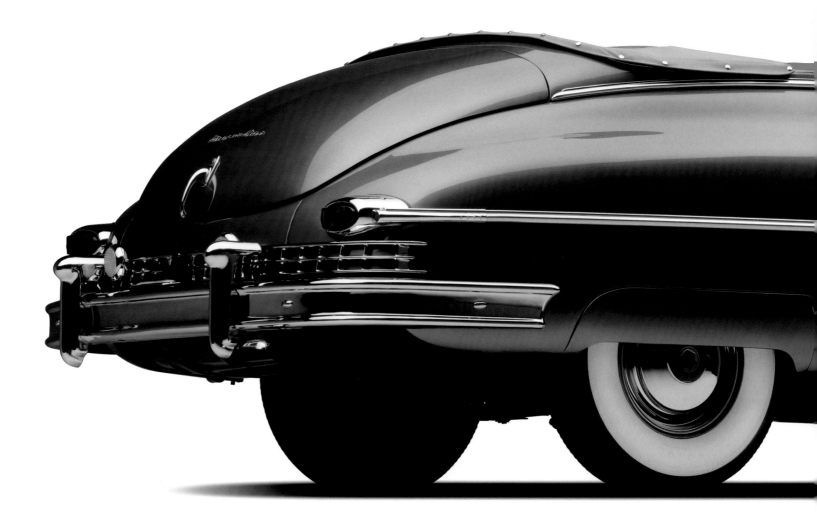

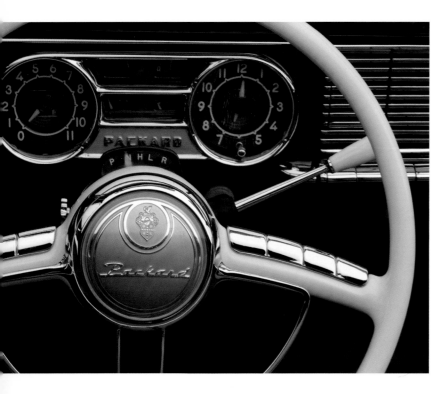

the company's mission and reputation and led to the Packard's later failure.

For 1950, Packard's bathtub styling remained and continued to be offered in the Standard/Deluxe, Super/Deluxe and Custom Eight series. Drivetrain options included overdrive for the three-speed manual transmission, an electronic clutch — along with overdrive — and the Ultramatic, which was Packard's excellent version of a fully-automatic transmission.

The Super Eight/Super Deluxe Eight line offered the greatest variation within the Packard catalog. Both the Standard and Deluxe models were available as either a four-door sedan or two-door club sedan. A long wheelbase model was offered as a seven-passenger sedan

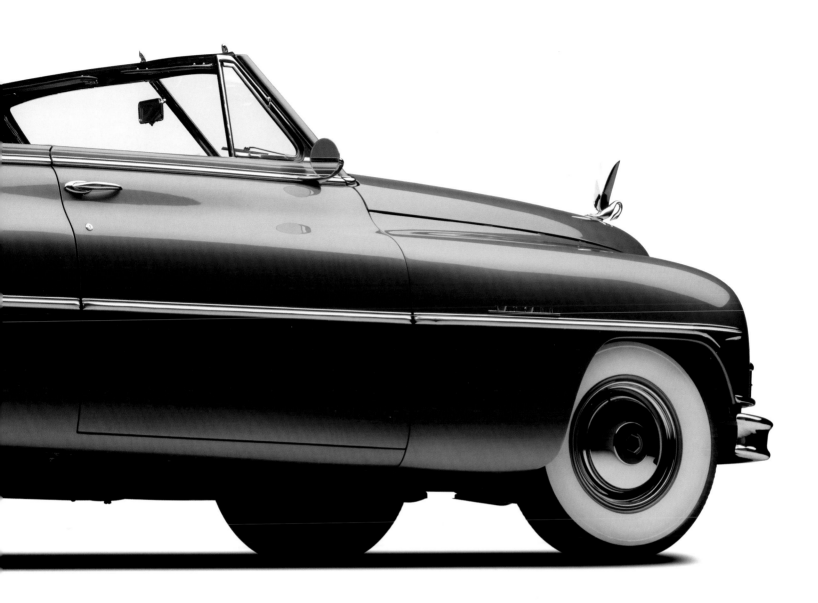

or as a limousine. The final model was the most stylish of the lot — a two-door convertible. Without the steel roof, the open car looked significantly less like a bathtub and took on a new sleekness. The low front bumper broke at the front wheels, but was cleverly picked up by two parallel trim strips running along the lower edge of the car. At $3,250, it was hardly an inexpensive car, but neither was it the chariot of princes and magnates.

The Victoria Convertible coupe was the most graceful of the 1950 Packards. A thoughtfully conceived and executed automobile, it featured fine detailing, from the cormorant hood ornament (above), to the instrument cluster (left) and the rear fascia (right).

1951 BUICK ROADMASTER CONVERTIBLE COUPE

SERIES: ROADMASTER 76C | STYLE: 51-4767X CONVERTIBLE COUPE | SERIAL NUMBER: 16425282

Harley Earl left his stamp on virtually every car that came out of General Motors from the end of 1927 through his retirement more than 30 years later. A big man with a strong sense of style and an equally strong personality, he liked large cars that made a statement.

Born and raised in California, Earl worked summers and after school at his father's Earl Automobile Works in Hollywood. He showed an early flair for design — with a good measure of showmanship thrown in. When a sports injury sidelined the Stanford student, Earl convalesced at home and joined the family business. In 1919, the senior Earl sold his coachworks to Cadillac distributor Don Lee. Son Harley, apparently, was part of the package.

Working for Lee, Cadillac was usually the chassis of choice for designer Earl, although Packard, Rolls-Royce, Pierce-Arrow and Renault were all included in the mix. Hallmarks of Earl's designs included low tops, rakish windshield angles, and flamboyant paint schemes. According to historian Mike Lamm, his work showed "a certain sporting

flair and a lot of good humored self-confidence, which was a fairly accurate mirror of the designer himself."

With Earl's work for Don Lee, it wasn't long before he came to the attention of top GM executives, among them the Fisher Brothers and Alfred P. Sloan Jr. Shortly after an extended visit to California in 1925, Larry Fisher invited Earl to visit Detroit and to bring along his dramatic flair for styling.

His first work for GM — as a consultant — was the 1927 LaSalle, which looked very much like a Hispano-Suiza. It was elegant and restrained and was the perfect launch vehicle for the new name plate. The car was so well-received by the public and Mr. Sloan that Earl soon found himself in charge of GM's new Art & Colour Section. Before long, he was changing the way all American cars were designed.

Earl had an innate sense of what America wanted in its cars at any given time. He also shared Sloan's view that each new car should be so special and exciting that it cooled the owner's ardor for anything already in the drive-

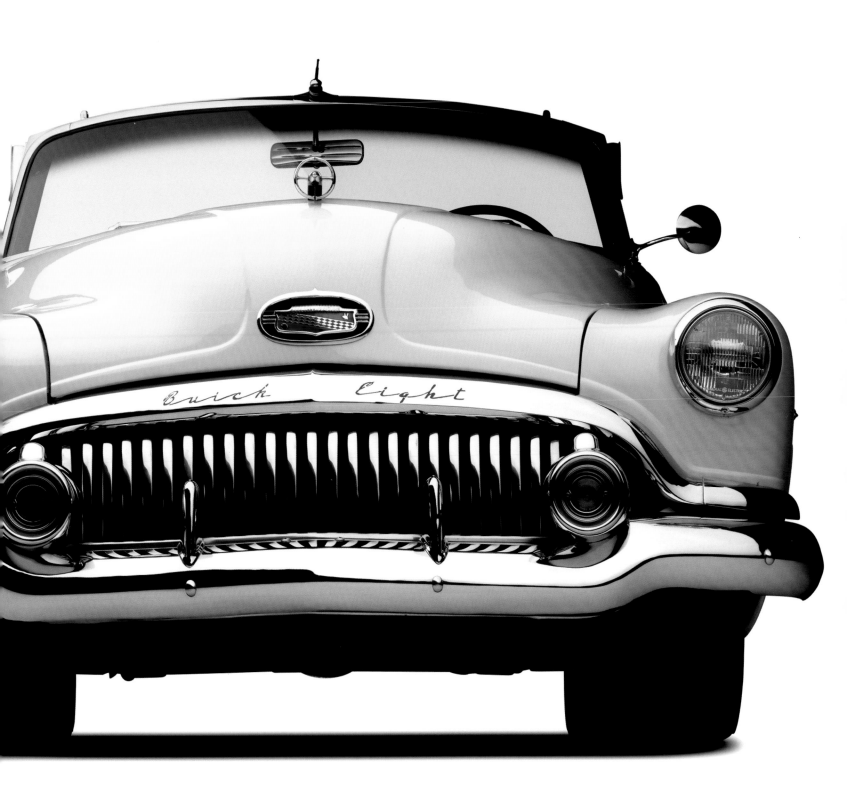

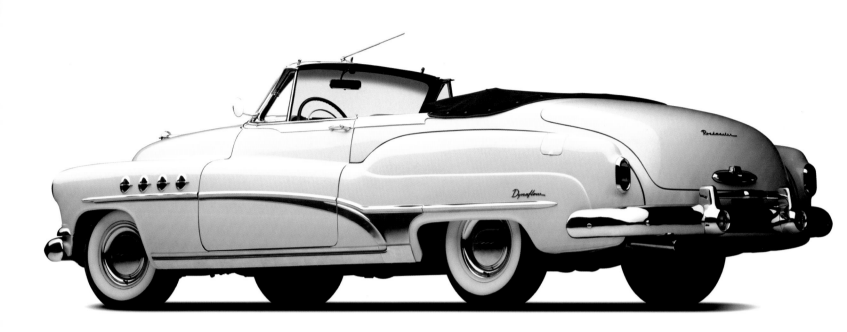

1951 BUICK ROADMASTER CONVERTIBLE COUPE

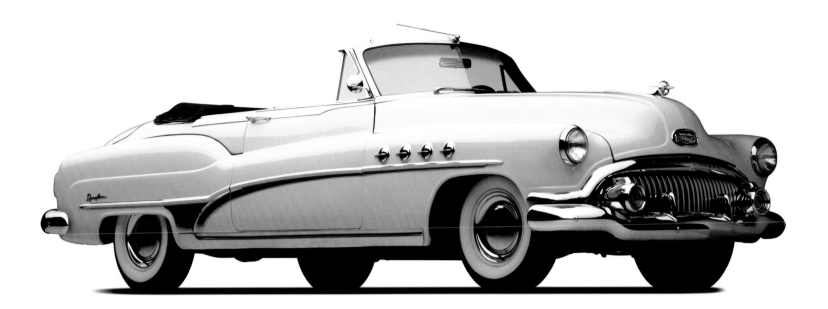

way. The all new 1949 Roadmaster was one of those models that could make any other car obsolete overnight. It's easy to imagine the neighbor's expression when he saw the new 1949 Buick Roadmaster in the driveway next door. It was long and low and sleek and covered in all that magnificent chrome.

The body may have been shared with other GM makes, but with that wide toothy grin of a grille, the sweeping side spear and those four glorious portholes on each side, the Roadmaster was simply dazzling. The coupe, and particularly the convertible, dazzled more than the rest of the line. Under that long hood lurked Buick's venerable overhead-valve straight eight. Rated at 150 horsepower, it had torque aplenty to roll the big two-tonner. A three-speed transmission was standard, but the Dynaflow automatic was available for additional cost.

The Roadmaster is considered one of the most respected nameplates in North America, and the 1949 through 1952 models did nothing to erode the

reputation. Roadmaster was top of the line for Buick in 1951, and, with the exception of the wagon, the convertible coupe was the most costly model. It was certainly the most desirable. For 1951, the 320.2 cubic-inch straight-eight was rated at 152 horsepower. Lesser Buicks came standard with a three-speed manual transmission, but only the Dynaflow was good enough for a 1951 Roadmaster.

When new, this Roadmaster featured the optional special leather door trim, which has been duplicated during its restoration. The car also has power steering, brakes, windows and a power convertible top. With all this convenience at hand, all the lucky owner had to do was drop the top, swing his arm around his girl and watch all the heads turn as the big eight burbled on by.

Even the smallest boy could immediately identify the new Buick. From the toothy grille (above) to the portholes (left), a Buick was instantly recognizable. That it had four portholes was a clear sign that it was a top-of-the-line Roadmaster.

FIFTIES STYLE

The Sky's the Limit

When the 1950s dawned, the sky was the limit. America was only five years past the most brutal war the world had ever seen. Yet, by mustering its formidable military and industrial might, it had put its shoulder to the Allied war effort and helped to defeat the Axis powers. Although the cost was high in both lives and dollars, when the war ended, America was literally on top of the world.

Despite fears of a post-war recession, the economy boomed and returning GIs looked to the next decades to complete their educations and start families. When it appeared that a full blown recession might kick in, there was additional military spending due to the Korean Conflict. And the economic prosperity continued.

Harley Earl

For those at home, a house in the suburbs — with an inexpensive and affordable mortgage — and a big and shiny new car in the driveway were the American dream. Those big cars were filled with lots of new American babies as the population soared.

Meanwhile, many industries boomed including housing, automobiles, aviation and electronics. The country's gross national product which had stood at $200,000 million in 1940, jumped to $300,000 million in 1950 and would reach $500,000 million by 1960.

Against this backdrop of prosperity, the entire American automobile industry was becoming realigned. Many automakers had failed in the 1930s. Those that had reached 1942 benefited from government contracts for war materiel. Though the contracts didn't solve the problems of the independent auto producers, the government work gave them a decade of prosperity. During the 1950s, Kaiser and Willys joined to create American Motors, while Studebaker and Packard joined forces in an ill-starred attempt at survival.

As the 1950s opened, General Motors was the strongest of the automakers, with deepest reserves and a fine record for engineering, styling and marketing. They were among the leaders of the industry as pre-war L-head engines were retired in favor of modern overhead-valve straight sixes and V-8s. It took from 1949 to 1955 for GM to put to pasture its old engine technologies from all of its divisions. Regardless of the automaker, what these new engines had in common was that they were powerful, moderately light and relied on vast quantities of natural resources to build and operate.

These were big, slow-turning engines — by European standards — that were ideally suited for modern superhighways. Although in short supply in the prewar

United States, good roads were a priority at the highest level. Having crossed the country in a military convoy in 1919, President Dwight Eisenhower was acutely aware of how important roads were to national safety and security. He also appreciated how troop movements were expedited during the invasion of Germany thanks to the excellent system of autobahns. As a result, he advocated creation of the interstate highway system. In 1956, he signed legislation establishing the National System of Interstate and Defense Highways, which would extend to approximately 41,000 miles of roads. Those excellent roads would further reinforce the position of the V-8-powered American car.

The cars developed and sold during the booming 1950s were exactly what America wanted. They fit a growing family, represented economic affluence and were perfectly suited to the vast expanse that made up the United States. Although imported cars began trickling into the country in the late 1940s and picked up volumes into the 1960s, they were novelties that were not yet a serious threat to the home-grown auto industry. Given a choice, few Americans would opt to cross 3,000 miles of America in a Volkswagen Beetle or a tiny MG TD when they could waft along in a full-size Cadillac with automatic transmission, power steering and power brakes.

Cars were often the ultimate object of aspiration in American society. As a result, automakers spent millions of dollars producing dream cars to excite consumers and give them a taste of tomorrow. The 1954 Oldsmobile F-88 was one of those vehicles designed to ignite desire. It didn't matter that the car never saw production — it explored limitless possibilities and gave Americans something else to dream about.

To many, a Cadillac was the ultimate symbol of success in an America where bigger was seen as better. Other cars like Packards and Buick Skylarks were also perceived as cars for people who could have virtually anything they wanted. Of course, a big car with a large engine and a top that went down was the ultimate dream of many — at least as perceived by Hollywood, which cast a disproportionate number of convertibles in its movies.

As early as the late 1940s, Cadillac had adopted the tailfin concept from World War II fighter aircraft. As the 1950s progressed, an increasing number of companies turned to aviation and aerospace themes. The Mercury X-M Turnpike Cruiser looked like it had jet engines beneath its grille, while tailfins on cars like the 1957 Thunderbird and 1957 Chevrolet Bel Air climbed ever higher. Before the decade was out, fins on Chryslers and Cadillacs would literally reach for the sky. After all, there was no limit for 1950s America.

Zora Arkus-Duntov

1953 CADILLAC ELDORADO CONVERTIBLE

MODEL: 53–62 ELDORADO | STYLE: 6267SX CONVERTIBLE | SERIAL NUMBER: 536269173

In 1953, three divisions of General Motors celebrated their 50th anniversaries. Those celebrations included a trio of expensive and stylish limited edition convertibles. Buick had the Skylark, Oldsmobile the Fiesta and GM top dog Cadillac announced the long, low and chrome-laden Eldorado.

All three of the deluxe drop tops received dramatic wrap-around windshields, but the Eldorado alone was treated to a flush-fitting metal cover to conceal the folded fabric top. The posh interior was trimmed in the finest leather, and a sparkling set of chromed wire wheels were the final touch of elegance. Standard features included radio, heater, white sidewall tires, power steering and Hydra-Matic transmission.

For years, Cadillac had been the American car most people aspired to owning. Rare was the man or woman who didn't want the looks, performance and aura that went with a brand new Cadillac. And, within the Cadillac line, no car was more charismatic or desirable than the new Eldorado convertible. All that chrome and the expansive leather interior sent a message of affluence, style and more than a little flamboyance.

The Eldorado was about more than just image, though. With the Hydra-Matic engaged in "Drive," the super-smooth transmission sent the better part of 210 very conservative horsepower aft from the 331 cid overhead-valve V-8. Designed by Cadillac chief engineer Ed Cole, the engine that motivated the Eldorado was something truly special. It was moderately light, extremely smooth and very powerful. It also had great potential for tuning. A pair of Cadillacs successfully lasted through the 24 Hours of LeMans in 1950. The engine also proved successful powering the English Allard J2 and J2X sports cars. In a stock 1953 Series 62 coupe, the same engine set new records at the Santa Ana, California, drag races. There was no question that the new Cadillacs were very quick indeed, with a top speed of 116 mph.

Many people saw the new Eldorado for the first time on January 20, 1953, when Dwight D. Eisenhower was driven down Pennsylvania Avenue to his first inauguration as President of the United States. With television becoming

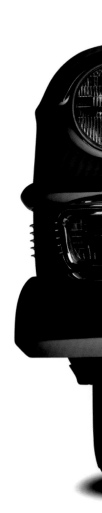

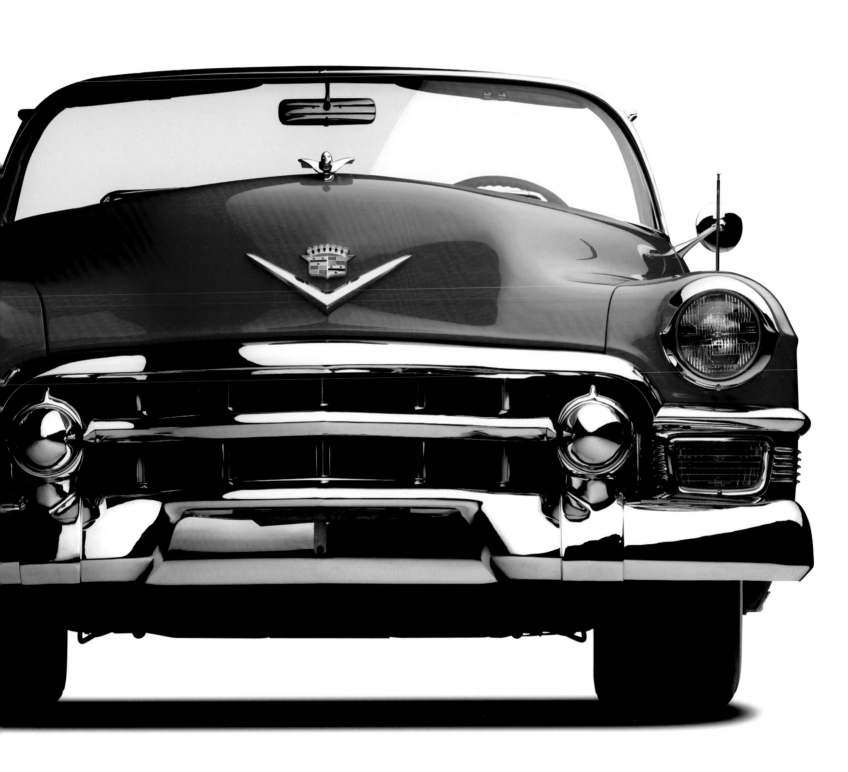

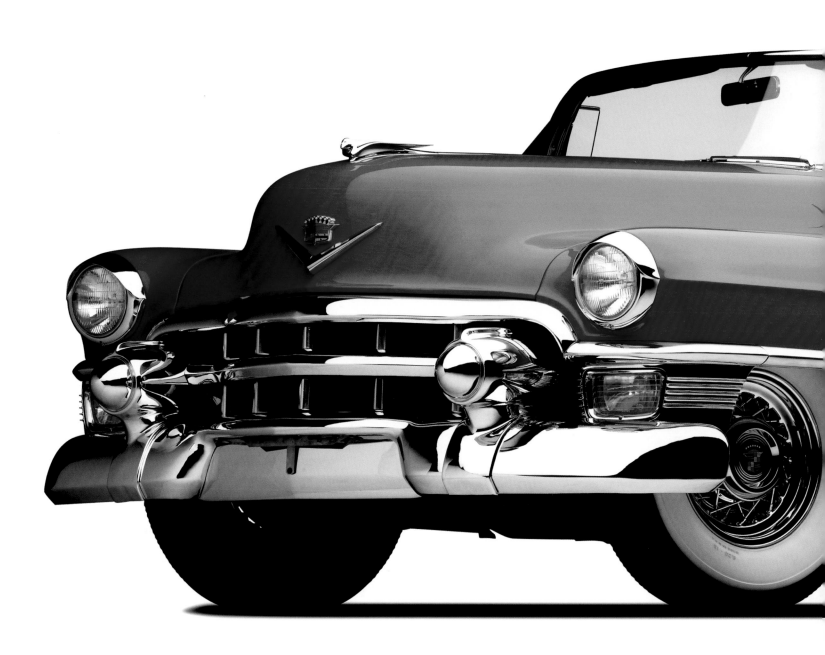

1953 CADILLAC ELDORADO CONVERTIBLE

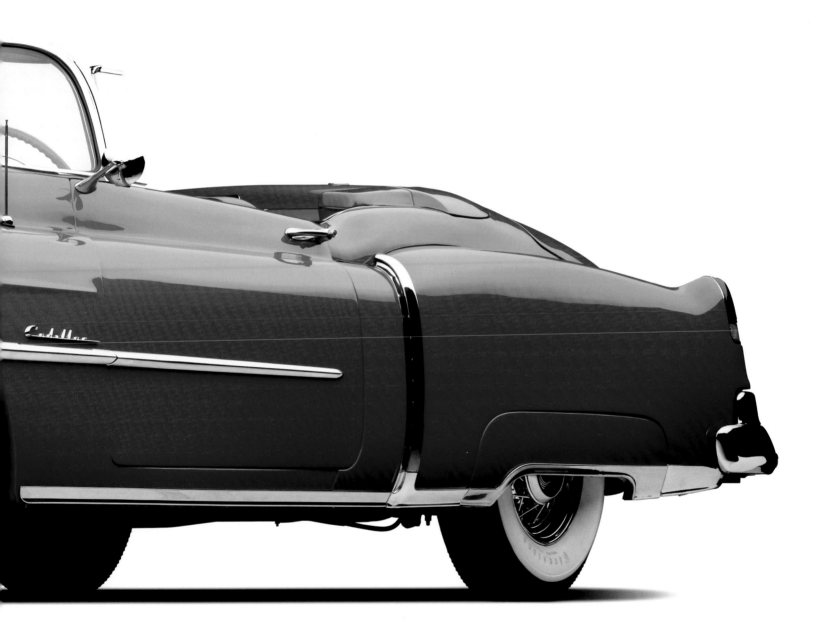

increasingly popular, the new Cadillac convertible certainly benefited from the exposure on the national airwaves.

The Eldorado is a truly massive car, tipping the scales at 4,800 pounds and stretching more than 220 inches. With the big and aggressive bumper and grille, as well as the vestigial tailfins harking back to the Lockheed P-38 fighter plane, the Eldorado wasn't for the shy and retiring — especially when painted Aztec Red. With a price of $7,750, it was also one of the most expensive American cars available. At twice the price of the top Lincoln and nominally more costly than a Henney Packard Limousine, the Eldorado Cadillac was strictly for the well-heeled.

This 1953 Cadillac Eldorado convertible is number 287 of 533 built. It is equipped with power windows, power seat, power top and a dramatic red and white leather interior. Arguably the purest of the Eldorados, the 1953 models are also the most collectible.

There was little that was subtle about the 1953 Cadillac Eldorado. However, the quality was unmistakable and the details, such as the rear fins (below) and flamboyant interior (right) were brilliantly executed.

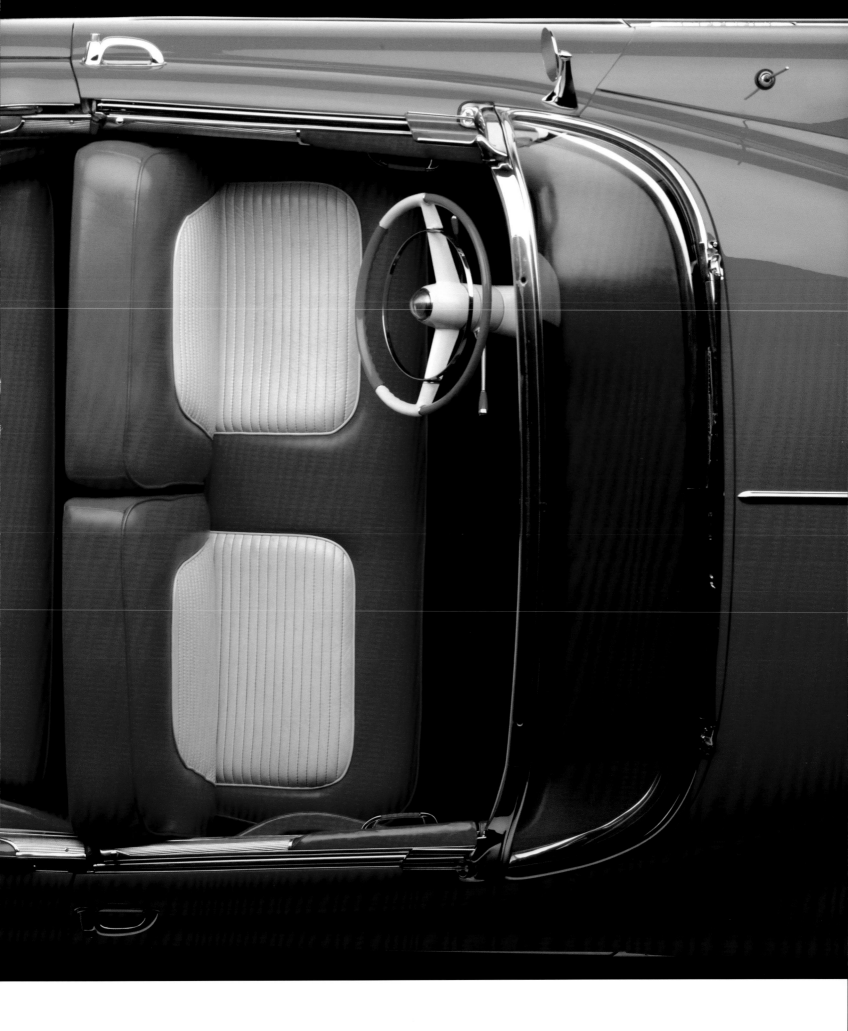

1954 BUICK SKYLARK CONVERTIBLE

MODEL: 100 SKYLARK | STYLE: 54-4667SX SPORT CONVERTIBLE | SERIAL NUMBER: V4884447

Immediately after World War II, the Buick Division of General Motors was rich with executive talent. Avid car collector Charlie Chayne was the chief engineer, human dynamo Harlow Curtice was general manager and sales were handled by William Hufstader, although working under styling vice president Harley Earl, Ned Nickles led Buick design. These men had worked together for years, and with comptroller Ivan Wiles, they made a formidable and very effective team.

When Curtice and Chayne were kicked upstairs as GM president and vice president of engineering, Buick suffered not at all. Wiles took the Buick helm and the good years continued.

Buick had a strong styling identity that continued to emerge — from the grille all the way back. In time for the 1953 model year, the company benefited from a new 322 cid overhead-valve V-8 engine rated at 188 horsepower. Known as the "nail-head" because of its small valves, the new V-8 — designed by Joe Turley — was lighter, more powerful and more compact than the old straight-eight.

A three-speed manual transmission was standard, while the famed Buick Dynaflow automatic was optional.

Very few cars of the postwar era came about accidentally, but the original Buick Sklylark was certainly not a result of precise product planning. As historians Larry Gustin and Terry Dunham have recounted, GM stylist Ned Nickles was planning to customize his 1951 Roadmaster and had made a number of detailed drawings. Buick general manager Ivan Wiles happened to spot those drawings and ordered a prototype. That car went into production as the 1953 Skylark.

With the exception of a series of Harley Earl show cars, no previous Buick had ever been as sporty or as stylish. It also had a hefty $4,596 price tag to go with the great looks. The price may have been high, but the options were few. Standard equipment included the Twin-Turbine Dynaflow transmission, power steering, power brakes, power seats, an automatic radio antenna and that dramatic wrap-around windshield,

One look was enough to prove that the Skylark was a Buick, thanks to the

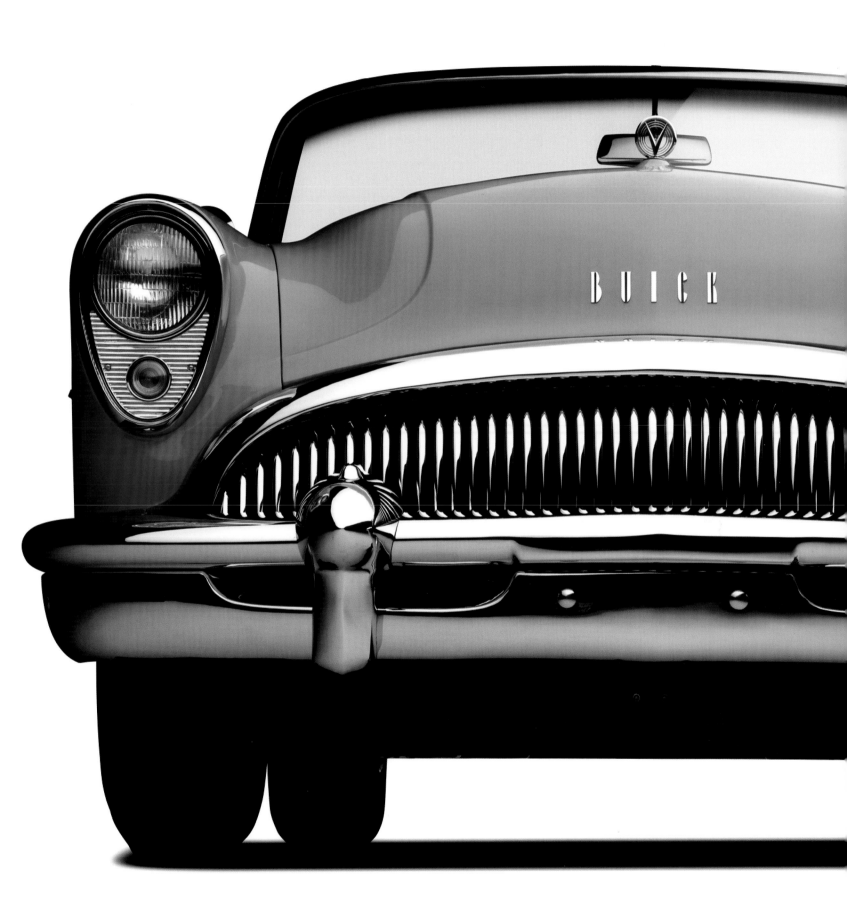

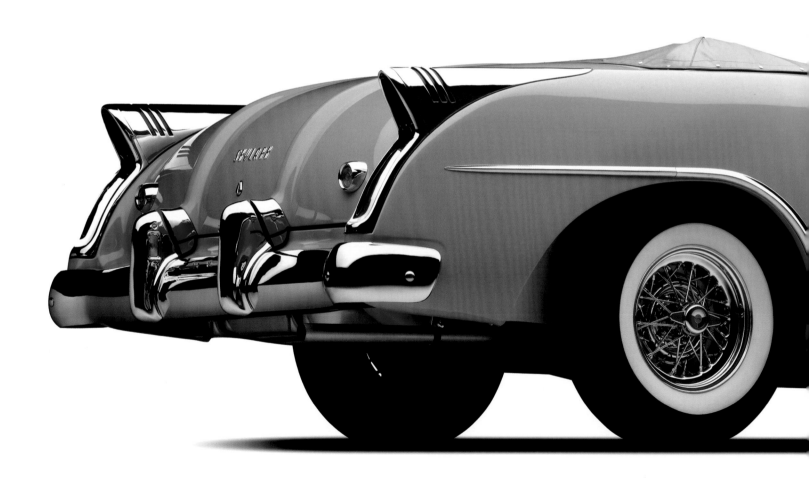

1954 BUICK SKYLARK CONVERTIBLE

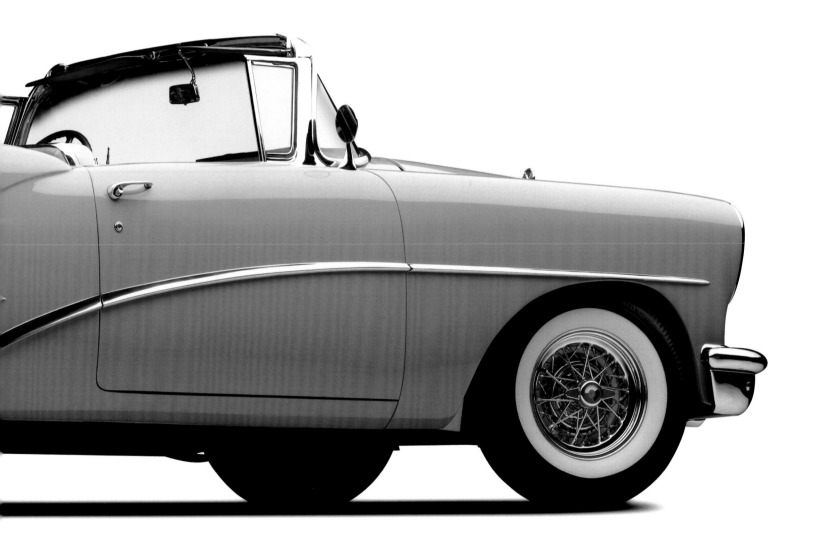

grille, hood and side sweep, but it made the other cars in the line look undeniably conventional. Under the dashing new skin was the Roadmaster's V-8 engine and running gear — which was very good news. The chassis came with four-wheel drum brakes, independent front suspension and a solid rear axle.

By Buick standards, the Skylark was not a high-volume car, with only 1,690 produced that first year. Second year production was significantly lower at 790 units and was now built on a shortened Century chassis. The 1954 shared much of the look of the earlier version, which was now extended across the Buick product line. To differentiate the Skylark from the work-a-day Buicks, the front and rear wheel arches were cut away behind the wheels. It was an exciting effect, but the wheels looked a little lost inside those massive wells.

Skylark prices were down for 1954, with a base price of $4,355, but value was up. The nail-head engine was up to 200 horsepower, the Dynaflo remained standard and the rear fenders had sprouted small chrome fins. Power equipment included seats, brakes, steering, convertible top, windows and radio antenna. A heater-defroster unit, whitewall tires and Kelsey-Hayes chrome wire wheels were also standard.

Finished in Gulf Turquoise, with white wheel well accents, the interior of this spectacular 1954 Skylark is trimmed in two-tone green leather. Not only is it a fine example of the model, it's also rolling proof that under Harley Earl, General Motors was the nation's styling leader as the boom years of the 1950s progressed.

The sculpting applied to Buick's 1954 Skylark was nothing short of spectacular and no feature stood out more than the cut-away front and rear wheel wheels (below) with contrasting inner body colors. The sweeping side trim (top left) and the small chrome rear fender fins (bottom left) added even more excitement.

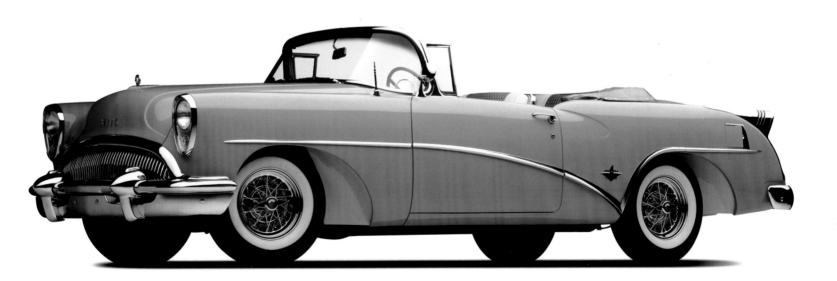

1954 OLDSMOBILE F-88

MODEL: F-88 | STYLE: ROADSTER | SERIAL NUMBER: 2665

By about 1949, the pent-up demand for new cars created by almost four years of deprivation slowed. That didn't mean that people didn't want new cars — they still did. It just meant that they had much more choice and could afford to select exactly what they wanted instead of scrambling for whatever they could get.

One of the directives given to Harley Earl's Art & Colour Department was to make every new car so exciting that last year's model was instantly obsolete. With just about the strongest styling department of any automaker and very deep pockets, General Motors had several advantages over the competition — in addition to adventurous styling, there were powerful new overhead-valve V-8s for Cadillac, Oldsmobile and Buick and excellent automatic transmissions.

Appeal was the name of the game and GM knew how to get the public's attention. Never failing to meet a challenge, for 1949 and 1950, the marketing mavens conjured up an extravaganza known as Transportation Unlimited. Visiting New York and Boston and

attracting more than 500,000 people, the traveling entertainment and automotive program was a smash hit. It also exposed potential customers to the newest cars from Chevrolet, Buick, Cadillac, Oldmosbile and Pontiac. For 1953, the name was changed to Motorama and the venue was New York's Waldorf Astoria Hotel. Broadway singers and dancers and flashy dream cars attracted hundreds of thousands of visitors and many inches of press coverage.

The hit of the 1953 Motorama was a small — by American standards — white Chevrolet roadster called the Corvette. The sporty looking car used a new body material called fiberglass and America fell in love. Heeding public opinion, GM president Harlow Curtice approved the Corvette for production very much as it was shown in New York.

For the 1954 Motoramas held in New York, Chicago, Los Angeles and San Francisco, GM went to work to come up with additional automotive dreams to catch the public's fancy. One was a concept known internally as the XP-20 project and pushed forward by Harley

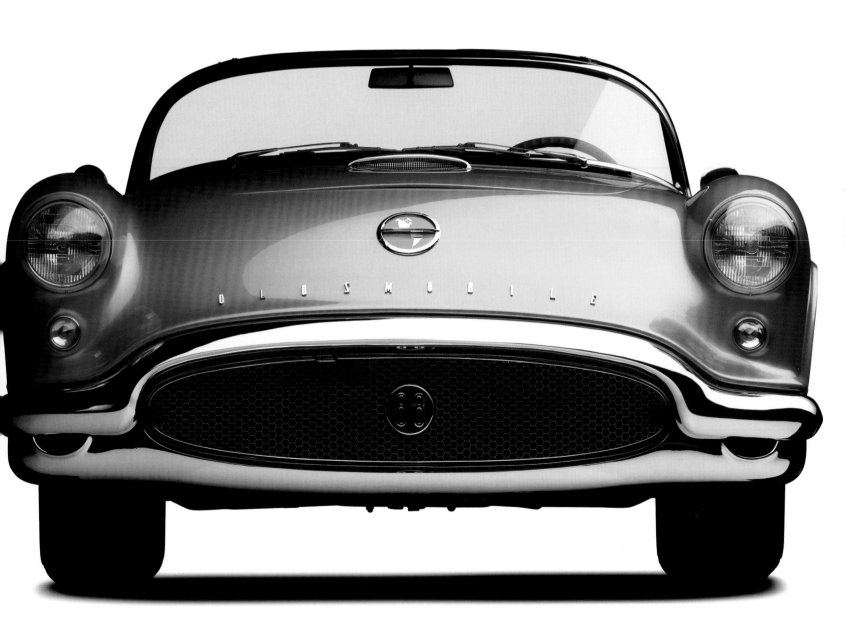

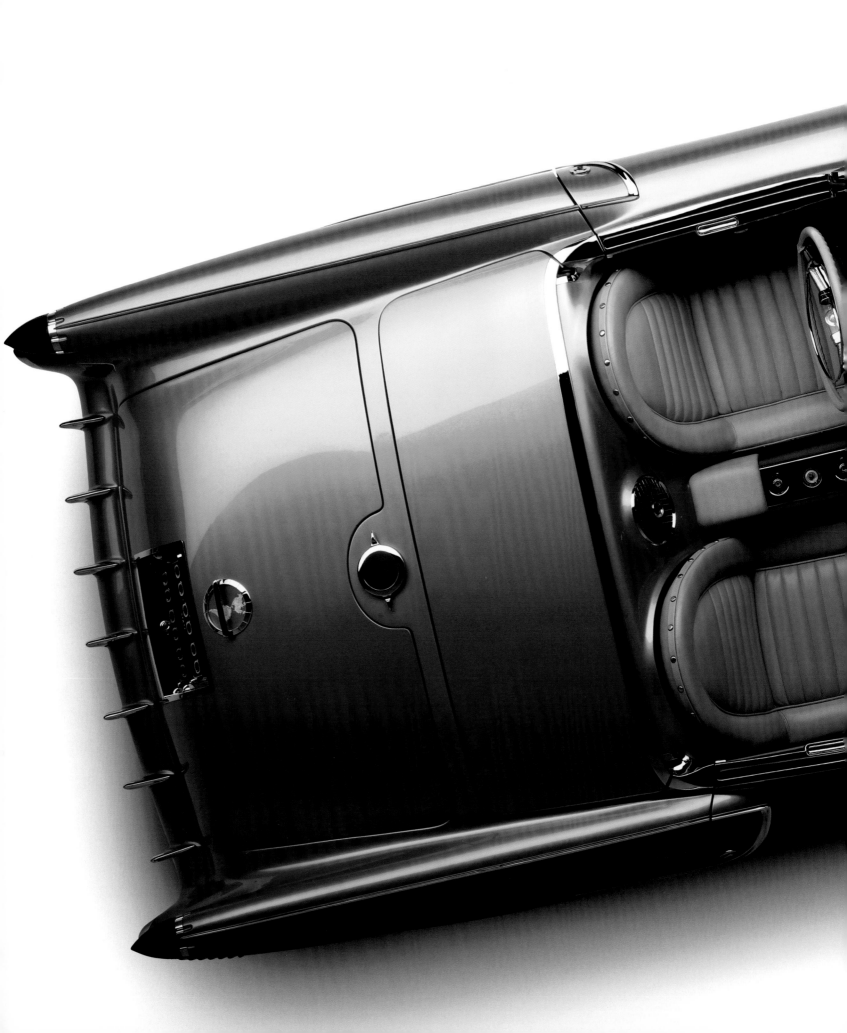

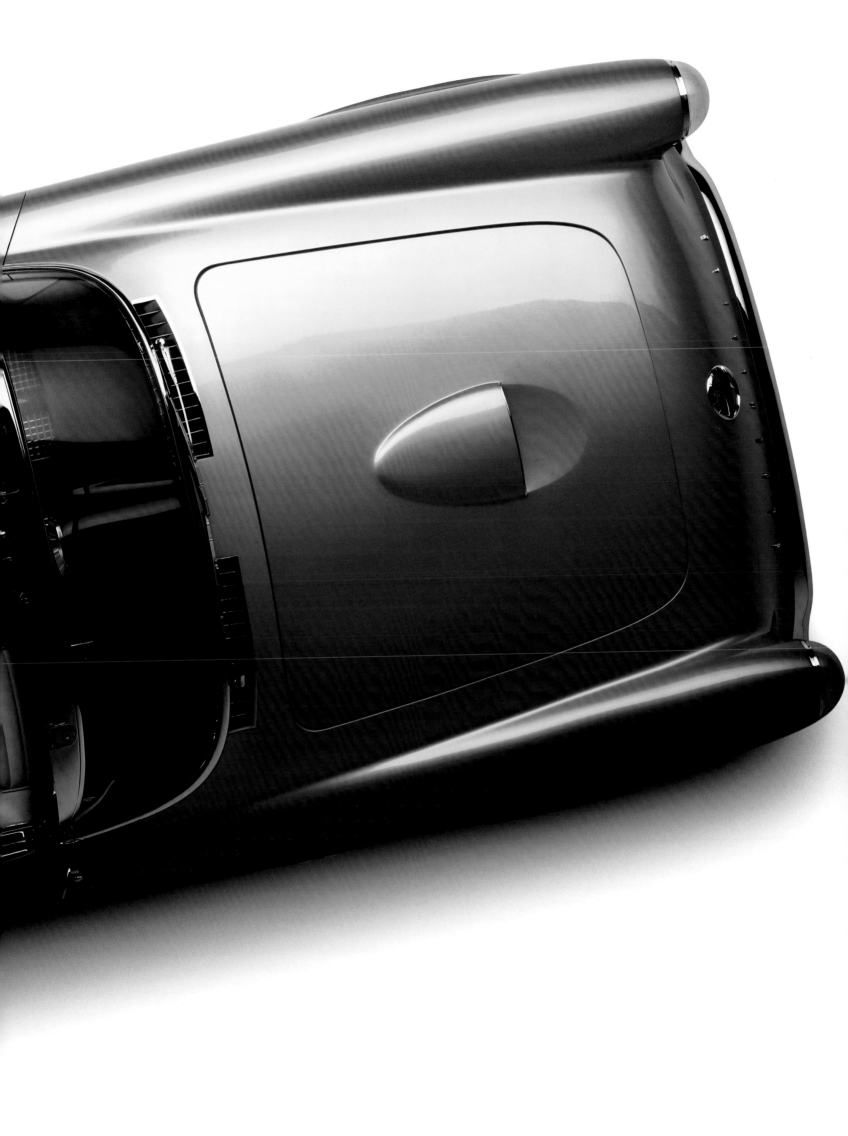

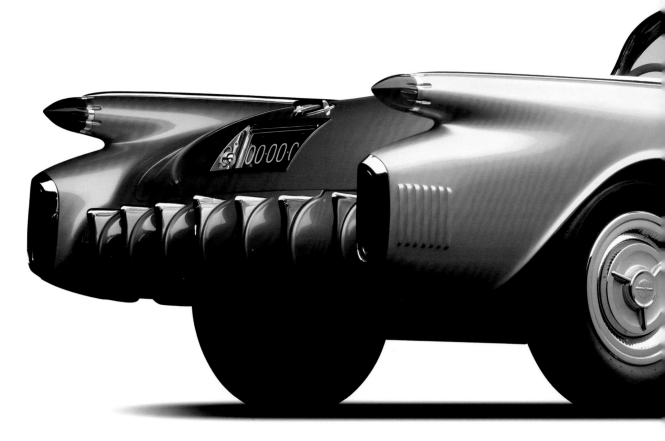

Earl, with the support of designer Bill Mitchell, Ken Pickering and new GM engineer Zora Arkus-Duntov. Although three examples of what was popularly known as the Oldsmobile F-88 are rumored to have resulted from the project, only one — styling order 2265 — is known to survive.

Built on the chassis of the new Corvette, the F-88 had its own distinct look but was visibly related to the Chevy sportster. Instead of using the 150 horsepower version of Chevy's Blue Flame straight-six mated to a Power-Glide transmission, the F-88 benefited from the availability of a 250 horsepower version of the 324 cid Oldsmobile Rocket 88 V-8 mated to a four-speed Hydra-Matic automatic transmission. Using an unmistakably Oldsmobile grille and fitted with vestigial fins like those on the 1954 Buick Skylark, the F-88 was finished in metallic gold with metallic green fender wells. The interior was flamboyantly trimmed in off-white leather. With 100 horsepower more than the Corvette, the sensational-looking car

had the potential for exceptional performance. However, based on the build-quality problems and slow sales — 300 the first year — of cousin Corvette, the F-88 was doomed to never see production.

After its Motorama life was over, the F-88's history descended into mystery. Common practice was for top GM executives and division heads to dispose of concept cars as they saw fit. Company accountants and lawyers, however, were far happier to see them cut up, which happened in many cases. The rationale was that concept cars were not properly engineered and could open the company up to legal action if offered to the public. In addition, every time the company scrapped an expensive concept car it could take a significant tax write-off.

While the gold car vanished from view, Earl had a Mk II version built. Originally finished in red, it was modified and repainted blue for the 1957 Motoramas. According to historian Michael Lamm, Oldsmobile is thought to have had the

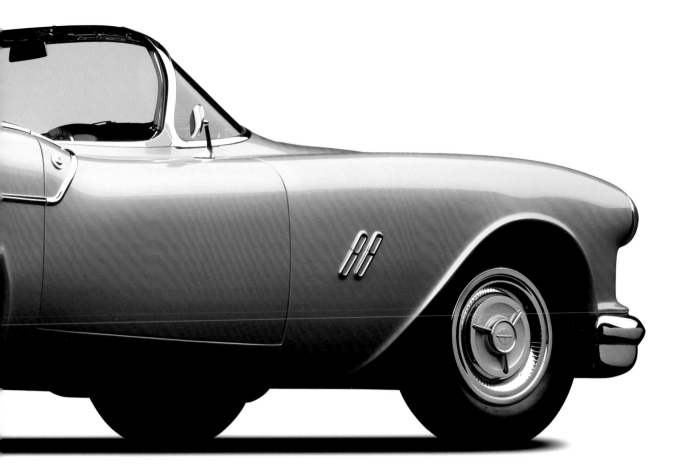

car destroyed. Lamm has also written that a final F-88 — the Mk III — was shown at the October 1958 Motorama. This car was given to Harley Earl upon his retirement from General Motors at the end of 1958. However, the Rochester fuel-injection proved problematic and eventually the car returned to Michigan after Earl's 1969 death and was destroyed at the direction of styling VP Bill Mitchell.

At some point, the mystery deepened when one of the F-88s was disassembled, packed into crates and shipped to E. L. Cord's California home. Although Cord had left the automobile business when he sold his holdings in Auburn, Cord, Duesenberg and Lycoming in the mid-1930s, he retained a life-long interest in cars. The panels and components remained in their crates and repeatedly changed hands without ever being assembled. This jigsaw puzzle of a dream car is believed to have been the gold F-88 of Motorama fame. Presumably it had been disassembled

to comply with GM company policy.

The crated F-88 remains passed through several owners including dealers Leo Gephart (twice) and Ed Lucas before being restored to its 1954 Motorama configuration by Lon Krueger of Sun Valley Classics. Krueger built it up on a Corvette chassis that is said to have been shipped from General Motors along with the crates of the other components. It subsequently went to the Blackhawk Collection in Danville, California, and was sold to a prominent West Coast collector. Resplendent in metallic gold and green, all that's missing is the singing and the dancing with which it was originally introduced at the Motoramas of 1954.

The Oldsmobile F-88 was a concept car built to excite the public and to gauge interest in new models and ideas. Although it never reached production, a few of its details look strangely familiar. Look closely at those bullet taillights and you'll see more than a passing similarity to the taillights used on the 1959 Cadillacs.

1956 CADILLAC SERIES 62 CONVERTIBLE

MODEL: 56–62 | STYLE: 6267X CONVERTIBLE | SERIAL NUMBER: 5562026320

As 1955 came to a close, Cadillac was easily the leader in the American luxury car market, with sales totaling almost 141,000. All the competition combined — Lincoln, Chrysler 300C, Imperial and Packard — only mustered 98,000 units. In terms of performance, style and luxury, the Chrysler 300C was a new and viable alternative to a Cadillac Coupe de Ville, but it didn't have the name and only found 1,725 buyers.

Meanwhile, many of the Packard models had moved down-market in an attempt to keep the ailing automaker afloat. Of course, the American cars weren't the only game in town anymore. The super-rich could buy a Rolls-Royce or a Bentley and the adventurous could get themselves a Jaguar sedan. In many cases, though, it never occurred to most upper middle class Americans to own a foreign car.

For 1956, Chrysler and Imperial remained relatively minor players and Packard was still struggling for its life. Lincoln, however, brought out a striking new car that soared right to the top of the market. While the new Cadillacs were flamboyant and shouted "Look at me!" the Lincoln Continental Mk II was gorgeous in a quietly elegant way and used very little chrome compared to its cross-town rivals. With 300 horsepower and full power equipment standard, the only thing that kept the Lincoln from making big trouble for Cadillac was the lofty $9,966 price tag — before air conditioning was added. In the end, with only 2,500 sold, the Mk II was not a serious threat.

If the new Lincoln Mk II was restrained, the 1956 Cadillac was its antithesis. From the massive chrome front bumpers with their large bullet-shaped overriders (also known as Dagmars in reference to a glamorous starlet), to the dramatic wrap-around windshields and futuristic tailfins, the Cadillacs were very impressive.

While other cars made quiet statements, a Cadillac in your driveway was like a trumpet. The day you drove home in a new Cadillac convertible your neighbors knew that you were doing well.

Although the basic body shell was carried over from 1955, the

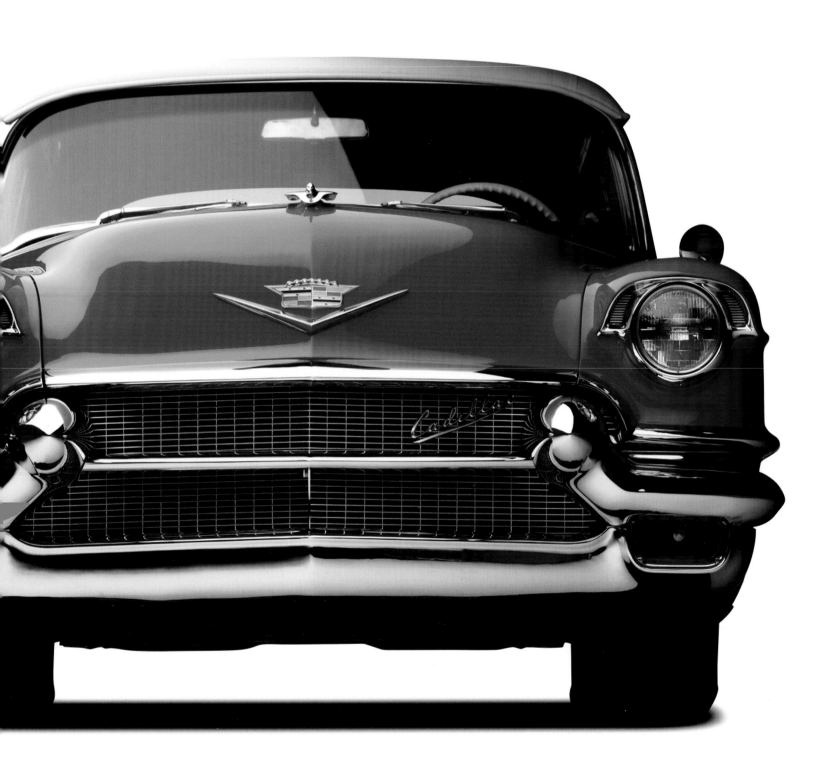

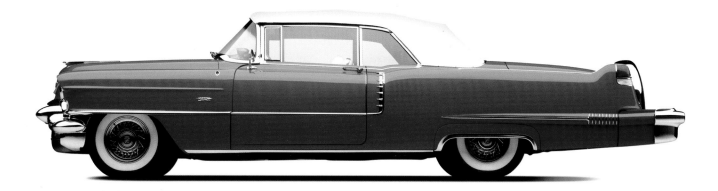

styling wizards at GM made the new Cadillacs look fresh. Careful changes included new trim and moldings, and a revised grille available either in a satin finish or the optional gold plating.

Mechanically, the standard Cadillacs were up to 285 horsepower, but once again, a more powerful engine — in this case 305 horsepower — was available for Eldorado. And befitting the marque's lofty status, it had what many considered the best automatic on the planet — the newly updated Hydra-Matic transmission. Suspension remained independent up front, with a solid rear axle in back. But, like all Cadillacs, the chassis was tuned for a soft ride, not for spirited driving.

Although the 1956 Cadillacs were better and flashier than ever, sales were down to just under 132,000 units, largely because of a weakening economy. Old rival Packard was in serious trouble, with sales plummeting to little more than 28,000 units. By the next year, Packards were rebadged Studebakers and the marque from East Grand Boulevard would never nip at Cadillac's heels again.

One of 8,300 Series 62 Convertibles built in 1956, this fabulous automobile includes a number of options: dual four-barrel carburetors, extravagant Continental kit, signal seeking pre-selector radio, power antenna and Autronic eye headlamp dimmer. Additional luxury features include, six-way power seats, remote trunk release with the soft close feature, power convertible top, power windows, steering and brakes and, of course, buttery soft leather seating.

Although the 1956 Cadillacs were the last to use a body shell that had been around for several seasons, there was nothing old about the look. Once again, styling geniuses Harley Earl and Bill Mitchell had proven that a nip here, a tuck there and a few bushels of chrome were enough to keep American buyers happy.

During the 1950s, General Motors built cars that were big, flashy and exciting. Despite their vast size, their sculpting could be truly inspired as in the case of the Eldorado, with its stunning hood mascot (top right), faux side vents (bottom right) and carefully considered chrome trim (above and below).

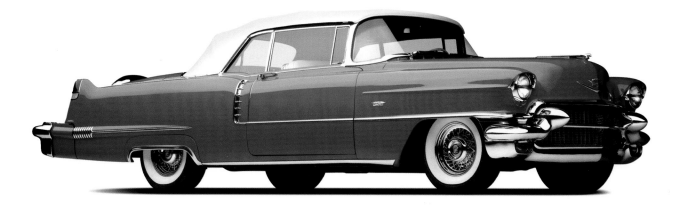

1956 FORD F-100 GOOD HUMOR ICE CREAM TRUCK

MODEL: F-100 | STYLE: REFRIGERATED DELIVERY | SERIAL NUMBER: F1006E53987

In the mid-1950s and 1960s, American towns and smaller cities were wonderful places to raise children. During the summer, kids could be found racing through yards and parks, swimming in public and private pools and playing dodgeball or catch in lightly trafficked streets. But everything stopped with the ringing of a little bell. Children of all ages would come racing out of pools and leaping off of swings to meet the white-suited Good Humor man in his pristine white truck.

It all began in 1920, when Youngstown, Ohio, confectioner and ice cream parlor owner Harry Burt followed his son's suggestion and put a chocolate-coated ice cream portion on a stick. It took three years, a trip to Washington and several buckets of Good Humor Bars before Burt was able to patent his ice cream on a stick. The chocolate covered vanilla ice cream was easy and relatively neat to eat. What's more, Good Humor had a wholesome image thanks to the company's polite, white-uniformed sales attendants.

Before long, Burt had a fleet of a dozen trucks making door-to-door deliveries of his new Good Humor ice cream products in and around Youngstown. After Burt died in 1926, wife Cora sold franchises and took the company public. Operations soon expanded to include much of the Midwest and eventually pushed east. The growing company came to be controlled by New York businessman M.J. Meehan, who bought 75 percent of the company stock in 1930. After World War II, the company aggressively expanded its fleet of trucks, making Good Humor a true American institution. In 1976, 15 years after being acquired by the massive Unilever conglomerate, the company parked its famous white trucks and set up distribution through supermarkets and free-standing freezer cabinets.

During Good Humor's period of rapid expansion in the 1950s, the company turned to both Ford and Chevrolet for its neighborhood delivery trucks. The bare chassis were sent directly to one of at least four truck body builders: Hackney, Wilson, Dekalb or Batavia. This particular Good Humor truck is based on a Ford F-100 fitted with a freezer box. Ford may

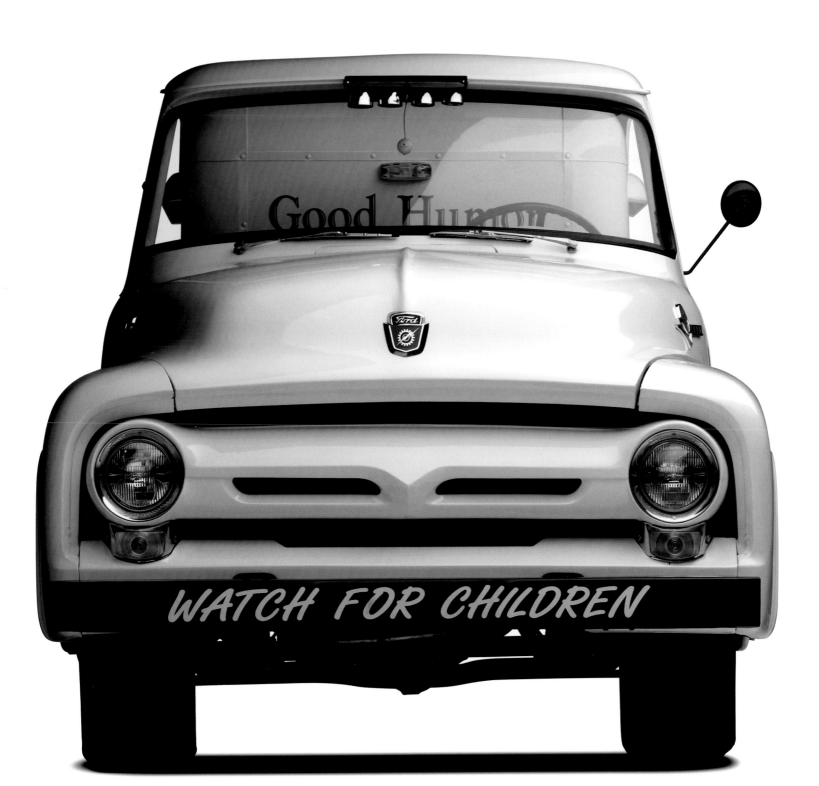

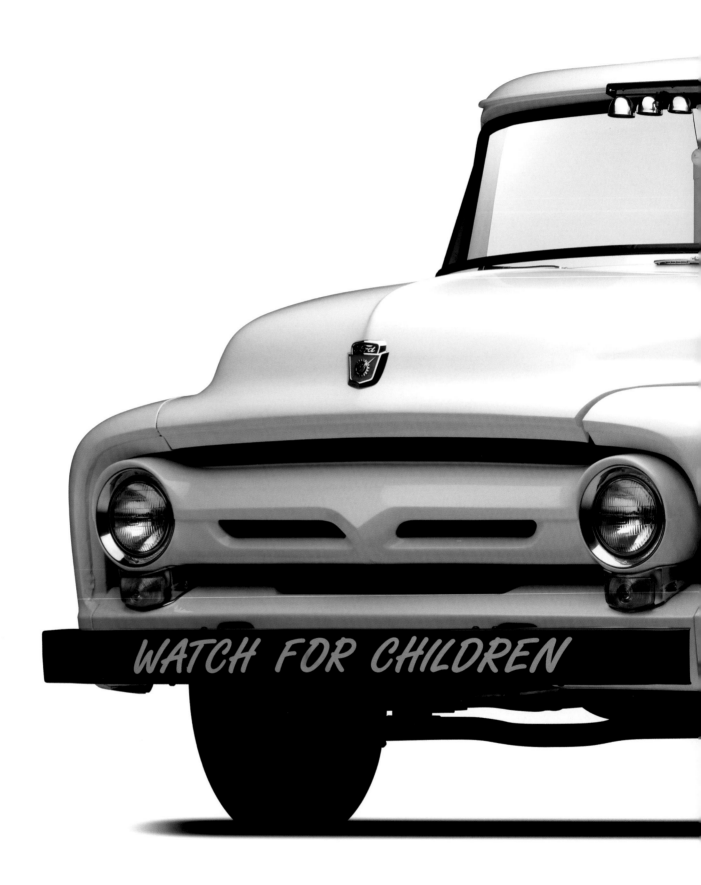

The image shows the text "WATCH FOR CHILDREN" on the bumper.

1956 FORD F-100 GOOD HUMOR ICE CREAM TRUCK

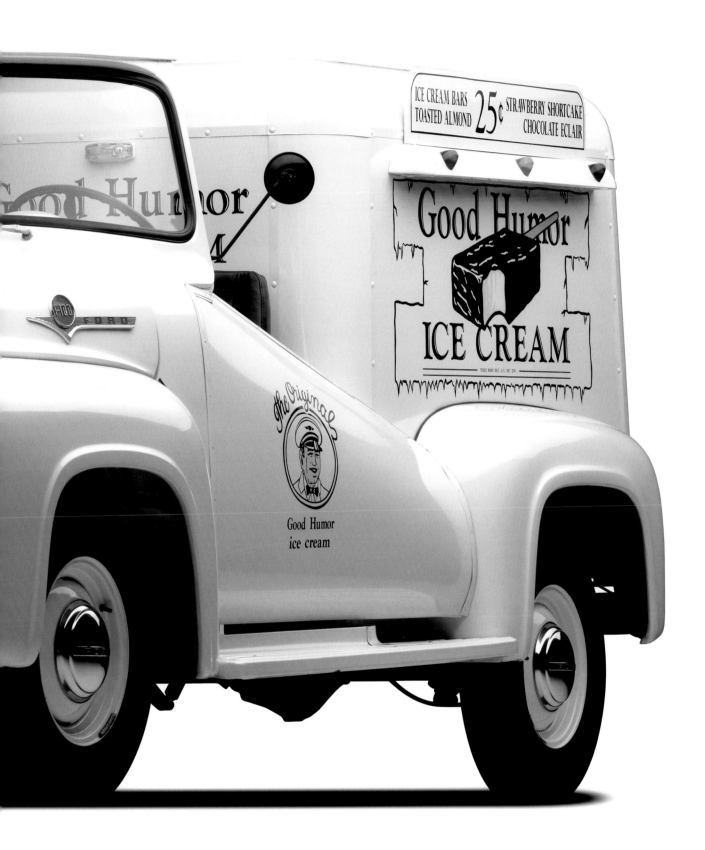

ICE CREAM BARS **25¢** STRAWBERRY SHORTCAKE
TOASTED ALMOND CHOCOLATE ECLAIR

Good Humor
ICE CREAM
TRADE MARK REG. U.S. PAT. OFF.

The Original
Good Humor
ice cream

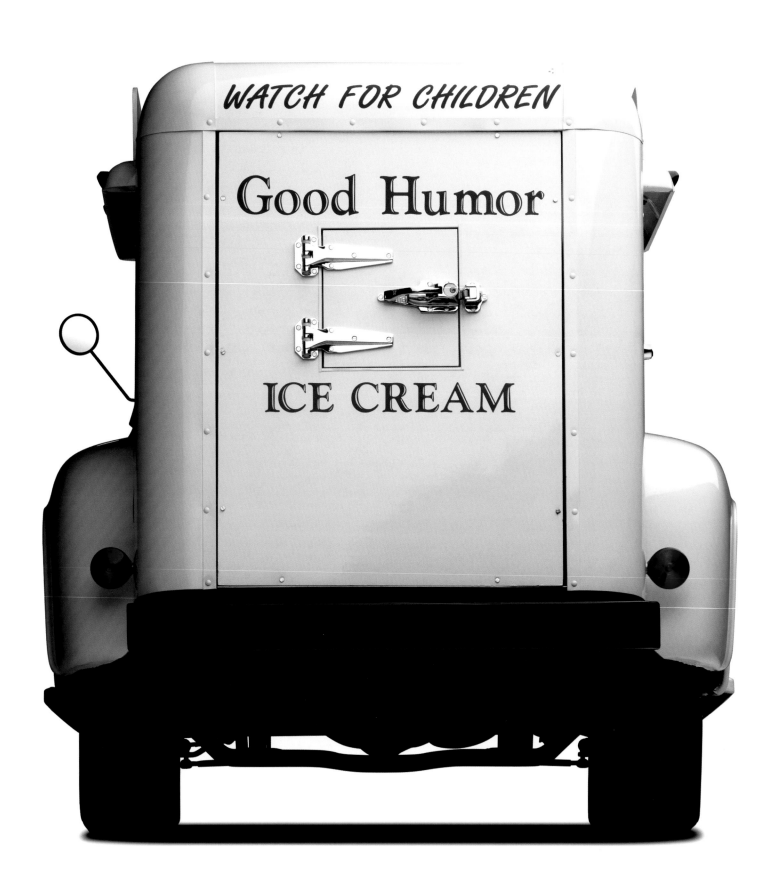

not have been the leading American automaker at the time, but it was still a huge force in the market for passenger cars and light trucks. The company's entry in the light truck market was the F-100, which had been extensively restyled for 1956, complete with the latest rage — a wrap-around windshield. With demand steady, Ford's F-100s were built in 15 assembly plants around the country; this particular truck's chassis rolled out of the Mahwah, New Jersey, facility before being sent to the body builder for completion.

The standard Ford truck body remained from the cowl forward. However, behind the windshield, the top was gone, and a rectangular freezer occupied the area aft of the cab. Although both V-8 and straight-six

engines were available in 1956, for the sedate use they were to experience, Good Humor specified the six mated to a three-speed manual transmission. That overhead-valve inline six displaced 223 cid and was rated 137 horsepower, which was more than enough for the urban and suburban use for which these ice cream trucks were intended.

This Ford F-100 ice cream truck is a reminder of a simpler time that included ice cream, a porch swing and a warm summer night.

This Ford F-100 Good Humor truck is all about function. The white paint suggested the wholesome goodness of the ice cream and the graphics (below) left no doubt about the purpose of the truck and its utilitarian freezer compartment (left).

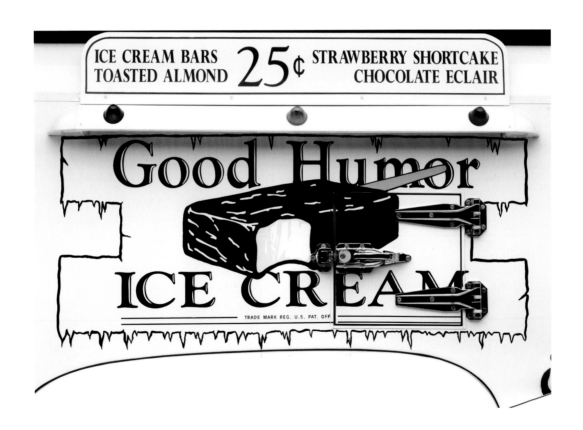

1956 FORD FAIRLANE CONVERTIBLE

MODEL: FAIRLANE SUNLINER | STYLE: 76B CONVERTIBLE | SERIAL NUMBER: M6EC101455

Inspiration for the names used on many Ford models came from a variety of sources. The Model T was so named because it came after the S. The Model A was used because it was essentially a fresh start with a vehicle almost totally unrelated to its predecessor, the Model T. Super, Custom and Deluxe were pretty much standard fare for automakers, but Fairlane had a totally different origin.

Fair Lane was the name of the Dearborn, Michigan, estate of Henry and Clara Ford. Construction started in February 1914 and continued for almost two years before the Ford's took up residence. The secluded 1,300 acre property had its own power-generating plant and provided the privacy that famous Henry Ford could no longer enjoy in Detroit.

Henry Ford had been deceased for eight years when the company he had founded assigned the name of his home to its top 1955 model. It may have been the senior Ford model, but the Fairlane was still offered in two distinct series differentiated by either straight-six or V-8 engines.

Like all other 1955s, the Fairlane was treated to a completely new body shell. Longer, lower and wider than the 1954 models, it took the Crestliner's place in the Ford line. As was the case with Crestliner, front suspension was independent, and the rear used a solid axle. Brakes were hydraulic drums at all corners.

The six-cylinder offering was an overhead valve unit displacing 223 cid and producing 120 horsepower. The standard V-8 had a displacement of 272 cid and was rated at 162 horsepower at 4,400 rpm. With a four-barrel carburetor, power was boosted an additional 20 horsepower. With the addition of the sporting new Thunderbird, the entire Ford line had another engine to choose from — a 292 cid unit producing 193 horsepower. Transmission choices included a three-speed manual, three-speed with overdrive, and the Ford-O-Matic automatic transmission.

For 1956, Ford reused the 1955 body shell and incorporated new style and safety features like a padded dashboard, sun visor and seat belts, which were offered for the first

Sunliner

time. The most noticeable of changes was the elongated parking lights, thick checkmark side trim called the "Fairlane stripe," aggressive horizontal grille rectangles and optional two-tone paint.

All six-cylinder and V-8 engines were upgraded for 1956. Ford's most powerful engine, the Thunderbird Special 312, came in at 215 horsepower. With the Ford-O-Matic, power was up slightly for all the V-8s.

Six body styles were offered for both six and eight-cylinder lines, with options including closed two and four-door versions, as well as the Sunliner convertible. Selling for a base price of $2,459, the big Ford convertibles were very popular, with combined sales of all versions totaling more than 58,000 of the more than 645,306 Fairlanes built.

This dashing V-8 Sunliner benefits from the striking two-tone red and white finish. With good looks, lots of chrome, plenty of power and a top that drops at the push of a button, it would be hard to ask for more.

Take away the two-tone paint (top right), Continental kit (bottom right) and the Fairlane stripe (above) and this big convertible would have been just another big Ford. But these features added excitement and flamboyance, which was just what the public craved in 1956.

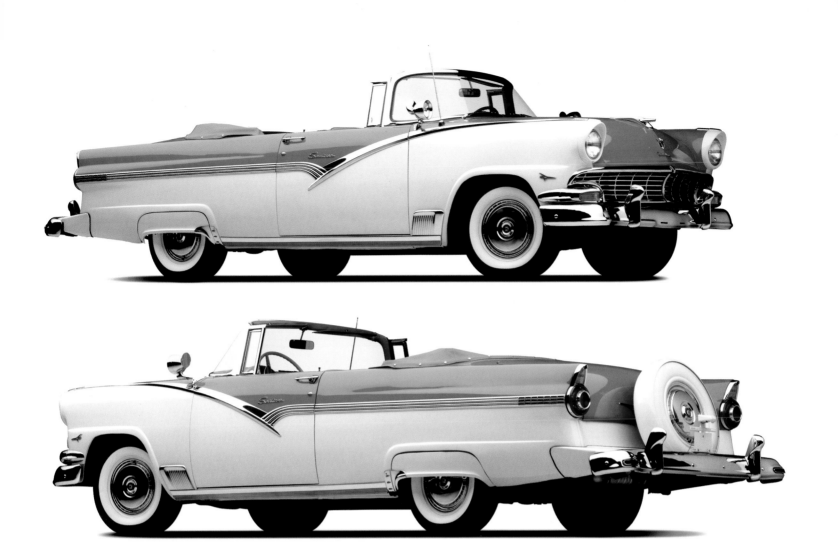

1957 MERCURY TURNPIKE CRUISER INDY 500 PACE CAR

MODEL: TURNPIKE CRUISER | STYLE: 76B CONVERTIBLE | SERIAL NUMBER: 57SL61233M

In the 1950s, dream cars caught the public's attention and often ideas were traded back and forth between these concept cars and the models that made it to the showroom floor. Such was the case with Mercury's 1956 X-M Turnpike Cruiser, which the company billed as an "idea" car. According to official literature, it "represents another chapter in the saga of the never-ending search by Mercury stylists and engineers to develop innovations keyed to the ever-changing trends in modern motoring."

Styled under the direction of Don DeLaRossa, the radical-looking car made heavy use of sharply-creased sheet metal. Extensive sculpturing of the sides created a channel that flowed rearward along the quarter panel and developed into outwardly-canted rear fins. A full-size two-door coupe, it also incorporated a steeply-raked rear window beneath an overhanging roof ledge. One particularly interesting feature was what Mercury called "A unique, new plastic 'butterfly' top." When the door was opened, a hinged plexiglass roof panel would pop up, "facilitating passenger entry and exit."

Overall, the design made use of jet-plane motifs up front and relied heavily on surface ornamentation and plenty of chrome.

Not content to have the X-M on static display, Mercury provided a dedicated truck and trailer to take the idea car around the country. In the best 1950s concept car tradition, many of the cues from the X-M — and part of its name — made it into a new 1957 Mercury production car called the Turnpike Cruiser. However, some accounts suggest that many of the styling devices already had been considered for the production car and instead were borrowed for the X-M.

Sitting at the top of the Mercury line, Turnpike Cruisers were available in three body styles: two-door hardtop coupe, four-door hardtop sedan and two-door convertible. Although the front-end treatment was far less complicated than that of the X-M, it was still anything but simple, with its concave, vertically slatted grille and heavily-hooded dual headlights. From the door back, much of the same styling motif used on the X-M was also applied, although the taillights were more restrained. In addition,

the rear roof overhang was also present on both the concept and reality cars.

Powered by Mercury's 290 horsepower, 368 cid V-8, the Turnpike Cruiser was packed with features. It included Merc-O-Matic transmission with "Keyboard Control" pushbuttons, power steering and brakes, a special flat-at-the-top steering wheel, quad headlamps and a "Monitor Control Panel" with a tachometer and "Average-Speed Computer Clock." Also included were "Seat-O-Matic" memory seats, an electrically retractable rear window (on hard top coupes only) for "Breezeway Ventilation" and twin air intakes.

For 1957, the Turnpike Cruiser was chosen as the Indy 500 pace car. Driven by Mercury General Manager F. C. Reith, the big Mercury convertible was finished in a rich, creamy white with gold pace car lettering. Despite the exposure of pacing the biggest race in America, the Turnpike Cruiser did not sell well. The low numbers were due, in part, to poor workmanship and unreliable gadgetry, as well as an economic downturn which began partway through 1957. Total Turnpike Cruiser production for all three body styles amounted to just 16,861 units, of which 1,265 were convertibles selling for $4,103.

This 1957 Mercury Turnpike Cruiser convertible is one of approximately 250 Indianapolis Pace Car replicas built. It is big, striking and powerful. It also shows the conflicted relationship between the dreams of designers and the reality of the marketplace.

The Turnpike Cruiser would certainly live up to its name. Aggressive styling (top right and right), a massive V-8 engine (center right), a smooth ride and a top that dropped made for a car that was perfectly at home on any of America's highways.

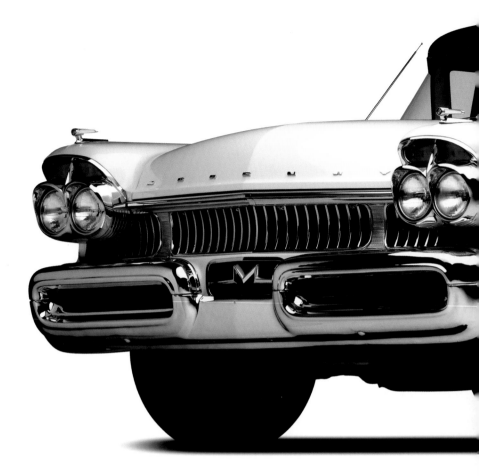

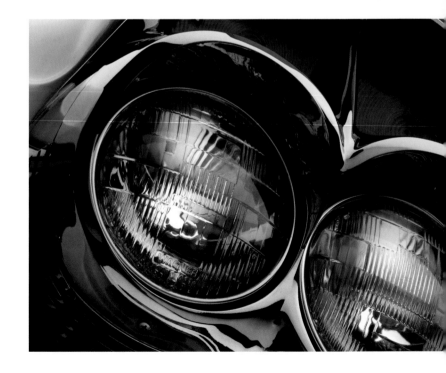

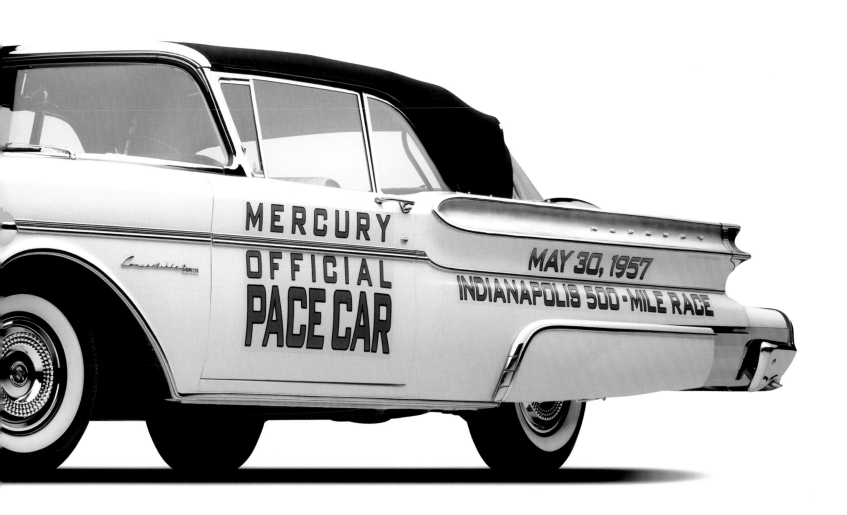

1957 MERCURY TURNPIKE CRUISER INDY 500 PACE CAR

1957 FORD THUNDERBIRD

MODEL: D7 THUNDERBIRD | STYLE: 40 | SERIAL NUMBER: D7FH132109

Ford's sales for 1951 and 1952 were well down from 1950 and top brass were understandably concerned. Industry leader Chevrolet had opened the gap over number two Ford.

Amid rumors of a possible Chevrolet sports car, Ford Division styling chief Franklin Hershey initiated clandestine work on a two-seater. Meanwhile, product planners were bandying about the concept of a "halo" car that would lure potential buyers into showrooms. Once their audiences were captive on the showroom floor, salesmen would have the opportunity to sell them on the bread-and-butter Fords. Incentives to produce a better sports car were high after the January 1953 Motorama at which the Corvette was introduced to an enthusiastic reception.

Working under a tight deadline, Ford's designers scrambled to craft a two-seat automobile. By May 1953, the basic exterior design was close to final. Clearly inspired by the foreign-built sports cars Americans found so appealing, it was built like a small luxury car. With a more comfortable ride and parts that were interchangeable with other Ford models,

Thunderbirds were as reliable as they were comfortable, fast and stylish.

Unlike Chevrolet's Corvette, the Thunderbird started life with a high-quality steel body and V-8 power, although the Chevy finally got the small-block in 1955. Until 1955, the Corvette only had the two-speed PowerGlide automatic, while the T-Bird started out with a choice of three-speed manual, three-speed with overdrive or Ford-O-Matic. In addition, the Thunderbird had roll-up windows, a more effective folding convertible top, power steering and power brakes. It also had excellent fit and finish — something that was sorely lacking in the fiberglass Corvette.

First year sales were 16,155, which sounds modest for a huge organization like Ford. However, that number compared well to the Corvette's third season sales of 700 units and three-year total of 4,640.

Ford considered Thunderbird successful enough to continue it into 1956. Several comfort and convenience modifications were made, including a porthole to add visibility to the blind rear quarter

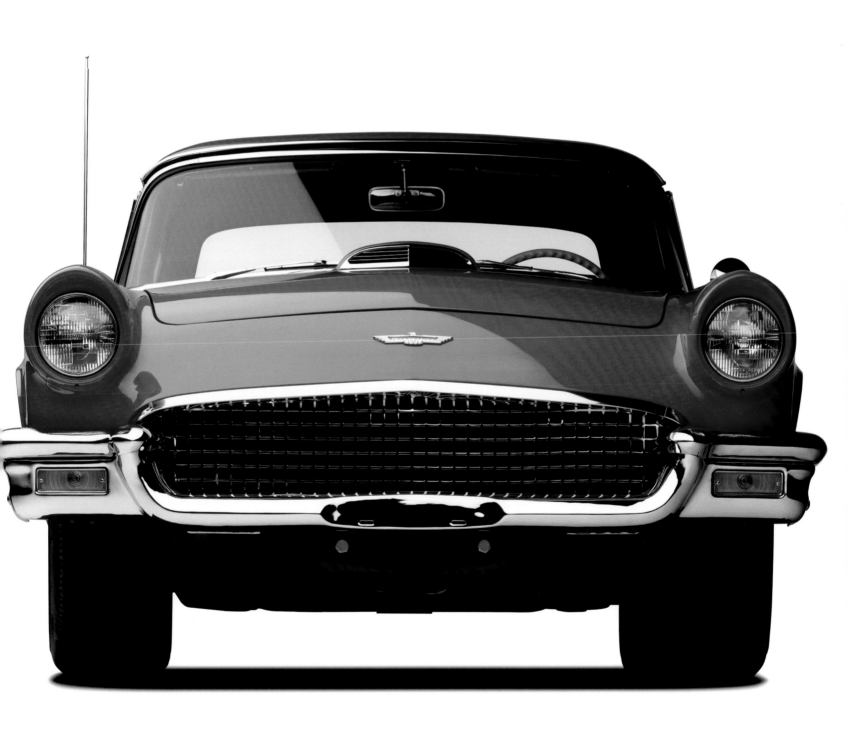

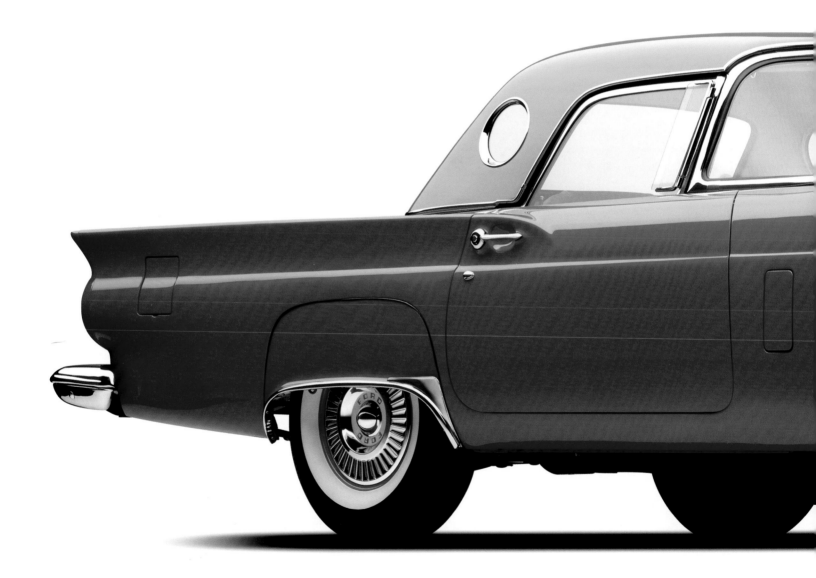

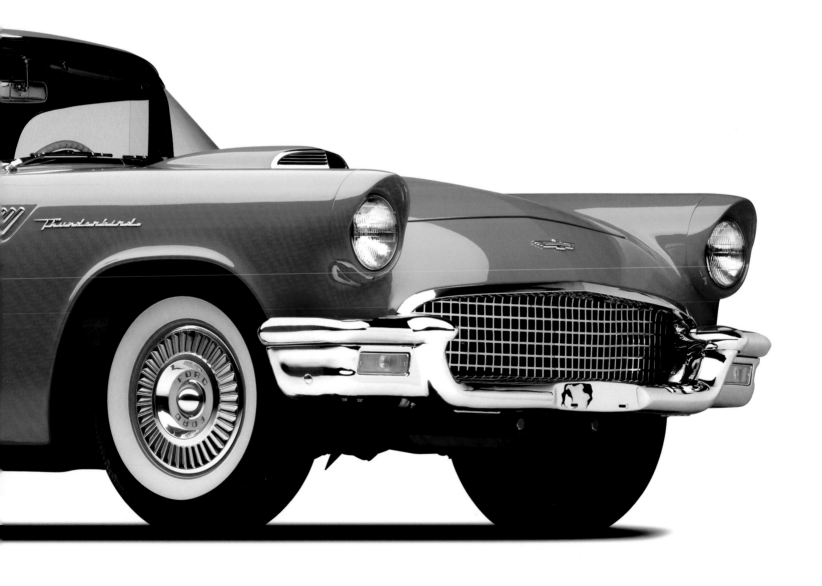

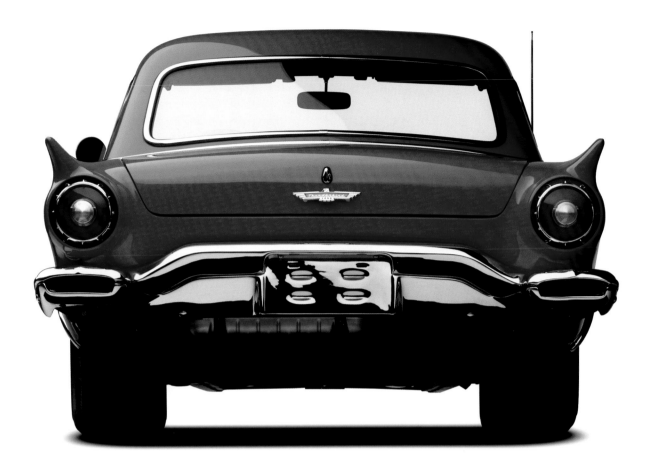

of the hardtop and a "Continental" kit to increase trunk capacity by moving the spare tire to the rear bumper. Sales were down slightly to 15,631, but still handily outsold the Corvette, which only moved 3,467 units despite a considerable increase in volume.

For the 1957 model year, Ford gave the traditional Thunderbird a facelift that included a low-mounted egg crate grille and small, canted tailfins. Engine options included a single-carburetor 312 cid V-8 producing 245 horsepower, a dual-quad version good for 270 horsepower and a supercharger-equipped unit rated at 300 horsepower.

This '57 T-Bird is equipped with the 270 horsepower Thunderbird Special 312 cid engine. Finished in bright red, contrast is provided by the rare all-white interior.

Although the Thunderbird con-sistently outsold the Corvette, largely due to its melding of performance and luxury, Ford decided to replace the "little birds" with a higher-volume four-seat version. The "square-birds" were new for 1958 and sold 37,893 units in their first year (up from 21,380 in 1957) and the accountants' decision was vindicated. However, many people both within and outside of Ford lamented the loss of the original-style Thunderbird. Partly thanks to their early demise, the 1955–57 "little birds" were among the first postwar cars to become serious collectibles.

With the 1957 Thunderbird, Ford perfected a shape that had been exquisite from the beginning. The clean grille (left), modest tailfins and even the simple wheel discs (top left) added up to an attractive two-seater that excited many Americans.

1957 CHEVROLET BEL AIR CONVERTIBLE

MODEL: 2454 BEL AIR | STYLE: 1067D TWO-DOOR CONVERTIBLE | SERIAL NUMBER: VC575192323

Few companies needed a fresh new model more than Chevrolet. Despite styling revisions for 1954, the cars in the Chevy line were relatively tall, narrow and uninspired. They also had modest performance at best. At a time when other American automakers and GM divisions were coming up with powerful new overhead valve V-8s, Chevy was confined to an elderly straight-six. With the three-speed standard transmission, the 235.5 cid Blue Flame Six was rated at 115 horsepower. Equipped with the two-speed Powerglide automatic transmission, horsepower was boosted by 10. This was the same engine that had been massaged and tweaked with three carburetors to generate 150 horsepower for the very low volume 1953 and 1954 Corvettes.

Nothing Chevrolet had ever built before prepared the American public for the One-Fifty, Two-Ten and Bel Air models of 1955. Built on a box-framed chassis, all three lines used a new ball-joint front suspension. Sitting on that fresh chassis, the totally redesigned Chevys were lower, sleeker and powered by what is arguably the most important American

automobile engine ever — the first of the "small-block" V-8s. These models — with the old straight-six as well as the more popular new eight — proved wildly popular. First year sales were an incredible 1.7 million units, up considerably from the 1954 sales of 1.14 million units.

Few models were ever so well-received and changed the image of a company overnight. Although Chevy had long outsold Ford, America's premier high-performance engine had long been the Flathead Ford V-8. Following the war, Cadillac and Chrysler made inroads into the Flathead's constituency. With the advent of Chevrolet's compact, light and powerful overhead valve V-8, the tables were turned forever.

Chevrolet's transformation was no accident. In 1952, engineer Ed Cole left Cadillac after more than 20 years to become Chevrolet chief engineer. With experience in designing engines (including the Cadillac flathead and OHV V-8s), chassis, suspensions and manufacturing, Cole was the perfect man for the job. The new 1955s were developed under Cole, and GM's senior management knew

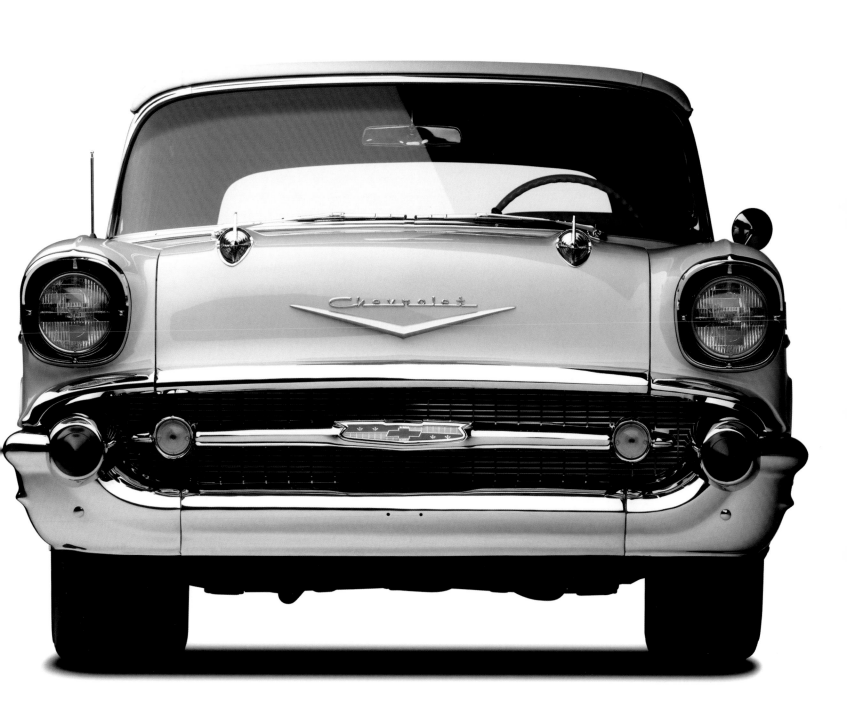

1957 CHEVROLET BEL AIR CONVERTIBLE

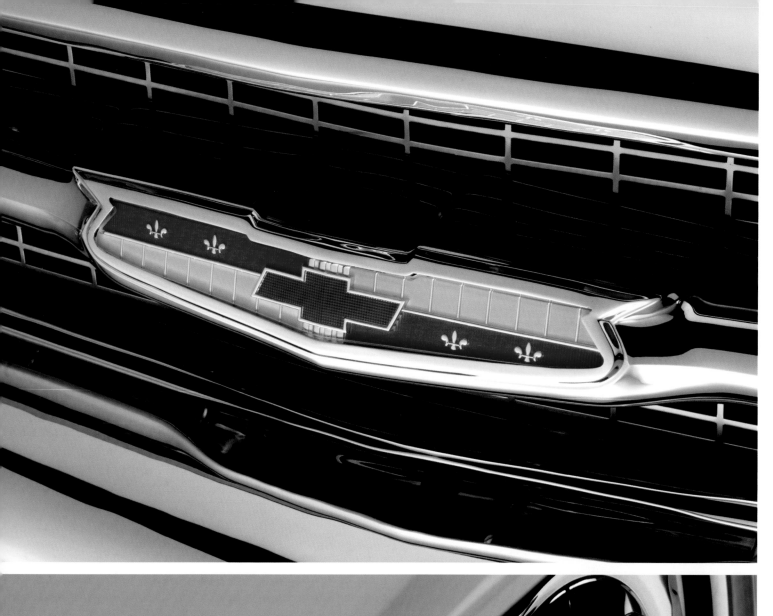

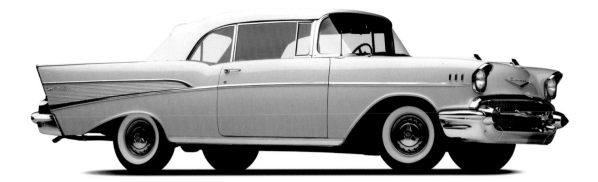

who was responsible for their success. Duly rewarded, Cole became Chevrolet general manager the following year.

By 1957, the full-size Chevrolet had reached maturity with a symmetry of design that started at the peaked head-lights and ended at the tip of an almost ideally-sized fin. The overhead-valve V-8 had matured also. It grew from 265 cubic-inches in 1955, to the optional 283 in 1957. Receptive to tuning, by 1957, the 283 version of the small block V-8 was available with outputs ranging from 185 to 283 horsepower. At the time, one horse-power per cubic inch was a monumental achievement matched by few engines anywhere. That significant output was attained through the use of Rochester mechanical fuel-injection, which had been supported by Ed Cole and developed by engineer John Dolza with the assistance of Zora Arkus-Duntov. Transmission choices included three-speed manual units with and without overdrive, a close ratio three-speed and a pair of auto-matics: Powerglide and Turboglide.

In 1957, *Motor Life* wrote about the entire Chevy class as a revival of power,

saying, "Never before has [Chevy] had so much to offer. And . . . as a matter of fact, never has it needed it more."

At the height of its popularity, the Bel Air was seen in bold colors such as Tropical Turquoise, Matador Red and Canyon Coral. Along with its '57 class-mates, top line Bel Air models featured shiny accents of gold. This Chevy Bel Air convertible was previously owned by the H. Robert Nelson Family. Fully-loaded, it is equipped with the four-barrel, 220 horsepower engine, Powerpack engine, Powerglide transmission, power steer-ing, power brakes, and power windows. Restored to the highest standard by Robinson Restorations, it is finished in Larkspur Blue with a white top. An AACA Junior and Senior winner, this spectacular '57 Chevy convertible would look perfectly at home in a period magazine or in front of that new suburban split level, circa 1957.

To many people, the 1957 Chevrolets were the quintessential American cars. The shape was clean (top), there was just enough chrome, the fins (bottom) were just the right size and they were powered by the strong and sturdy small-block V-8.

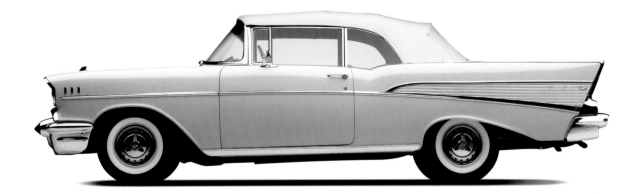

1958 CHEVROLET CORVETTE CONVERTIBLE

MODEL: J800 CORVETTE | STYLE: 867 TWO-PASSENGER CONVERTIBLE | SERIAL NUMBER: J58S107022

The story of the original Corvette was one of promise and disappointment. When first seen publicly at the Motorama at New York's Waldorf Astoria hotel in early 1953, audience response was overwhelming. People simply loved the looks of the trim white sports roadster with the red interior.

Once deliveries began, reality set in. Fit and finish of the fiberglass body was poor, performance was disappointing and creature comforts were limited in dry weather and appalling when it rained. Only 300 cars were sold in 1953, followed by 3,640 in 1954 and a paltry 700 in 1955. Meanwhile, dealers struggled to rectify problems with the first sports car and the first fiberglass bodies they'd ever had to work on.

With dismal early sales, the Corvette owes its very existence today to two events: the first was when Ford introduced its Thunderbird in 1955 — sheer pride kept GM in the sports car business. The second factor was the arrival of Zora Arkus-Duntov at General Motors.

A European-trained engineer with racing experience, Duntov had seen the Corvette at the New York Motorama. Smitten with the car, he knew that it could be truly great if developed using the resources of the largest company on earth.

The first step was to improve body construction and assembly quality. Then for 1955, the folks in Chevrolet engineering made a match between the company's wonderful new overhead valve V-8 and the hitherto under-performing Corvette. It was a marriage with a great future, especially with manual transmissions added into the equation.

When the 1956 Corvettes came out, the body was extensively redesigned and incorporated roll-up windows for the first time. Added weather protection was available with the addition of a removable hardtop. Although the chassis was largely unchanged, the body was fresh and very American-looking, flashing its toothy grille.

In 1955, when General Motors began designing the 1958 Corvette, the initial plan had been to use the futuristic Oldsmobile Golden Rocket concept car as inspiration. However, the redesign was halted in early 1956 and Corvette

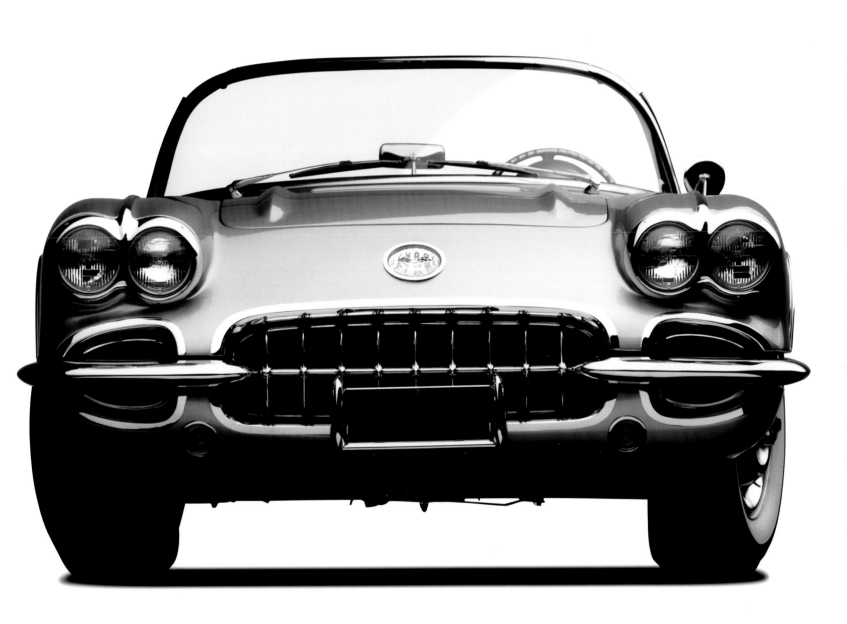

resources were diverted to other projects. The only remaining alternative was to freshen the existing body style as used in the 1956 and 1957 Corvette. However, traces of the Italianesque Golden Rocket could be seen in the front fender and headlamp treatment of the 1958 model.

The clean lines of the base car were still evident beneath the simulated hood louvers and fake air scoops. Further ornamentation included indented body side coves and twin chrome bars running down the trunk lid. Quad headlights in widened front fenders and a narrower grille with fewer teeth, flanked by smaller nostrils, were the main identifying points for 1958.

Not so evident for 1958 was the addition of 9.2 inches in length and 200 pounds. The hefty new body also featured more substantial bumpers that were attached to the chassis and offered better protection.

This 1958 Chevrolet Corvette convertible is finished in Silver Blue with silver coves — one of 757 delivered in that combination. This numbers matching car is one of 540 1958 Corvettes equipped with the 250 horsepower version of the fuel-injected engine. It is mated to a T-10 four-speed manual transmission.

With the right combination of engine and transmission, the Corvette had quickly become a world-class sports car. Thanks to Duntov's development work, the car was becoming successful in competition. Although it still lacked chassis refinement and the brakes of some European competitors, it was now clearly a contender instead of the has-been it could so easily have become.

Harley Earl and Bill Mitchell made sure the 1958 Corvette was loaded with eye candy, from the fake hood louvers (top right) and side vents (bottom right), to the deeply-sculpted side-cove (below). But under the skin, the Corvette was a real sports car thanks to small-blocks of up to 290 horsepower.

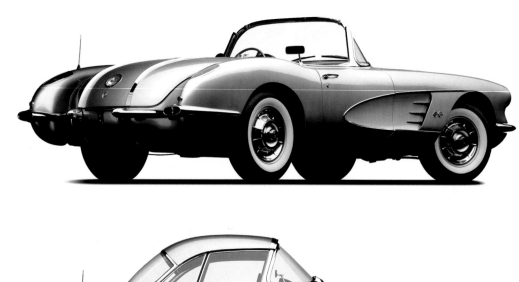

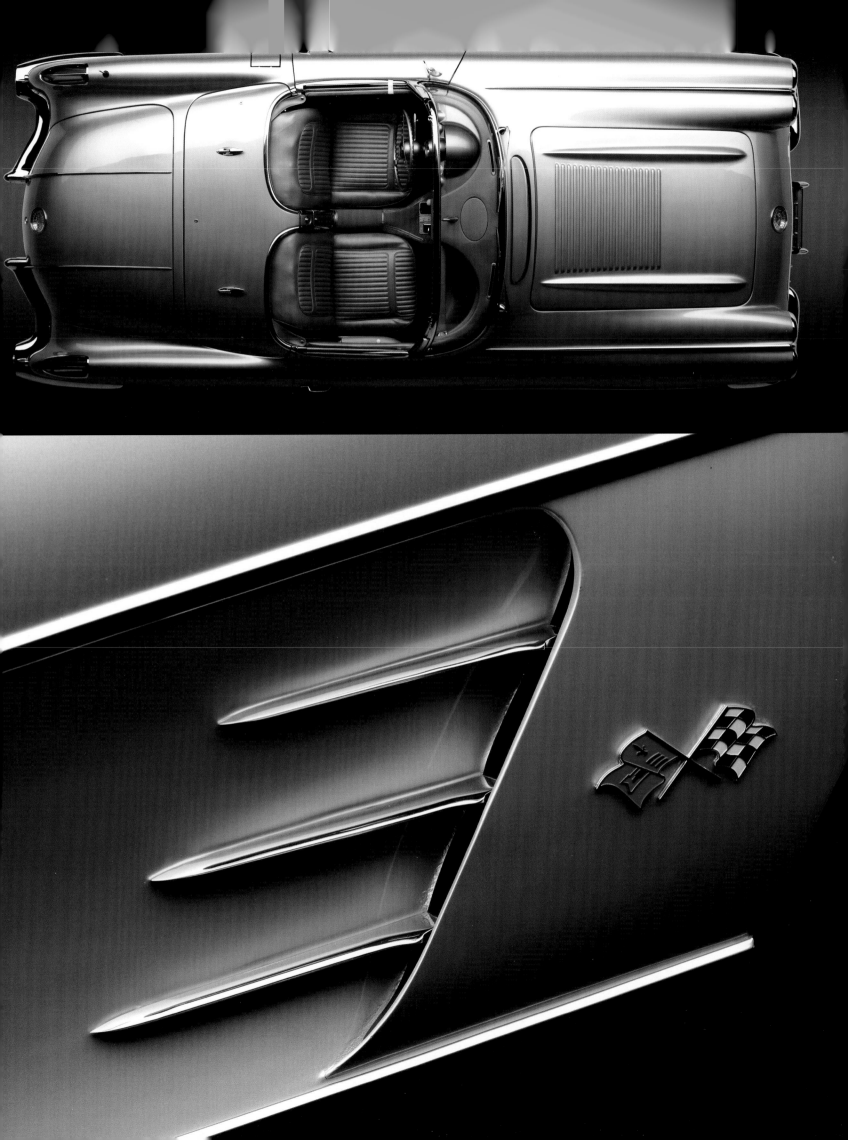

MoPar AIR CLEANER
PART NO. 2130633
DO NOT WASH OR OIL
Normal operation: Remove filter cartridge
and tap gently to remove dirt every 5,000
miles. Install new MoPar filter cartridge
every 15,000 miles. Service more frequently
under severe conditions.
CHRYSLER CORPORATION PARTS DIVISION

DETROIT MUSCLE

Production Performance

America was the land of the free and, in the 20th century, the country had engaged in two colossal wars to prove it. With vast open expanses to be traveled, in the days after World War II, America was also the land of the large high-performance engine, although they were often in big and heavy cars. The first of the modern high-performance engines came along in 1949 when Cadillac and Oldsmobile introduced their overhead-valve V-8s and the mighty Chrysler Hemi followed in 1951. Ford soldiered on with its venerable flat-head V-8 until it was replaced by a new overhead-valve unit for 1954.

The end of the flat-head Ford also signaled the end of a performance legacy. If an American driver wanted a true high-performance car, he usually had to build it himself. In most cases, the basis for any hot-rodded car was a flat-head Ford. Although Ford's 1954 new Y-Block engine was 25 percent more powerful than the engine it replaced, it was not the high-performance motor of the future. That mantle fell to the Chevrolet small-block engine that came along in 1955.

All these new and very tunable V-8 engines were mostly fitted into massive cars weighing between 3,200 and 4,000 pounds. Performance was just fine for commuting, long distance travel and shopping. But street racing and track racing were a bit beyond their abilities — most of the time. Lincoln had good success in the Mexican Road Race and the C-300 and 300B Chryslers certainly proved their mettle on the NASCAR circuits. But where the American engines really showed massive potential was when they were dropped into much lighter cars. Cadillac and Chrysler V-8s wreaked havoc when installed in British Allard sports cars, while Chrysler engines won the 12 hours of Sebring in a Cunningham C4-R for 1952. West coast hot rodder and sports car racer Max Balchowsky terrorized the Ferraris and other expensive European cars with his home-built Buick-powered "Ole Yellar" specials. But still, American production cars were held back by their sheer girth.

The first two cars to seriously challenge the "bigger is better" mentality from the Detroit automakers were the 1953 Corvette and the 1955 Ford Thunderbird. At 2,700 and 2,900 pounds respectively, there was less mass to move and per-

DETROIT MUSCLE: PRODUCTION PERFORMANCE

formance was pretty darned good, especially when Chevy's sports car received the small block V-8 in 1955. This lesson didn't develop further until 1964 when several American automakers dropped powerful engines into mid-sized cars. The performance dividends were numerous. Pontiac started the "muscle car" wars with the Tempest LeMans with the GTO option. A 325 horsepower 389 cid engine in a 3,100 pound car made for fantastic performance. With the optional engine, it got even better, with 0–60 times in the 6.5 second range and the quarter mile in under 15 seconds. Mid-year 1964, Oldsmobile joined in with the 4-4-2, which used a 345 horsepower, 330 cid engine in the Cutlass body. Although not as quick as the GTO, it was certainly a contender, along with Chevrolet's 300 horsepower Chevelle Malibu SS. Plymouth's Valiant Barracuda also entered the fray in 1964, but was well behind in the power sweepstakes. Ford's Mustang wasn't exactly in the same category because it was smaller and lighter. With 271 horsepower available from its most powerful engine, it was extremely fast, although it couldn't seat a family of five in comfort. The Camaro and other "Pony" cars were also very quick when equipped with the right engine and powertrain options, but much of the attention was on the mid-sized muscle cars.

Carroll Shelby

By 1965, the picture was clear. All the major American automakers were stuffing powerful engines in lighter bodies. Before long, those engines were growing to 400, 427, 428 and even 454 cid. With the big engines, the cars were nose-heavy and weak in the handling department — but that didn't matter. These cars weren't meant to cut it up on road courses with sports cars — they were all about bragging rights and straight line performance.

The most exotic of the engines being stuffed under the hoods of these mid-size road burners were the Hemis from Dodge and Plymouth. These 426 cid, 425 horsepower engines were essentially de-tuned NASCAR racing motors. They were in the passenger catalog specifically so that they could be used in racing. They were also highly successful on drag strips across the United States. Ford had its mighty 427 and 428 engines and Chevy had its 396 and 427 engines. Those 427s were available in cast-iron, with aluminum cylinder heads and as all-aluminum engines.

Hemi 'Cudas and LS6 Chevelles sold for little more than $4,000 when new. Today the most desirable of all the muscle cars are the ones with the rarest and most powerful engines and tops that go down. These very cars have captivated a new generation of collectors and regularly bring a million dollars or more when they roll across the auction block.

1961 CHRYSLER 300G CONVERTIBLE COUPE

MODEL: RC4-P 300G | STYLE: 845 TWO-DOOR CONVERTIBLE COUPE | SERIAL NUMBER: 8413154368

Many MOPAR purists insist that the Chrysler 300 series "letter cars," which first debuted in 1955, were the first muscle cars. Although big and luxurious, they offered tremendous performance for their time. They also brought an undeniable logic to the naming process — at first. The first Chrysler 300 was so named for its horsepower rating.

Prior to 1955, Chrysler had been known for engineering excellence as well as a lack of visual panache. In other words, they were conservatively-styled cars your great uncle might swear by. But, in 1955 the entire Chrysler line had been extensively reworked. At the top of that line sat the new C-300 hardtop coupe.

What Chrysler designer and automotive historian Jeffrey Godshall has called a styling "revolution," was led by the highly-respected Chrysler styling Vice President Virgil Exner. The new shape of Chrysler, Dodge, DeSoto and Plymouth exterior design was known as "The Forward Look." These new designs were undeniably attractive and a totally new direction for the traditionally staid company.

The flagship Chrysler C-300 was largely a triumph of parts bin engineering — while the shape was fresh, the many components came from a variety of corporate sources. The body came from the Chrysler Imperial hardtop coupe, while the rear quarter moldings were donated by the Chrysler Windsor and the Imperial grille was modified to fit.

For many years, the Chrysler catalog had included a mighty hemi-head, overhead-valve V-8 that was incredibly powerful and capable of even greater output. That 331 cid Hemi was tweaked from 245 horsepower, all the way up to the trademark 300. The only available transmission was the tried and true two-speed PowerFlight automatic unit. Front suspension was independent by coil springs, with a live axle using semi-elliptic leaf springs bringing up the rear. Spring rates were adjusted to accommodate the greater horsepower package. Brakes were power-assisted drums front and rear.

Unlike most big and luxurious cars of the day, very few options were available. Those choices included power steering, power front seats, electric windows,

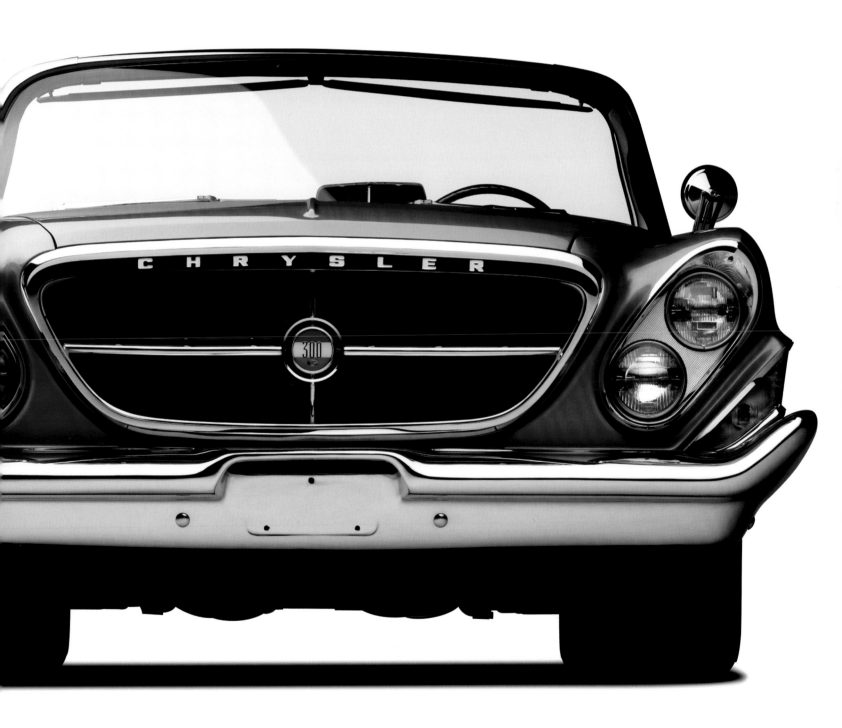

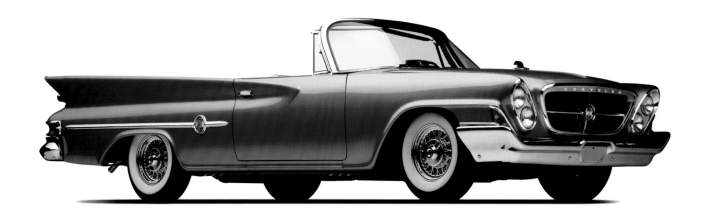

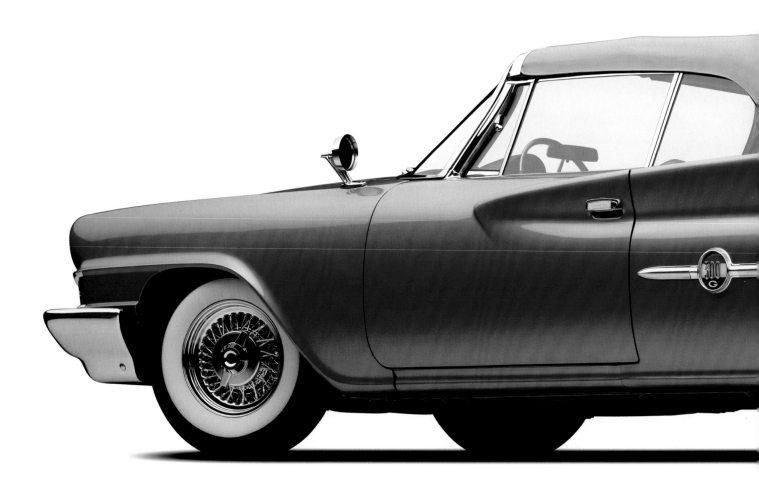

1961 CHRYSLER 300G CONVERTIBLE COUPE

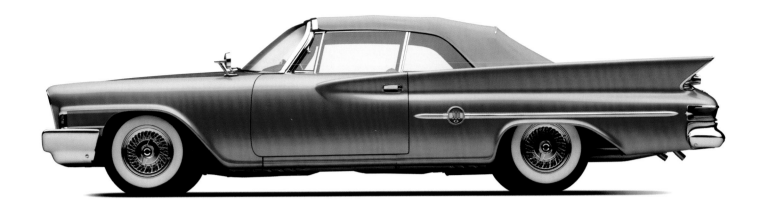

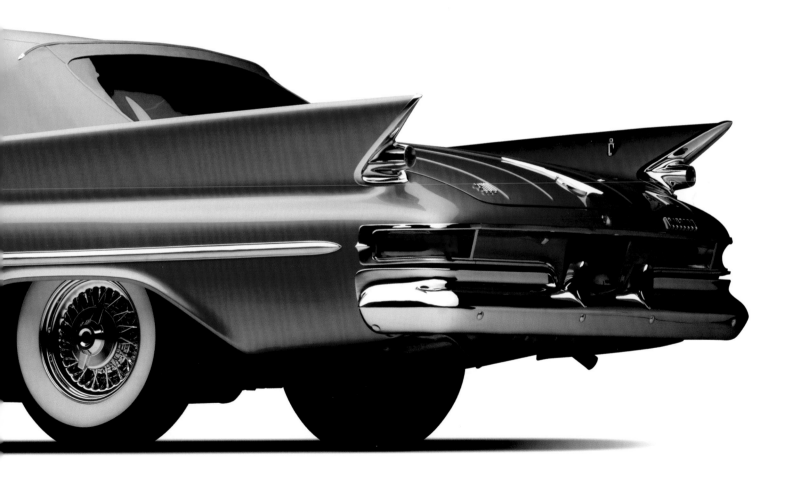

1961 CHRYSLER 300G CONVERTIBLE COUPE

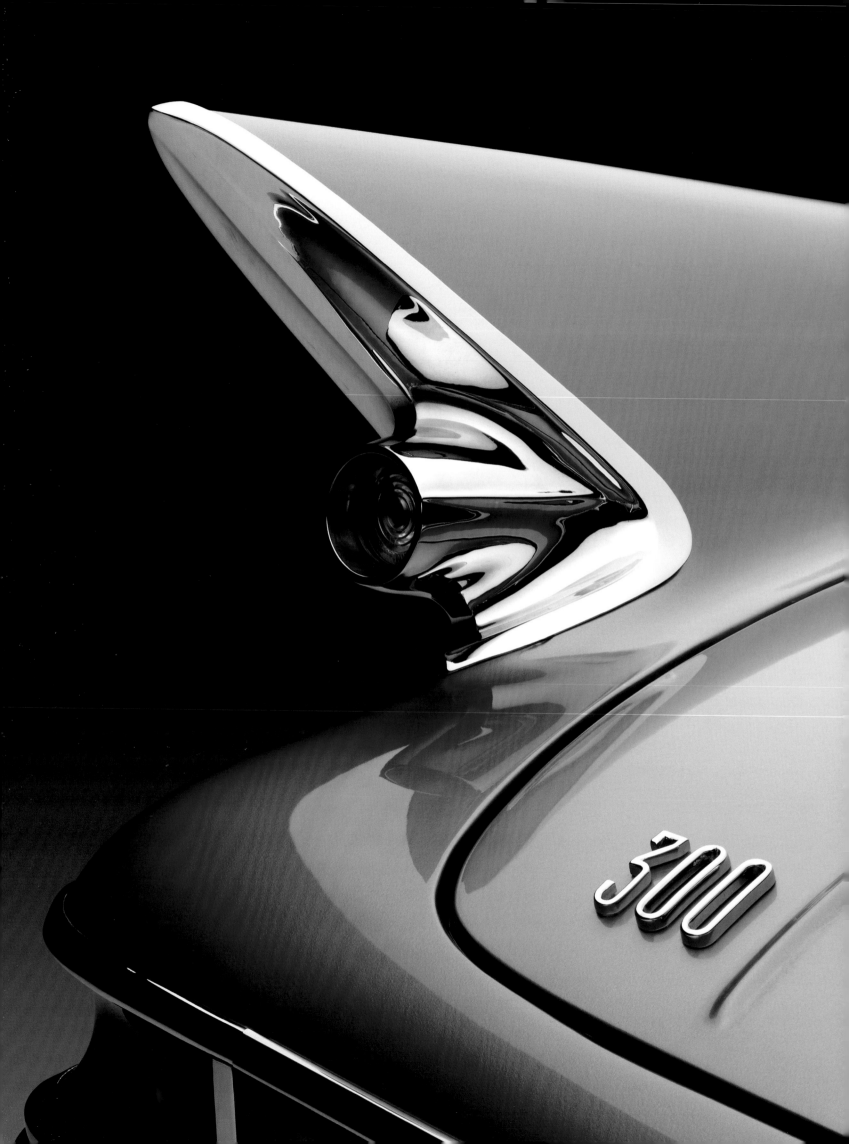

electric clock and wire wheels. Back-up lights and exterior side view mirrors were not available. With performance in mind, power-sapping air conditioning was not offered. Interior trim came in natural leather only, while exterior colors were limited to Platinum, Black and Tango Red.

Although never a huge seller — just 1,725 in 1955 — the C-300 made a massive impact — especially in NASCAR and in record breaking. Those accomplishments were good for the Chrysler image and the line was continued with the 300B in 1956 and a dramatic new body style for 1957.

By the time the alphabet had advanced to F in 1960, there had been extensive revisions, with yet another new body shell that year. Additional styling changes were implemented for the second year of the shape in 1961. The grille had an inverted shape, headlights were redesigned, and the taillights were relocated from the fins to above the rear bumper. Other changes included reshaping the canted tailfins and replacing the (optional) Imperial-like trunk lid with a ribbed panel.

Inside, the revised interior included a 150 mph speedometer, a black finish for all painted sections of the dash and redesigned dash panel padding and seat perforation. Available in both coupe and convertible versions, four exterior colors were cataloged: Formal Black, Alaskan White, Mardi Gras Green, and Cinnamon. Among the 300G's equipment features were chrome wheel covers, a "SilentFlite" fan drive, front and rear armrests, windshield washers and an electronic clock. Numerous options were available including air conditioning, remote-control exterior mirrors, six-way power seat, power door locks, and a "Sure-Grip" differential. Two different Wedge V-8s with "long" and "short" ram tubes were carried over, but a standard axle ratio of 3.23:1 gave the 300G a slight top speed advantage over the 300F.

This stunning 1961 Chrysler 300G Convertible has a long ram 375 horse-power, 413 cubic inch engine and rare Borg-Warner 3-speed manual transmission on the floor. The exterior color of Pinehurst Green has been documented as an original special order color. One of only 337 300G convertibles produced, this car is a powerful statement of both styling and performance. It is also the ultimate expression of the Virgil Exner design era at Chrysler.

The 375 horsepower 1961 Chrysler 300G was a taste of things to come for MOPAR (derived from Motor Parts, but referring to any high-performance Chrysler product). It was flamboyant and modern, from the beautifully conceived and executed instrument panel (below), to the spectacular tailfin (left).

1967 FORD SHELBY MUSTANG GT-500

MODEL: GT-500 | STYLE: TWO-DOOR FASTBACK | SERIAL NUMBER: Z67400CF7A02674

The Mustang came to life thanks to Ford Division General Manger Lee Iacocca who wanted Ford to have a more youthful image. Ford already had the right tools: the compact Falcon platform and a six-cylinder engine for economy and low cost. The company also had a light-weight V-8 that could be tuned for higher levels of performance.

On April 17, 1964, the Mustang was introduced in both coupe and convertible body styles built on the Falcon chassis; a 2+2 fastback followed in short order. Depending upon how it was ordered, a Mustang could be virtually anything for anybody. Equipped with the base 200 cid inline six, the Mustang could be an inexpensive and sporty commuter vehicle with either an automatic for Aunt Bess or a manual transmission for more fun. To boost performance — but not too much — a 260 cid V-8 was available. With that one little option, power would shoot up from 116 horsepower to 164. A bigger 289 cid V-8 was available with a base 195 horsepower, or in states of tune up to 271 horses. Transmission choices included three and four-speed manual gearboxes and the Ford-O-Matic automatic.

All those early Mustangs were fitted with independent front suspension and live rear axles. Ford offered suspension and wheel packages to help the first "Pony" cars handle the more powerful engine options. Unfortunately, with drum brakes the stopping power didn't match the performance.

For most drivers, the Mustang should have offered plenty of performance. But former racer turned car constructor Carroll Shelby wasn't like most drivers. The Texan had already had incredible success with making Ford-powered cars go really fast. In 1963, Shelby had stuffed a 260 cid Ford V-8 into a small British sports car called the A.C. Ace to create the Cobra. The Shelby Cobra was an uncompromising and extremely fast car that became a race winner immediately. Soon, the Cobra graduated to 289 and 427 Ford engines.

Not content to merely offer the Ford-powered Cobras, Shelby decided to work his special brand of magic on the Mustang. By 1965, a buyer could walk into his neighborhood Ford dealer and drive

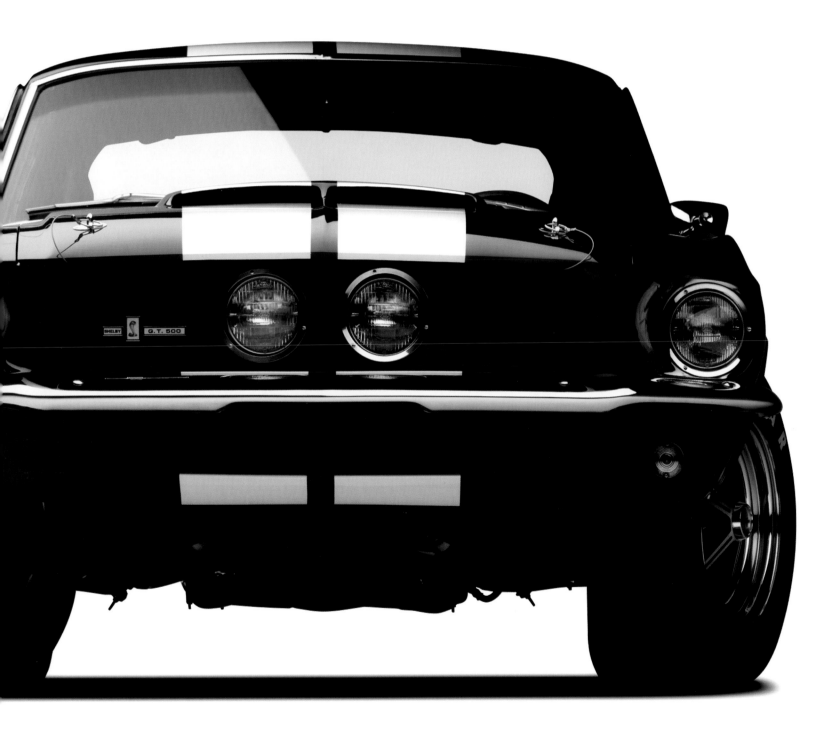

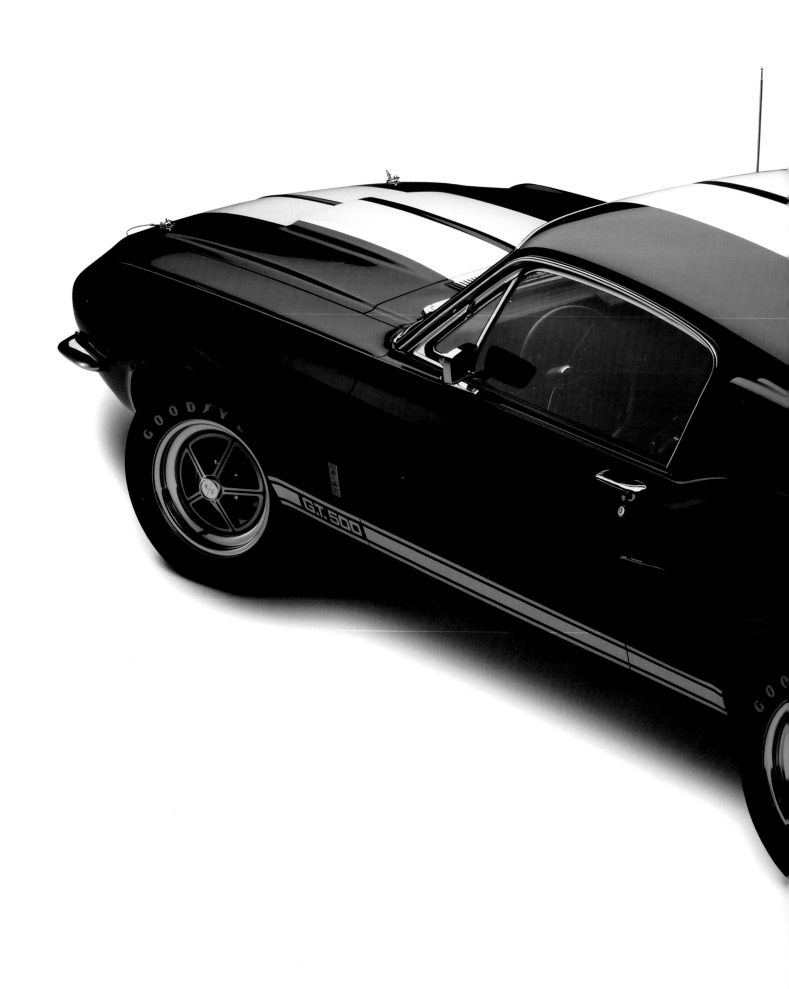

1967 FORD SHELBY MUSTANG GT-500

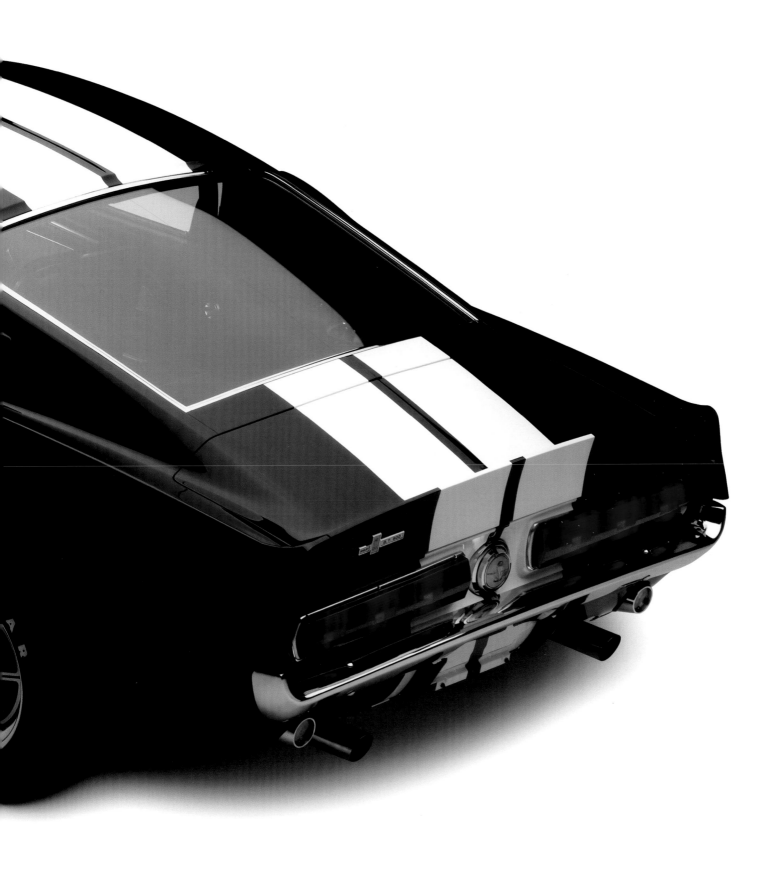

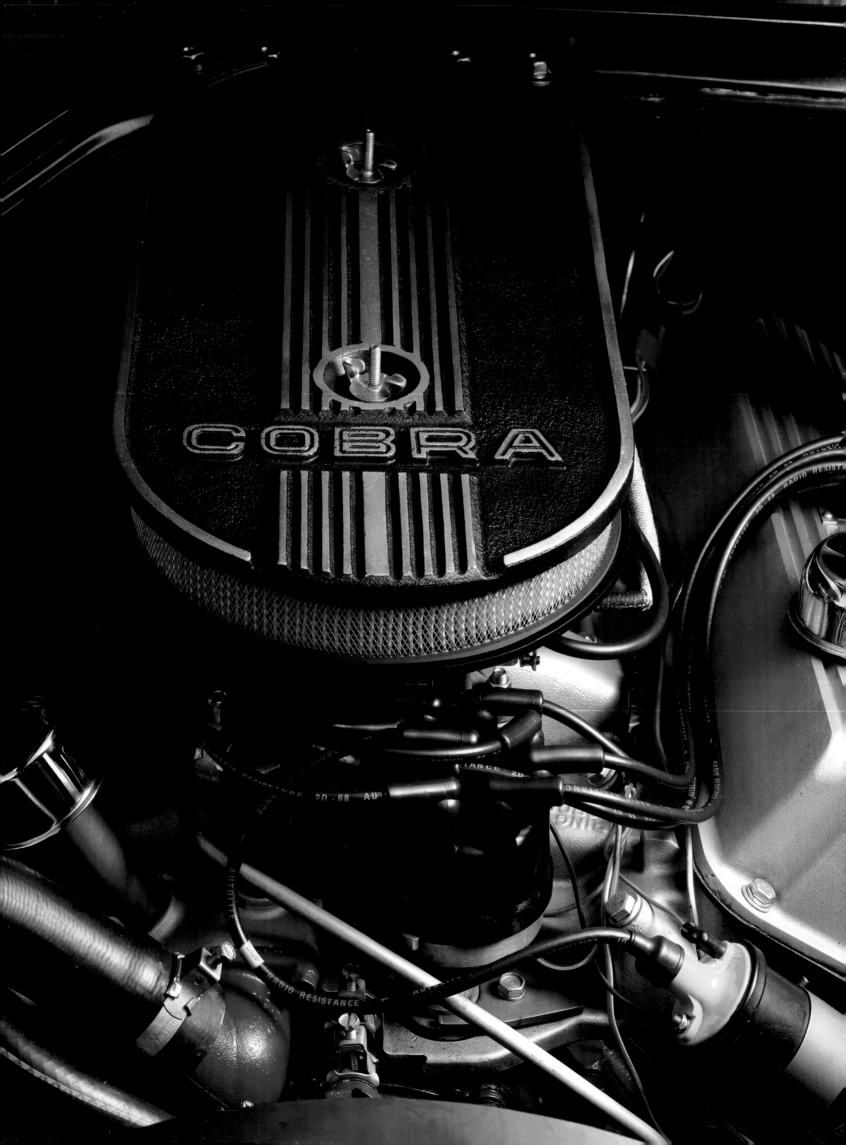

out in a Shelby Mustang with a 306 horse-power engine and an extensively modi-fied chassis and suspension. Externally, the 289-powered Shelby GT-350 looked like a Mustang Fastback with stripes and some other detail differences. Never a huge seller, Shelby sales were boosted by an order from Hertz rent-a-car for 936 GT-350H models — prob-ably the fastest rental cars anywhere.

In 1967, the Mustang grew. It still looked like a Mustang, but it was longer, wider and heavier than the original. The engine range was also bigger than ever. Base Mustangs still came with the six, but in addition to the 289, a big 390 cid engine was available as well.

Shelby adopted the new body shell just as he had the first generation. Air scoops, hood pins, high beams set into the grille and the usual Shelby stripes helped differentiate these mighty Mustangs. For the first time, the 289 cid GT-350 was joined by a big-block Shelby. Instead of the 390, the new GT-500 was fitted with a 425 horsepower 428 cid engine. Straight line performance was formidable, although handling of the nose-heavy Shelby suffered.

This 1967 GT-500 is finished in dark

blue metallic with white Le Mans stripes and a black interior. The 428 cid V-8 is mated to the desirable four-speed manual transmission. It is equipped with power steering and power front disc brakes/rear drums. It retains its original AM radio and rolls on proper Goodyear Speedway F-70/15 raised white letter tires.

With a price tag only $200 more than that of the GT-350, it's not surprising that the big block car outsold the 289 ver-sions 2,050 to 1,175. From 1968 through 1970, the Shelby Mustangs gained a convertible version and continued to be offered through Ford dealers. However, 1967 was the last year that they were actually completed at Shelby American's West Coast facility before Ford took over final assembly. Wherever they were built, the Shelby GT-350s and GT-500s were the ultimate Mustangs — they were fast, looked great and carried the blue oval badge to victory on road courses and drag strips across the country.

The Shelby GT-500 was the ultimate Mustang. It was gorgeous, handled well and had a big 428 cid engine (left). Although they rarely saw road courses, they could be very effective on drag strips across the country.

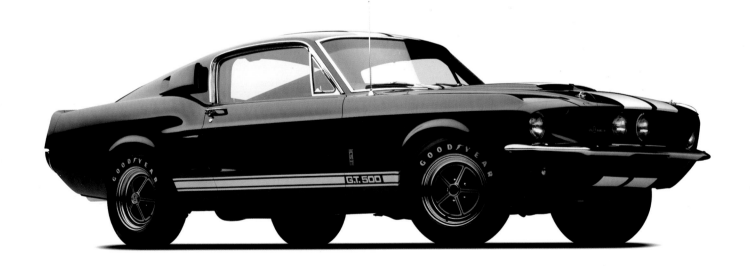

1968 CHEVROLET CAMARO SS/RS CONVERTIBLE

MODEL: 123/124 | STYLE: 67 TWO-DOOR CONVERTIBLE | SERIAL NUMBER: 124678N466872

In mid-1964, Ford's Mustang hit the market and sold 126,538 of its sporty new model in little more than half a year. GM, meanwhile, refused to be left out of the new "pony car" market. Chevy's response was the Camaro, which was unveiled in the fall of 1966 as a 1967 model. Like the Mustang, the Camaro used long-hood, short deck styling. It's sculpting was elegant, but with less lavish exterior detailing than that of the Mustang. It also used a front subframe combined with unit-body construction to provide a more rigid structure and better ride and handling characteristics.

Mechanical specifications were very similar to the Mustang. Front suspension was independent, with a live axle aft. Standard brakes were drums all around, although front discs were standard with the high-performance Z-28 and optional on other models. Engines could be anything from a work-a-day, 230 cid straight-six to any number of V-8s, including 302 (Z-28), 327, 350, and 396 cid. Performance ranged from adequate with the six to positively riveting with the top-rated 375 horsepower

version of the big block. Transmission choices included a pair of three-speed manuals, four-speed manual and both two and three-speed automatics.

Customers of the day raved about the Camaro's solid construction and tight handling. Camaro was available in coupe or convertible body styles and could be equipped with a variety of appearance, performance and luxury options.

One of the very best features of the Camaro was that it took the fight to Ford — on the track and on the street. The rivalry between the two nameplates became legendary and, for most Camaro variations, there was a corresponding Mustang. The exciting facet of that rivalry was the grudge match that took place at every Trans Am race. Sure there were 'Cudas, Challengers and Javelins, but the real racing went on between the front-running Camaro Z-28 of Penske driver Mark Donahue and Mustangs driven by George Follmer and Parnelli Jones. The whole purpose of the Camaro Z-28 with its 302 engine and disc brakes was to win on the track in the Trans Am against the similarly-powered Boss 302 Mustang.

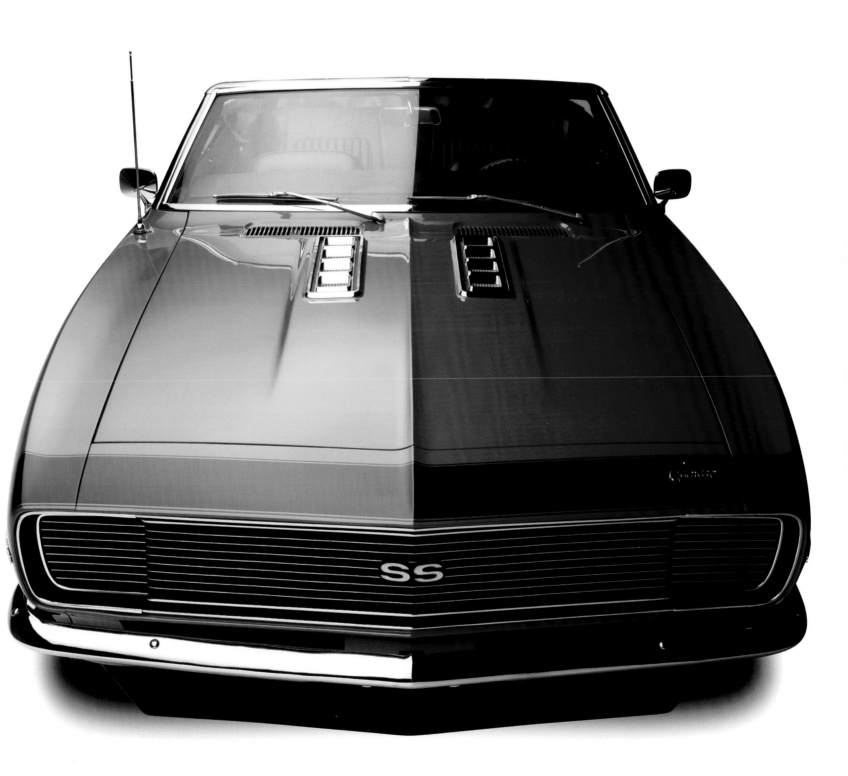

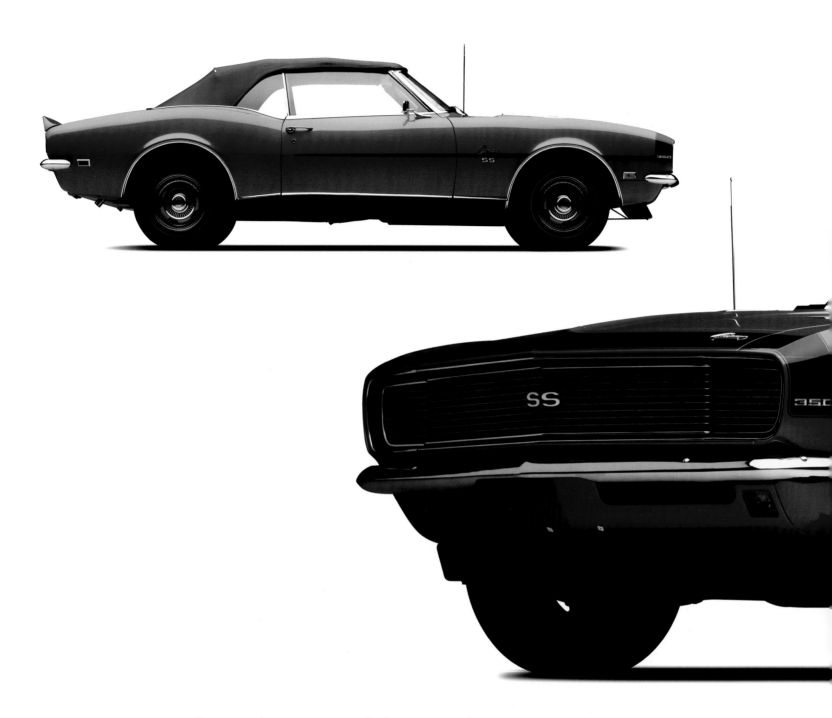

That on-track competition worked wonders for the car's image, as did Donahue's 3 wins in 1967. The following year he dominated the series in a Camaro, with 10 victories out of 13 races. Nobody else even had a shot at the Trans Am championship that year.

Z-28 was the performance package that presented many of the parts needed for competition in the Trans Am series. However, the SS option was favored for high-performance street use. Engine choices for 1968 SS models included a 295 horsepower 350 cid unit or one of several 396 cid mills rated from 325 to 375 horsepower. Springs and shocks were uprated to handle the extra power and — in the case of the big block cars — the extra bulk up front. One of the most desired appearance packages was the Rally Sport, which could be added to any of the other packages. In addition to a variety of interior and exterior trim items, it included covered headlamps, which made it immediately identifiable without even spotting the RS badges.

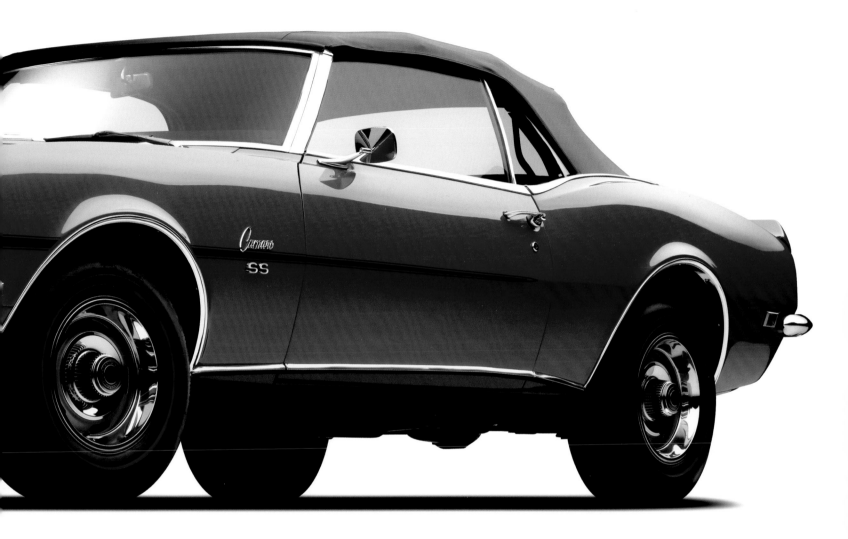

This pristine 1968 Camaro Convertible SS/RS is fully-documented and retains all of its original components, including its L-48 350/295 engine, Muncie 4-speed transmission, 3:31 gears, 12 bolt rear end, power steering, power brakes, tilt wheel, AM radio, "Tic-Toc tack console" with gauges and walnut steering wheel. It has been driven just 68,125 miles since leaving the General Motors' Norwood, Ohio, assembly plant. Finished in its original — and uncommon — Corvette bronze hue, it rolls on the correct Rally Wheels.

The battle between Mustang and Camaro started way back in 1966 and developed into one of the great American automotive rivalries. That rivalry continues today at drag strips, vintage races and Main Streets across America.

In 1967, Chevrolet entered the Pony Car Wars with the Camaro. With the right equipment — like the SS and RS packages and the 350 V-8 — included in this 1968 Convertible, the Camaro was a very potent and desirable car.

1970 PLYMOUTH BARRACUDA "HEMI 'CUDA"

MODEL: FB2 'CUDA | STYLE: BS23 TWO-DOOR HARD TOP COUPE | SERIAL NUMBER: BS23ROB100010

There's nothing unusual about humble beginnings in America. Abraham Lincoln grew up in a log cabin, became a distinguished lawyer and held the highest office in the land. Walter P. Chrysler, on the other hand, started by sweeping the floors in a Union Pacific Railroad shop and ended up as one of the most powerful industrialists in America.

The story of the Plymouth 'Cuda is also a rags-to-riches tale of a sort. In 1960, Chrysler introduced the Valiant, an economy car that was to be a stand-alone brand. Although instantly popular, it became part of the Plymouth model line the following year. One of the least successful of the Virgil Exner era designs, the Valiant was heavily sculptured with creases and fins and all kinds of arguing angles.

Despite looks that were best appreciated by the designers, in the first year the slant-six powered car sold approximately 192,000 copies of both high and low-level lines. With prices starting just above $2,000, it was affordable and reliable. Frugal with fuel, it was also the foundation for Plymouth's most sensational performance car.

When introduced in 1964, the Barracuda was a two-door fastback coupe variant of the Valiant. Standard power for the base Barracuda was the Valiant's optional 225 cid slant-six rated at 145 horsepower. Plymouth's sportiest model was available with an optional 273 cid V-8 producing 180 horsepower. Although named after a fish, the Barracuda actually predated the first Pony car — Ford's Mustang — by several months. Approximately 90 percent of Barracuda owners decided that the plain-Jane six wouldn't do and opted for the V-8. Even strong performance couldn't overcome its blatant economy car origins and the less-costly Mustang outsold it eight to one. Of course, the irony is that the Mustang, too, came from the economy Falcon.

Barracuda continued to develop — but as part of the Valiant line, gaining a more powerful 235 horsepower version of the 273 cid engine in 1965. It continued as the top line Valiant until it was finally emancipated in 1967 and gained a body — and a place in the catalog — all its own. It also grew to three body styles: coupe, convertible and fastback. The shapes

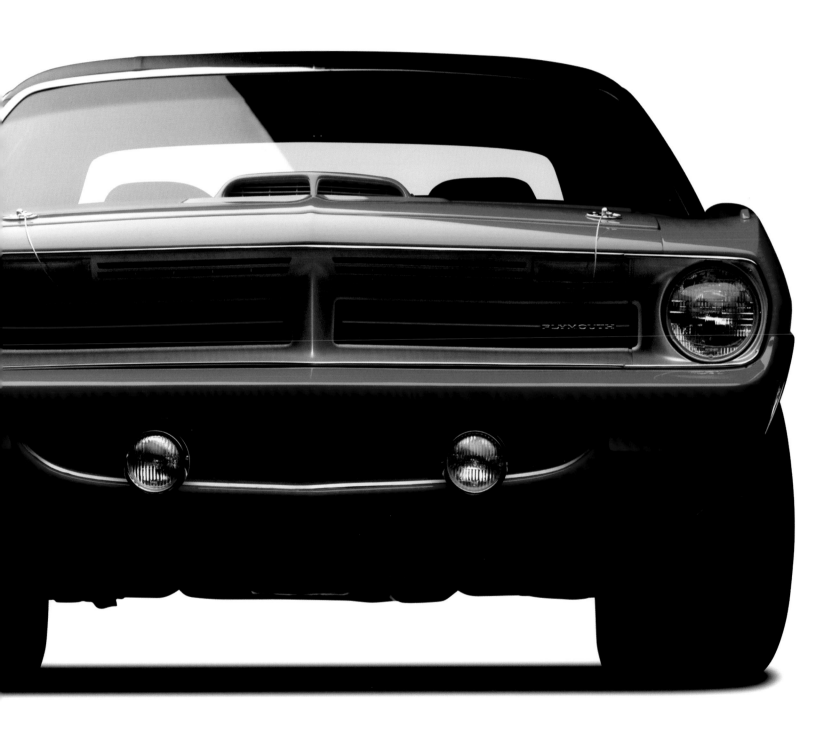

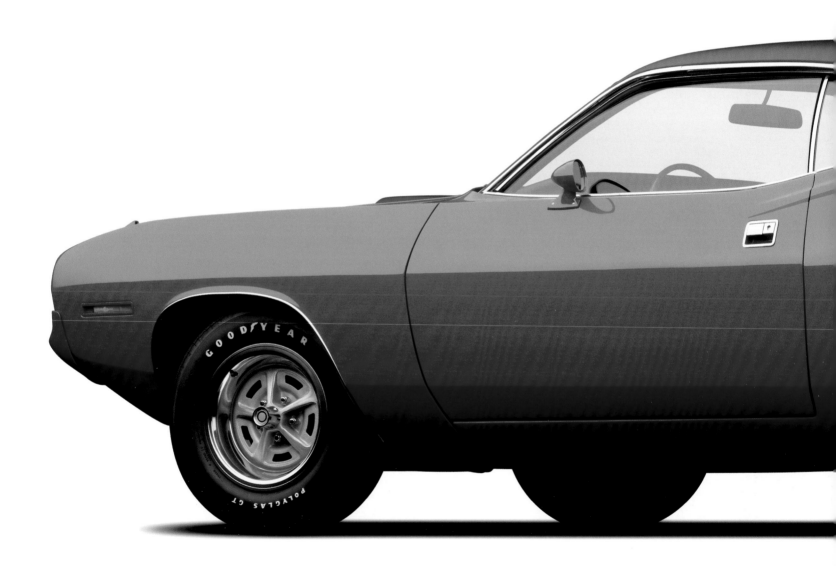

1970 PLYMOUTH BARRACUDA "HEMI 'CUDA"

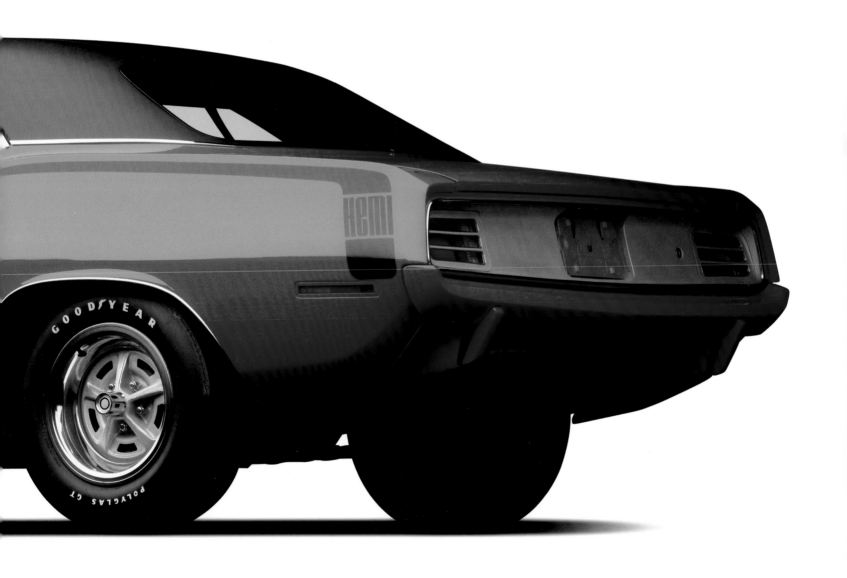

were sleek, clean and quite attractive. The bigger body was also able to accommodate the large Chrysler 383 in addition to the six and the smaller 273 cid V-8.

The Barracuda continued to benefit from development and from the addition of the 340 engine option for 1968. This very effective high-performance engine was rated at 275 horsepower, while the improved 383 was good for a hefty 300 horses. Although a three-speed was standard with all engines, a four-speed manual or Torque-Flite automatic was also available with the eights. Strictly for drag racing, the Barracuda could be ordered with a 426 Hemi which added truly brutal performance — a quarter mile at a time. The 'Cuda finally emerged in 1969 as a performance package for the Barracuda and included graphics, upgraded suspension, four-speed transmission and the 340 or 383 engine.

An even bigger, all-new Barracuda body shell came along for 1970. It was an instant classic with long hood, and short deck styling. Offered in three levels, Barracuda, Gran Coupe and 'Cuda versions, each line offered a coupe and a convertible. Barracuda and Gran Coupes were available with sixes or eights, but the top of the line performance 'Cuda came with V-8 power exclusively.

From its humble days as a Valiant sibling, the 'Cuda had risen to the point where its base engine was a 383 cid high-compression V-8 rated at 335 horsepower. And, that was just the

starter mill. The 440 was available in both 350 and 390 horsepower versions. But that wasn't all — the truly intrepid with the need to go faster could order up the twin four-barrel-equipped 425 horsepower 426 cid street Hemi.

With the Hemi, only a very few road-legal cars could live with the 'Cuda for very long. At the drag strip it would do the quarter mile in 13.10 seconds with a terminal speed of 107 mph.

Whenever a new car enters production, the manufacturer generally builds several pre- or early-production examples to turn over to the press for magazine previews and road tests. During 1970, only 652 Hemi 'Cudas were built, and this car was the second one off the line on the very first day of production. Documented as the "press preview car," this striking red example is one of 368 automatic-equipped Hemi 'Cudas. Trimmed with a black vinyl top and interior, the front bucket seats are upholstered in leather. Other options include a six-way power driver's seat and a center console.

As fast as Hemi 'Cudas were, they couldn't outrun extinction. They were built for just two years before emissions, gas prices and insurance pressures forced them out of production.

Beneath the "Shaker Hood" (top right) of the Hemi 'Cuda lurked the potent 425 horsepower, 426 cid Hemi engine. Polyglas performance tires (bottom right) were hard pressed to cope with all that horsepower and massive amounts of torque.

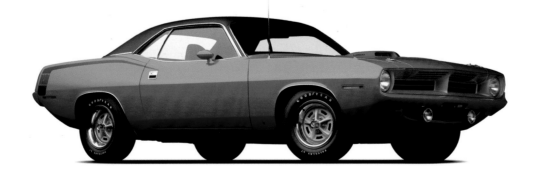

1970 PLYMOUTH SUPERBIRD

MODEL: FR2 PLYMOUTH ROADRUNNER SUPERBIRD | STYLE: RM23 TWO-DOOR COUPE | SERIAL NUMBER: RM23UOA2665361

As of the early 21st century, NASCAR's Nextel Cup racing cars are now tube-frame racers with sheet metal loosely mimicking the cars they're supposed to represent. A Taurus isn't really a Taurus and a Monte Carlo is hardly the one down on the Chevy dealer's showroom floor.

However, once upon a time, stock cars were really stock. Cars could be driven off the showroom floor and raced with relatively few modifications — like roll bars, wider wheels and balanced and blueprinted engines. Those were the cars that NASCAR fans saw race on tracks like Charlotte or Darlington or Daytona. The Chrysler C-300s running in NASCAR in 1955 and 1956 used stock bodies, complete with bumpers, and other chrome trim. Visible modifications included roll cages, protective grille screens, the removal of front lights and wide steel wheels. For a while, NASCAR's convertible division even used ragtops just like those customers could buy.

Teams were limited by the basic equipment that came from the automaker they represented on the track. If the biggest production engine a company had was a 396, then that was all the teams could run. Of course, the automakers could always make available a bigger engine as a special order item to get around the rule restriction. But, gradually, race teams realized that bigger engines and more horsepower could only push a big, heavy — and extremely blunt — object through the air so fast. Regulations also prevented teams from making extensive body modifications or fabricating aerodynamic aids.

Nothing, however, prevented an automaker from shaping a car's body so that "out of the box" it had better air penetration and increased down force. And that's where the Plymouth Road Runner Superbird came in. In 1969, sibling Dodge had great success with the extended nose Dodge Charger Daytona. The higher the speed, the more effective the nose and the rear spoiler became. For 1970, Plymouth decided to follow suit with the Road Runner Superbird.

Although the Dodge and Plymouth looked quite similar, neither the noses nor the rear airfoil were the same. The purpose, however, was identical — to increase speed and stability on

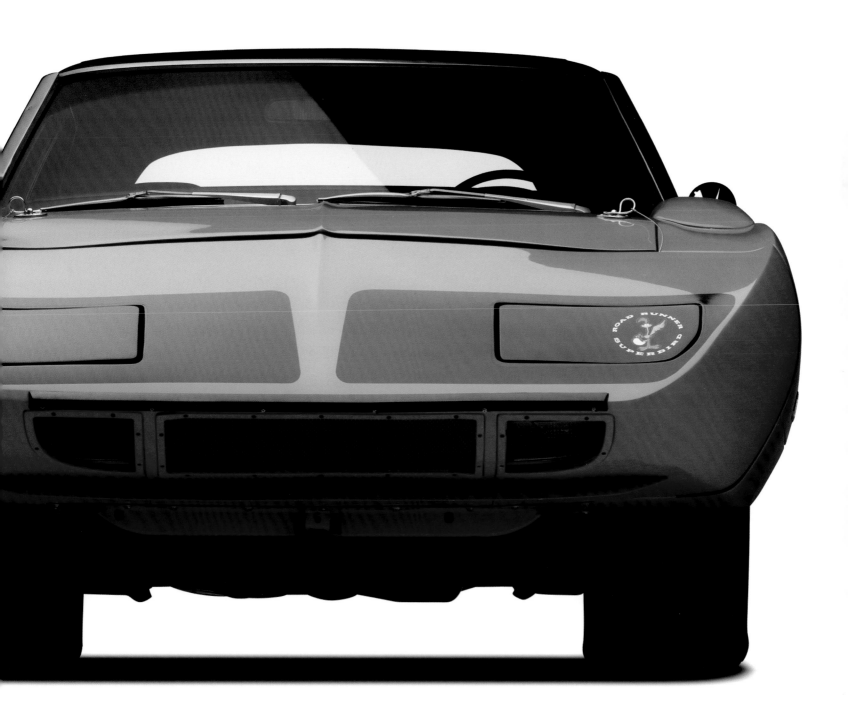

the high-banked super speedways such as Talladega and Daytona. Although Chrysler led the way, Ford soon followed with the 1969 Torino Talladega and Mercury's Cyclone Spoiler II. But the one to beat was the dominant Plymouth Superbird. In 1969, NASCAR stipulated that 500 examples had to be built of any given model for it to be eligible for competition. However, in 1970, Plymouth went one step further with a production run of 1,920 — one for each of its dealers.

Despite tremendous success on the track, the model was made for one year only.

A Superbird was essentialy a Plymouth Roadrunner with 19-inches more of nose, a front chin spoiler and the high-mounted rear air foil. Fenders were also modified and options were extremely limited, with power brakes and steering part of the package.

The base engine for a Superbird or Roadrunner was hardly what most buyers would consider entry-level. The

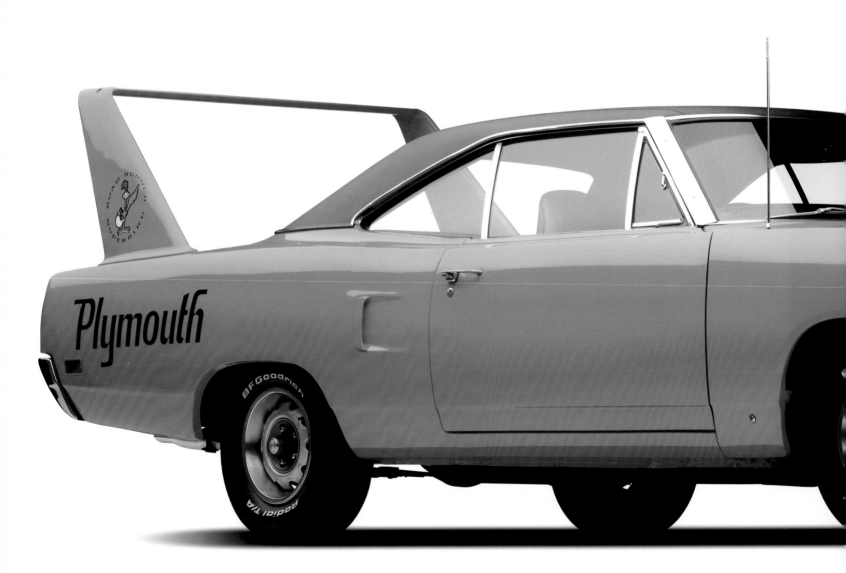

440 cid Commando V-8 with a single four-barrel carburetor was rated at 375 horsepower. With the Six-Barrel (triple dual throat Holley carburetors), power was up to 390 horsepower. For those who wanted more and were ready to pay for it, the 426 Hemi would deliver 425 horsepower. Of the total production run, 665 were Six-Barrel cars and a mere 93 had a Hemi in their engine bays.

From any vantage point, the Superbird is a dramatic-looking car with an incredibly long nose. This car is one of the 1,162 four-barrel 440s. But even with the "base" engine it is an extremely fast example that proves how racing really could improve the breed.

The Plymouth Superbird may have looked wild, but Detroit was finally learning about aerodynamics. The sloping, extended nose (bottom left) helped the car cut through the air and attain a higher top speed on NASCAR superspeedways, while that tall rear wing helped prevent it from going airborne (below right).

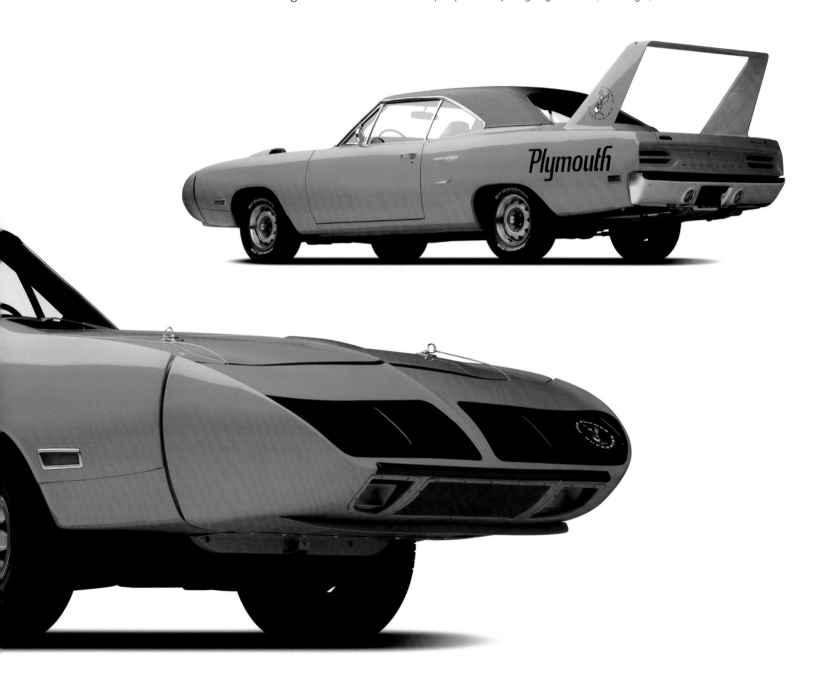

1971 OLDSMOBILE 4-4-2 CONVERTIBLE

MODEL: 442 | STYLE: 4467 | SERIAL NUMBER: 344671M122482

Oldsmobile was early to join the overhead-valve V-8 brigade when it gained the "Rocket V-8" in 1949. Despite that terrific engine with much tuning potential, Oldsmobiles were not usually known as performance cars, despite success in NASCAR and in the Mexican Road Race during the early 1950s. They tended to be bought by successful men and women who wanted a large and comfortable car with enough power to keep up with traffic.

In the styling department, Oldsmobiles were as conservative as most of their drivers. The convertibles were sleek-looking, and the two-door club sedan from 1950 wasn't bad, but the two- and four-door sedans were anything but exciting to look at.

The first heavy dose of style for Oldsmobile came in 1953 when the division received the Fiesta. Sister under the skin to the lovely new Cadillac Eldorado and Buick Skylark, the Fiesta was truly special. It was unmistakably an Oldsmobile, but it looked lower, longer and wider. It was adorned with carefully placed bright trim and two-tone paint schemes. Performance was also pretty good, thanks to the 170 horsepower version of the V-8 from the Olds Ninety-Eight series.

Throughout the later 1950s, Oldsmobile benefited from the adventurous styling coming out of General Motors. Engines were also getting bigger and more powerful, but Oldsmobile cars still tended to focus on comfort and luxury more than on performance. However, before long, Oldsmobile would get a dose of performance that would appeal to an entirely new market segment.

General Motors launched its campaign for the important youth market with the big block Pontiac GTO in 1964. Later in the year, Chevrolet entered the segment with the 327-powered version of the Chevelle Malibu SS, while conservative Oldsmobile also weighed in with its own contender.

The Oldsmobile F-85 Cutlass with the 4-4-2 option debuted in mid-season 1964 as the division's muscle car entry. The designation "4-4-2" stood for four-barrel carburetor, four on the floor and two exhaust pipes. Too late

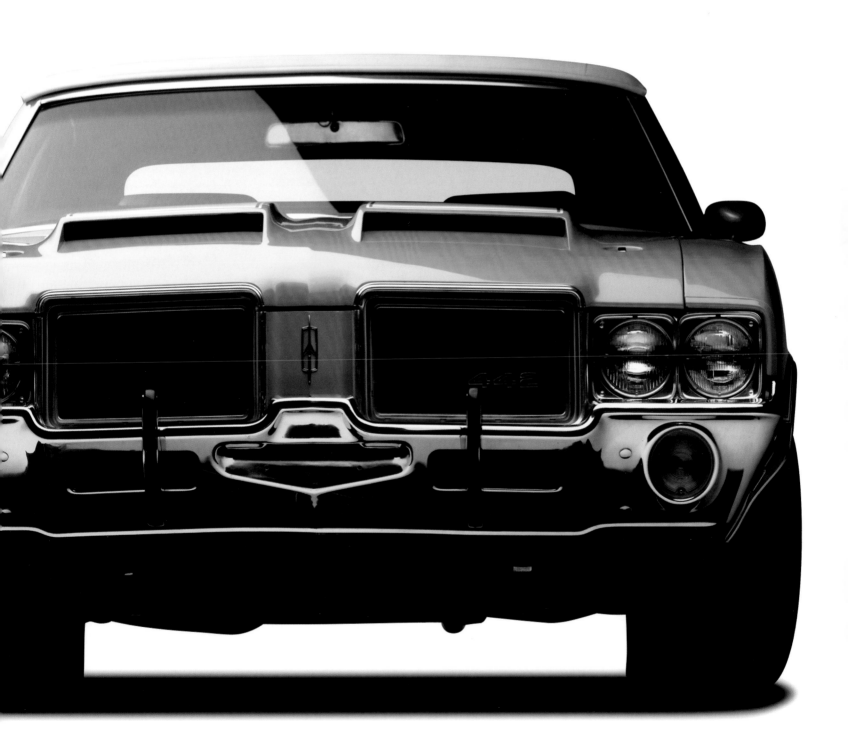

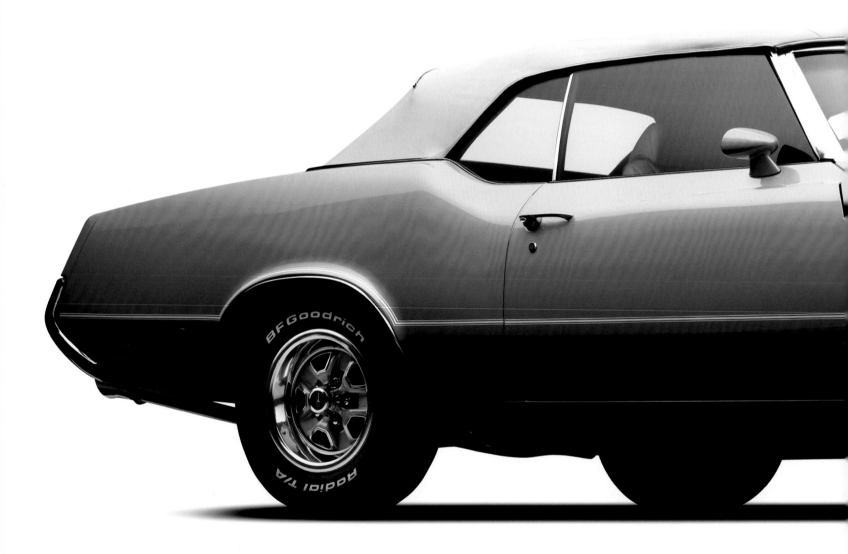

1971 OLDSMOBILE 4-4-2 CONVERTIBLE

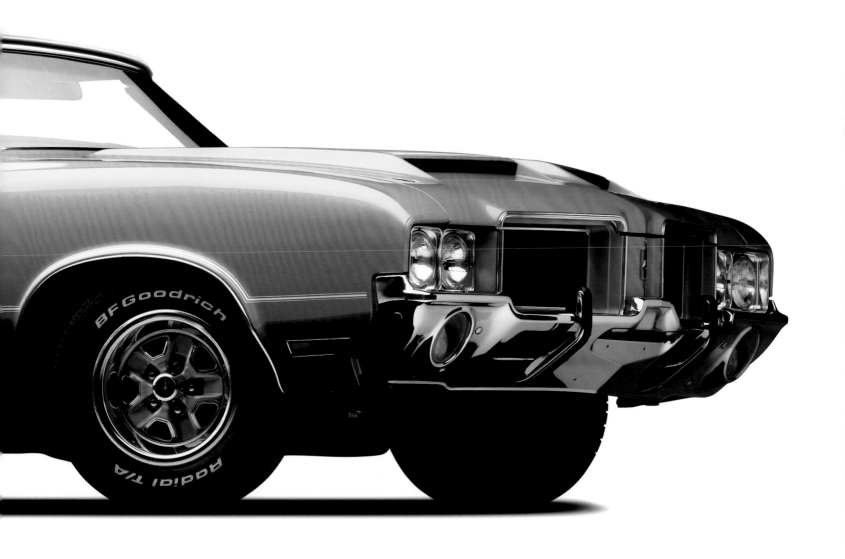

for a spot in the 1964 full-line Olds catalog, the 4-4-2 received little formal fanfare, although word of its powerful features quickly spread. Its 330 cubic inch Jetfire Rocket V-8, 310 horsepower, ram induction with functional scoops on a fiberglass hood and front disc brakes spoke of high performance and speed. Despite little marketing attention, 2,999 were sold in that first partial year.

Not to be outdone by Pontiac's GTO, for 1965 the Oldsmobile parts bin coughed up a mighty 400 cid engine good for 345 horsepower. So equipped, a 4-4-2 was clocked at 5.5 seconds for the sprint from 0–60. The fast Oldsmobile continued to be an option package for the Cutlass until 1968, when it was finally established as a model in its own right. It was a great looking model thanks to a graceful and modern shape. Still based on the Cutlass, it included heavier springs, front anti-roll bar, upgraded shock absorbers and wheels, and all the fancy trim items the marketing folks liked to add for model recognition. Most important, though, was the 400 cid V-8 which used a high 10.5:1 compression ratio and a big Rochester four-barrel carburetor on the way to pumping out 360 horsepower.

That same basic two-door coupe body would do duty in the Cutlass and 4-4-2 lines through 1972. It was attractive, sporty and — with the right equipment — it would scream "performance."

This Saturn Gold 1971 Oldsmobile 4-4-2 Convertible originally sold for a base price of $3,742. It is one of just 1,304 open versions built in the final year that the 4-4-2 was its own model. The Gold Olds retains its original high-torque 340 horse-power, 455 cid V-8 and Rochester four-barrel carburetor. It is equipped with the optional three-speed Turbo Hydra-Matic 4400 automatic transmission with Hurst dual gate shifter and posi-traction rear.

A very fast car in a straight line, some muscle car enthusiasts insist that few of its competitors handled corners as well as the 4-4-2. Sadly, by 1972, the 4-4-2 had returned to being just an option package on the Cutlass. The muscle car era was coming to a close.

Beneath the nostril-like hood scoop (right) of the Oldsmobile 4-4-2 lurked a 400 cid V-8 generating 360 horsepower. Not the fastest of the Detroit muscle cars, some consider it the best handling of them all.

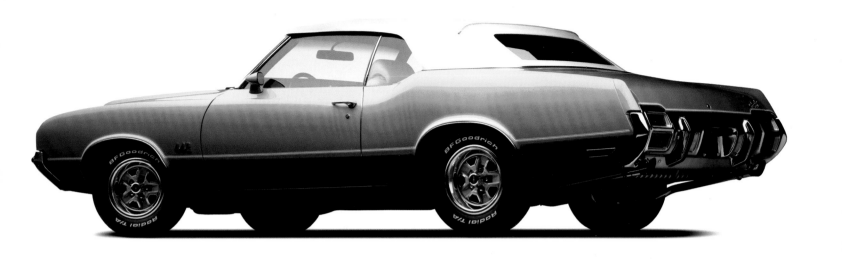

1971 PONTIAC GTO JUDGE

MODEL: 242 GTO JUDGE | STYLE: 24237 TWO-DOOR COUPE | SERIAL NUMBER: 242371P111583

In the mid- to late-1950s, Pontiac was on the ropes in many ways. One of the last GM divisions to get an overhead-valve V-8, Pontiac was about the last company youthful buyers would look to for exciting design and top-level performance. Even the styling motifs — the Indian head and those "Silver Streaks" on the hood had been around for a couple of decades. Thanks to the new V-8 and fresh styling in 1955, Pontiac sales had moved sharply upward. But the sales turnaround was short-lived. By the following year, sales were again slipping.

With sales headed for the basement, Semon "Bunkie" Knudson arrived as General Manager of Pontiac. Early on, he recognized what Pontiac was up against when he commented: "You can sell a young man's car to an old man, but you'll never sell an old man's car to a young man." Not one for idle observation, Knudson brought in top engineers and marketers and began tooling up for performance with what was known as the "Super Duty" group. All sorts of high-performance camshafts, manifolds, pistons and other engine components were being developed by Pontiac engineers for their latest offerings.

For 1959, longer, lower and wider Pontiacs were touted as "Wide-Track." The advertising theme took hold and, thanks to fresh styling with the new split-grille and increased performance, Pontiac was very well received. Two years later, Pontiac earned lots of ink when the new Tempest was named *Motor Trend's* "Car of the Year." The mid-size Tempest evolved into the LeMans for 1963 and would become an ideal performance platform.

That platform for high-performance came along in 1964 as an option package for the 3,400 pound LeMans. Dubbed the GTO, it combined Pontiac's 389 cid V-8 with other performance options and quickly launched Pontiac to the front of the fledgling muscle car movement. Although there had been big cars with big engines — like the Chrysler 300 letter cars — GTO was among the first to offer big engines in smaller, lighter cars. Before long it was heralded by both the press and in popular song, and the GTO quickly became part of pop culture in 1960s America.

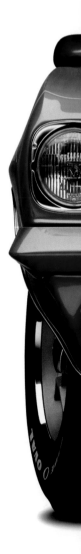

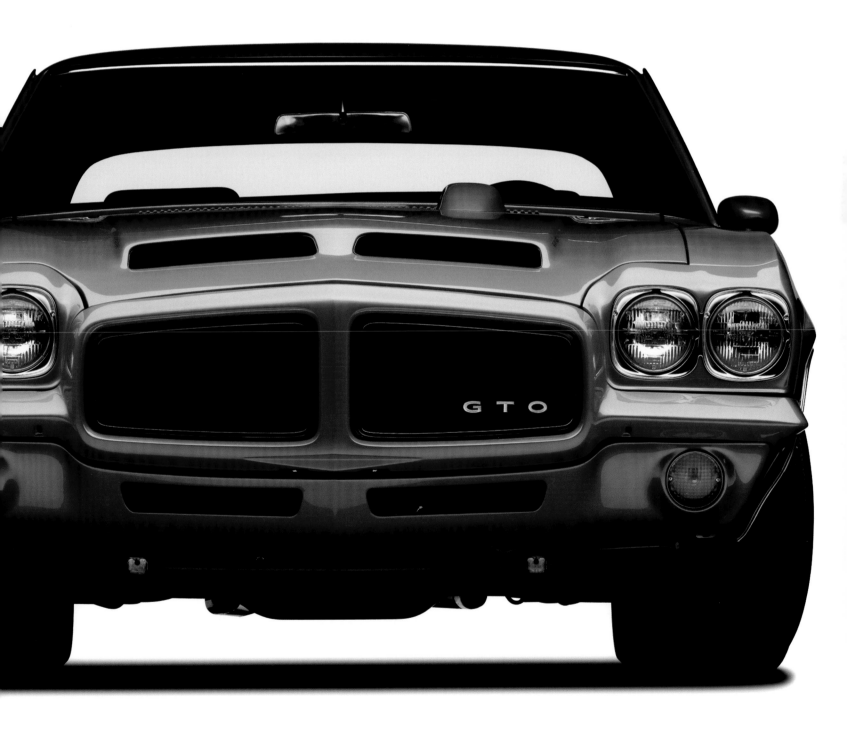

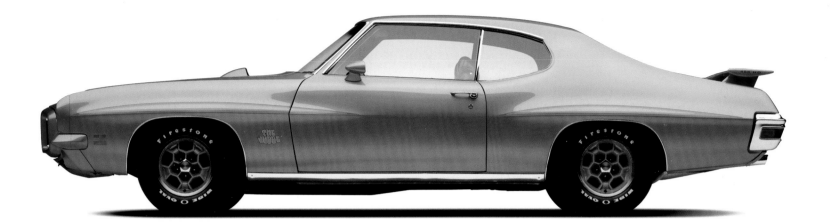

In 1969, the GTO "Judge" was Pontiac's attempt to keep pace with improving muscle cars from Chrysler and other GM divisions. Pontiac General Manager John Z. DeLorean gave the car its unique name after overhearing a popular Laugh-In catch phrase: "Here comes da Judge." Under the hood of the sleekly curvaceous body, the Judge featured a 370 cid engine displacing 400 cid and was available with either a four-speed manual or three-speed automatic transmission. Performance was strong, with a 0–60 time of 6.2 seconds and an elapsed quarter-mile time of 13.99 seconds at 107 mph.

For 1971, the GTO was in its final year as a stand-alone model. It was also the first year of reduced compression as Pontiac began to face up to increasing regulation and the introduction of unleaded gasoline. The standard GTO engine was a 300 horsepower version of the 400 cid mill, while all cars with the Judge option received the big 455 cid engine rated at 335 horsepower. This 1971 GTO Judge is fully-documented by Pontiac Historical Services as one of 357 hardtop coupe GTOs with the Judge option. Finished in Canyon Copper with Dark Sienna interior trim, this Judge is also equipped with the desirable M22 four-speed transmission with Hurst shifter.

The last of its breed, when new, this GTO Judge was sure to be the object of admiration and desire for many a young man. It had all the right stuff: good looks, sterling performance and lots of rubber to leave on the road.

The GTO Judge was everything a muscle car should be: it looked great, had a big 455 cid engine and was incredibly quick. It also had very fine detailing, from the honeycomb wheels (above left) to the delicate wire mesh grille (below left).

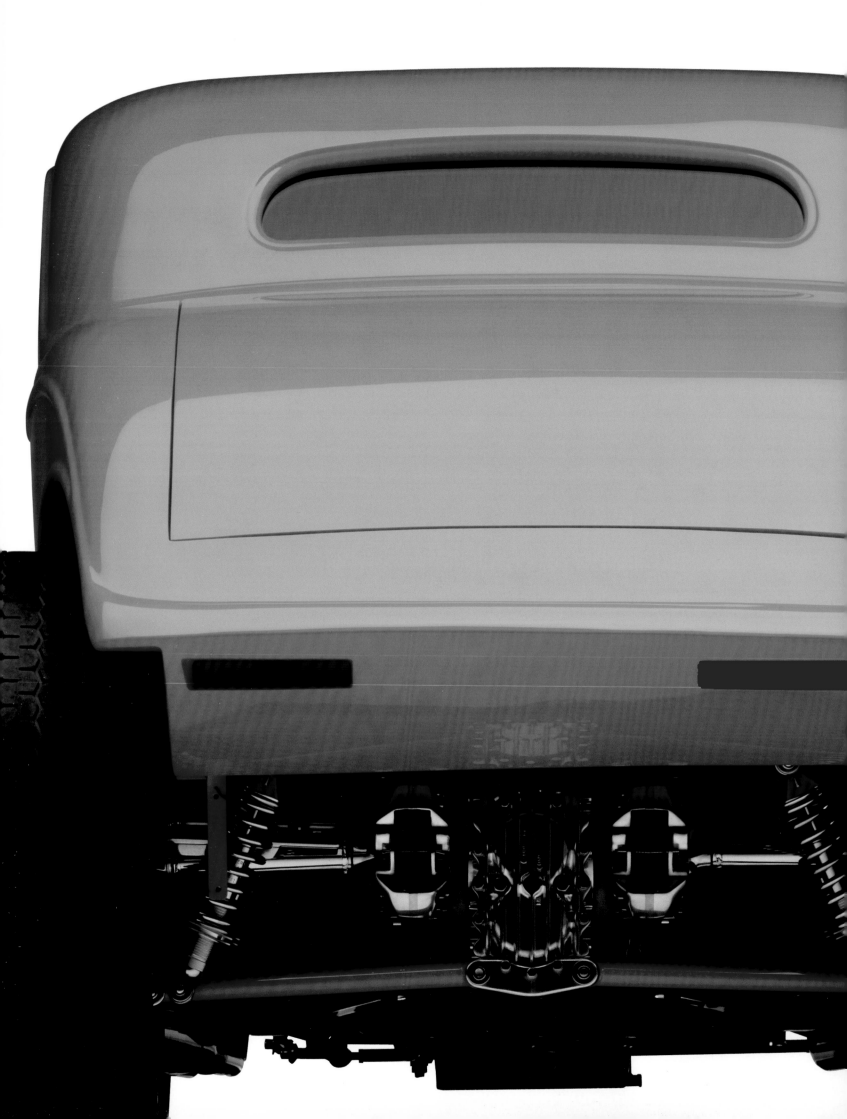

AMERICAN HORSEPOWER

Racing and Rods

As soon as the first automobile rolled into the American consciousness, there was a young man thinking about how he could make it go faster and look better. At first, the easiest way to make a car move more quickly was to remove parts. Without fenders and running boards a car weighed less and the standard engine didn't have to work as hard.

But as long as the automotive population consisted of many different companies producing a limited number of vehicles, modification required an individual approach to every car. That changed with the inexpensive Ford Model T in 1908. With similar cars being built by the tens of thousands, it made business sense for companies to enter the market with performance accessories. Intake manifolds, carburetors, and revised cylinder heads all became available to the back yard mechanic.

The vast numbers of Fords had another effect. Soon there were thousands of cheap used cars on the market that someone with modest means could purchase and start "hopping up" thanks to the ever growing number of speed equipment manufacturers. The trend continued with a vengeance following the Ford Model A of 1928. It proved even more responsive to tuning than the T — plus it started with twice the horsepower. In keeping with the many go-fast items available for the old Model T, soon both overhead valve and overhead camshaft cylinder head conversions were offered for the Model A. It all depended on what the owner had in his mind and in his wallet.

Radical change hit the hot rodders' world in 1932 with the introduction of the Ford V-8. Production built up quickly and soon there were used V-8 Fords as well as the odd wrecked car in junk yards. Before long it was possible to get a cheap flathead engine to stuff into Model Ts and Model As. The effect of pulling the 20 horsepower T motor and replacing it with a 65 horsepower Ford V-8 was dramatic to say the least. More than a few Chevys and even foreign exotics like Bugattis were also repowered by the sturdy Ford V-8.

That flathead reigned supreme with hotrodders until after World War II. At first, overhead-valve Cadillac, Oldsmobile and Chrysler V-8 were selected, but every other engine was just a pretender after 1955 when the Chevrolet small-block V-8 claimed the throne. It was light,

Boyd Coddington

compact and could be tuned to an amazing degree. The high-performance industry immediately focused on the prolific Chevy and, within a couple of years, those V-8s were making well over 300 horsepower.

As Chevrolet developed its small-block, the potential became even greater. The most prevalent of the small-blocks is the 350 cid Chevy, which is available in great supply from scrap yards or over the counter as a crate motor. The 1931 Ford Model A Vicky is a typical example of modern street rodding. Take an old Ford or Chevy, yank the original motor and install a brand new or nicely detailed rebuilt 350 mated to a Turbo Hydra-Matic transmission. Motor and transmission mounts are readily available, along with modern radiator, suspension components and brakes. Cars like the Vicky or the 1939 Chevy Business Coupe can be used every day or for recreational travel and cruising. Other modified cars, such as the single-seat Plymouth have a more focused use — vintage racing or solo drives. Then there are cars like In-Excess, which is a multiple show-winner built for one purpose — winning shows. If driven, the performance would be beyond imagining.

As rodding has become increasingly popular, two American builders have risen above the rest: Boyd Coddington and Chip Foose. If their names are attached to cars, the prices climb much higher than otherwise. As a result, anything they build grabs attention. The Max Hemi may have started with a mundane Dodge Polara, but it is a careful execution of a simple design and had plenty of publicity and television coverage.

Chip Foose

The Mustang Stallion is a different approach to the rodder's art. It's an attempt at limited production of a design that came out of a custom shop. The concept isn't new: it harks back to 1940 when Packard endorsed the Darrin bodies built on its chassis, offered them through dealers and eventually assumed production responsibility. It also serves to mainstream the art of the custom car, much as Daimler-Chrysler did with the Prowler in 1997.

Depending upon the definition of custom or hot-rodded cars, the art has been in practice for 90 years or more. With the interest in street rods, low-riders and customs of all kinds, it's obvious that tuning and modifying production cars — or building one-offs from scratch — is just as important to American drivers as the roads they drive on.

1931 FORD VICKY STREET ROD

MODEL: A | STYLE: TWO-DOOR VICTORIA COUPE | SERIAL NUMBER: W35027

In 1931, Ford's Model A was in the last year of its life. It had been a vast improvement over the Model T, used a conventional manual transmission and had put millions of Americans into their first automobile.

When they rolled out of Ford assembly plants, Model As were fitted with a 40 horsepower flat-head four-cylinder engine and a three-speed manual transmission. Brakes were mechanically-actuated drums on all four wheels. With solid axles front and rear, transverse leaf springs were used at both ends. The Model A was reliable and tough, important traits it inherited from the legendary Model T.

Although 40 horsepower seems like virtually no power compared to modern 150 horsepower economy cars, it was a big step up from the 20 horsepower Model T. However, back in the late 1920s there were plenty of young men who wanted to go faster than Henry Ford intended his Model A to go.

All around the country — but particularly in California — scores of companies began supplying speed equipment to hop up the Model A. There were overhead-valve cylinder heads, dual carburetor set-ups, special exhaust manifolds, stronger crankshafts and pistons of every imaginable shape.

However, in 1932 those 40-horsepower four-cylinder Model As became obsolete overnight. It's true that the new V-8s were sold alongside the four-cylinder Model Bs, but the four-banger was utterly eclipsed by the 65 horsepower Ford V-8.

Those who couldn't afford a new '32 Ford V-8 often had an old Ford and enough money to pick up a hotter engine or some high performance parts. This 1931 Ford Vicky street rod follows many of the same principles that early rodders applied to their cars.

In the 21st century, there are three ways to build a 1931 Ford Model A Victoria street rod: start with a 75 year-old original, buy a new chassis and fiberglass body or go for a new all-steel body. The builder of this 1931 "Vicky" started with an all-steel body and a fresh chassis. Obviously, there was no way an anemic 40 horsepower Ford was going to go under the hinged hood panels.

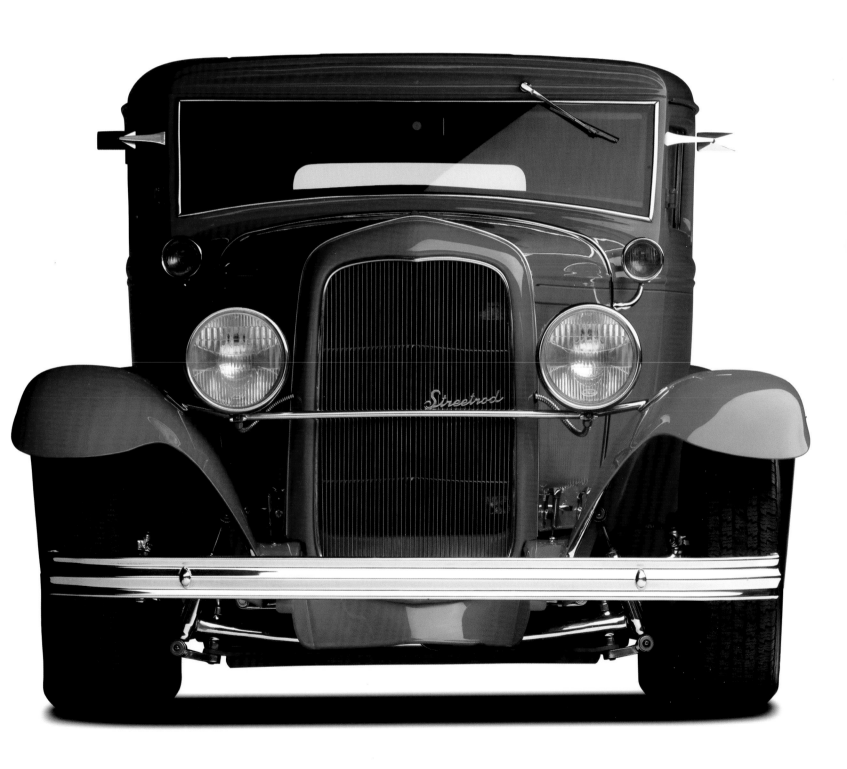

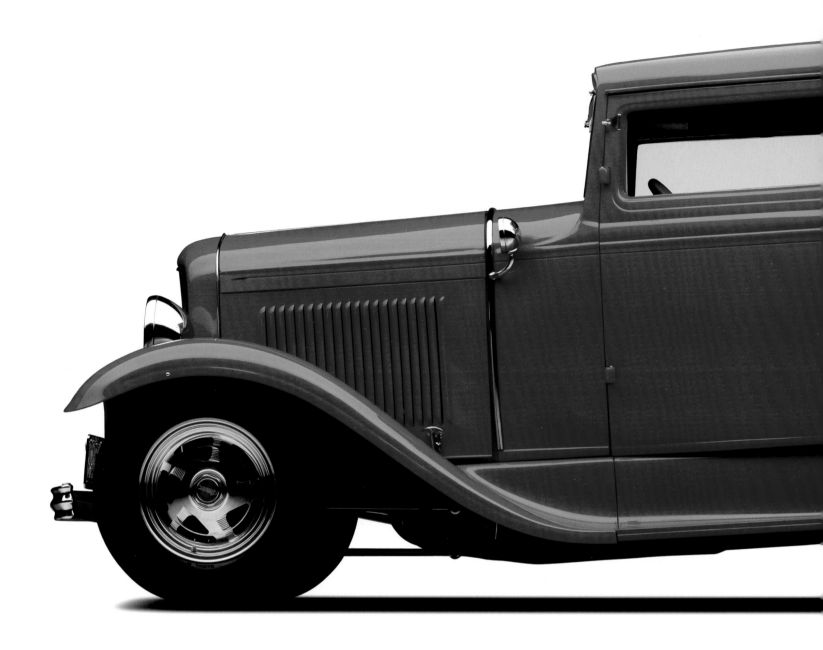

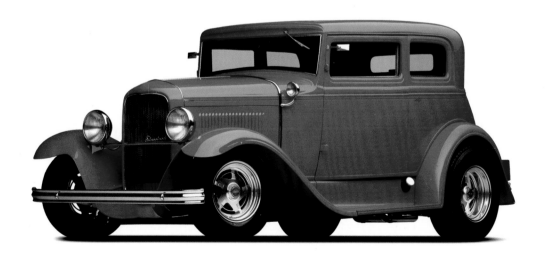

1931 FORD VICKY STREET ROD

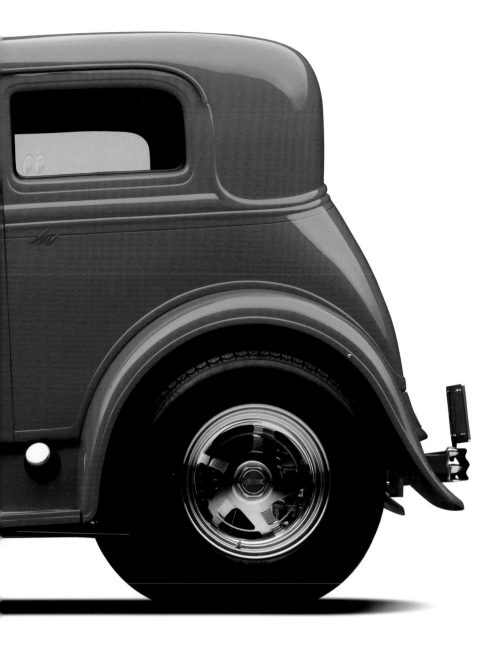

That's where the ubiquitous small-block Chevy literally came in. In the case of this Vicky, the engine was a 350 Tuned Port Injection unit so popular in the 1980s and early 1990s. It was mated to the excellent 350 Turbo Hydra-Matic automatic transmission. A new tubular front end was used with a 1961 Jaguar rear end. Brakes are hydraulic discs all around to provide the stopping power approximately 300 Chevy horses demand.

No question that this Vicky will move out briskly. It also looks terrific thanks to the 2.5 inches chopped out of the roof height to give the car that sinister look. To complete its transformation, beefy Michelin radials on 15-inch Budnick chrome billet alloy wheels lurk beneath the fenders.

Every street rod built is a personal motoring expression. Each of these rods is also proof that Americans like to express their individuality at home, at work and in the cars they drive.

Henry Ford never imagined that one of his Model As could ever look like this. He'd probably be aghast to learn that it was powered by a 300 horsepower Chevrolet V-8 and automatic transmission, not to mention the Jaguar independent rear suspension.

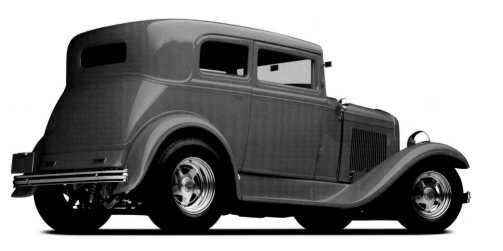

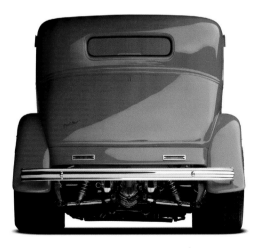

1933 PLYMOUTH RACE CAR

MODEL: NONE | STYLE: SINGLE-SEAT OPEN ROADSTER | SERIAL NUMBER: PC4503

In 1933, Plymouth introduced its first six-cylinder car. Apparently, dealers and customers alike wished they hadn't, although there was nothing fundamentally wrong with the new Model PC. Built on a short 107-inch wheelbase (later stretched by an inch), the new six was mainly criticized for its awkward styling that suggested a mere four-cylinders lurking under the hood.

Sales never lived up to expectations and, mid-year, the PC was replaced by the hastily updated PCXX and PD after 60,000 examples were built. The newer models were built on a longer wheelbase and featured more cohesive and appealing styling, while the 70 horsepower six-cylinder engine soldiered on.

Until 1932 and the advent of the Ford V-8, the foundations for most modified street cars — and many racers — were Ford's Model T and Model A. After 1932, the mighty flat-head was the foundation for most hotted up cars seen on the roads. That doesn't mean there weren't exceptions.

This 1933 Plymouth is one of those exceptions. When it came time to build a "special," the constructor picked a very much unloved car that few people would miss — a Plymouth PC. Although the original body style is unknown, it retains its flat-head, 70 horsepower, straight-six engine and Plymouth three-speed manual transmission. The suspension uses live axle front and rear with leaf springs at all corners. Brakes are hydraulic drums and the gearshift linkage has been specially modified to move the shifter to the right side of the car.

Little is known of this car's early history, but it is believed to have been built in the early 1940s as a "California hot rod" at a time when the Model PC Plymouth was little more than an old car with a very low price. Although the chassis appears to be original Plymouth, it looks to have been narrowed. Definitely a single-seater, the handsome body evokes many of the two-man "junk formula" cars raced at Indianapolis from 1930 to 1937. This formula stipulated that all entries be based on production cars and accommodate a driver and a riding mechanic.

Finished in creamy white with a green frame, wheels and accents, the

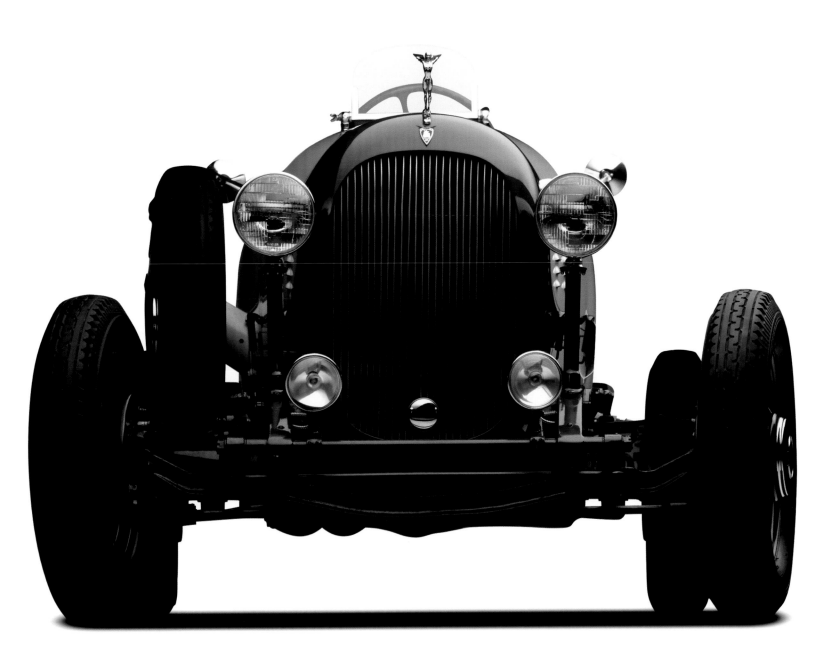

interior is fully-trimmed and paneled in brown leather. From the engine compartment to the chassis, the entire car is well-finished and shows excellent attention to detail. Although it doesn't have a known period racing history, this 1933 Plymouth is proof that a little American ingenuity can turn the most mundane car into a quick, unique and handsome mount for road or track.

Whatever magic was worked on an unloved Model PC happened after it left Walter P. Chrysler's jurisdiction. In contrast to many modified or hotrodded American cars, the body and interior were entirely new, while the engine and drive-train were not far removed from their origins.

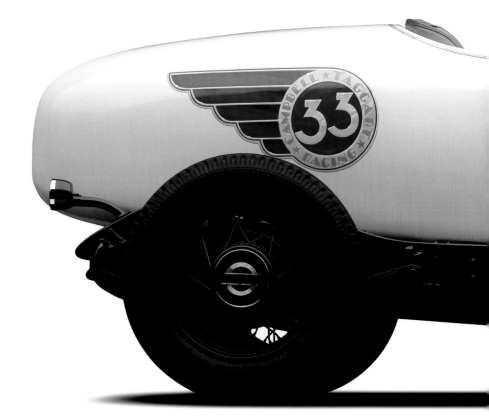

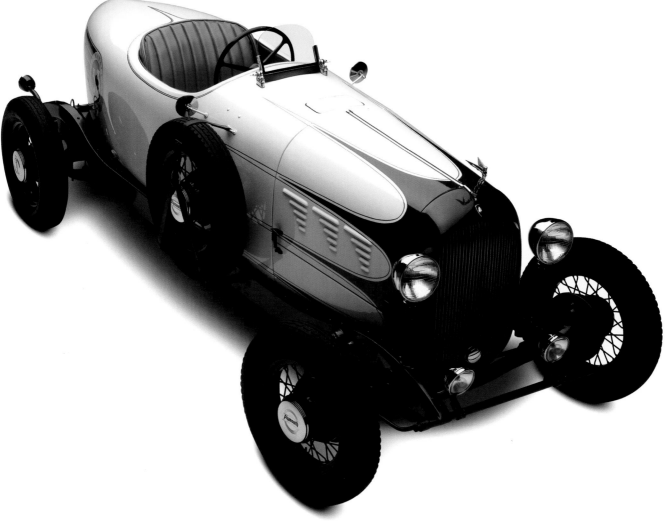

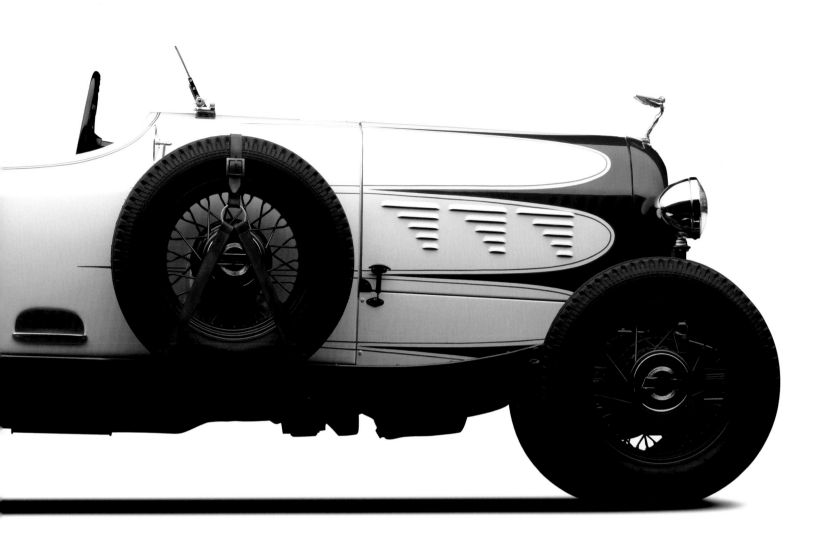

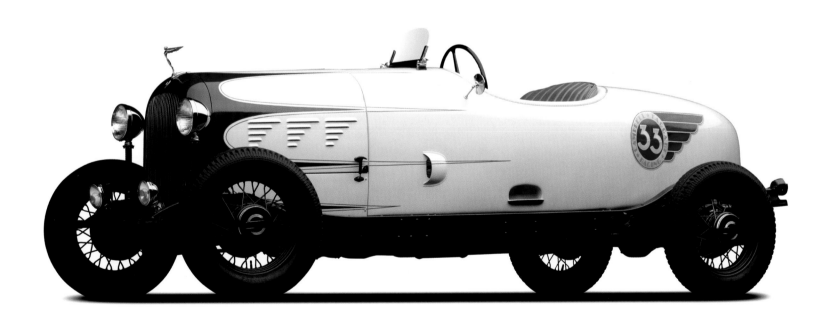

1933 PLYMOUTH RACE CAR

1934 FORD CUSTOM COUPE "IN EXCESS"

MODEL: 1934 FORD V-8 | STYLE: THREE-WINDOW COUPE | SERIAL NUMBER: FD34CPE1992

In 1934, The Ford Motor Company built 26,348 three-window coupes. They were powered by a 221 cid flat-head V-8 rated at 85 horsepower and mated to a three-speed manual transmission. With modest power, sensible trimmings and conservative paint finishes, there wasn't a Dearborn-built '34 that had anything in common with this fire-breathing three-window coupe.

Appropriately named, this '34 coupe is known as "In Excess," which pretty much sums up the scope of the work on this striking orange rod. The starting point was a pair of reproduction frame rails built to stock specifications. They weren't stock for long, with the addition of another foot of length. Those frame rails were also boxed and smoothed and fitted with a rectangular H member. A chrome moly dropped tubular front axle was fitted to the front of the frame, along with early Ford spindles and custom fabricated steering arms connected to a Mullins billit steering box. Front damping was the responsibility of Aldan aluminum coil over shocks. Out back, a Halibrand quick change independent

rear axle assembly was used in conjunction with Carrera coil-over shocks.

To finish chassis preparation, Wilwood vented disc brake rotors sit inside each classic-looking Cragar SS alloy wheel. Those very light and extremely effective brakes are actuated by a Wilwood dual master cylinder.

Instead of the usual small-block Chevy found in the average street machine, the builders of this stunning three-window coupe opted for keeping everything in the Ford family. They fitted a Boss 429 engine punched out to 433 cid. The heads were fully ported, the Boss 429 crank was nitrided and cross-drilled, while a Canton oil system was installed along with a Lunati flat tappet camshaft. But what really catches the attention is the massive Kuhl 14-71 60 degree Roots-type supercharger and a custom-built Fowler blower drive assembly. All that power — some 1,000 ground-shaking horsepower — reaches the rear wheels through a competition C-6 automatic transmission with a Hurst shifter.

The Downs fiberglass 1934 three-window coupe body has had a full

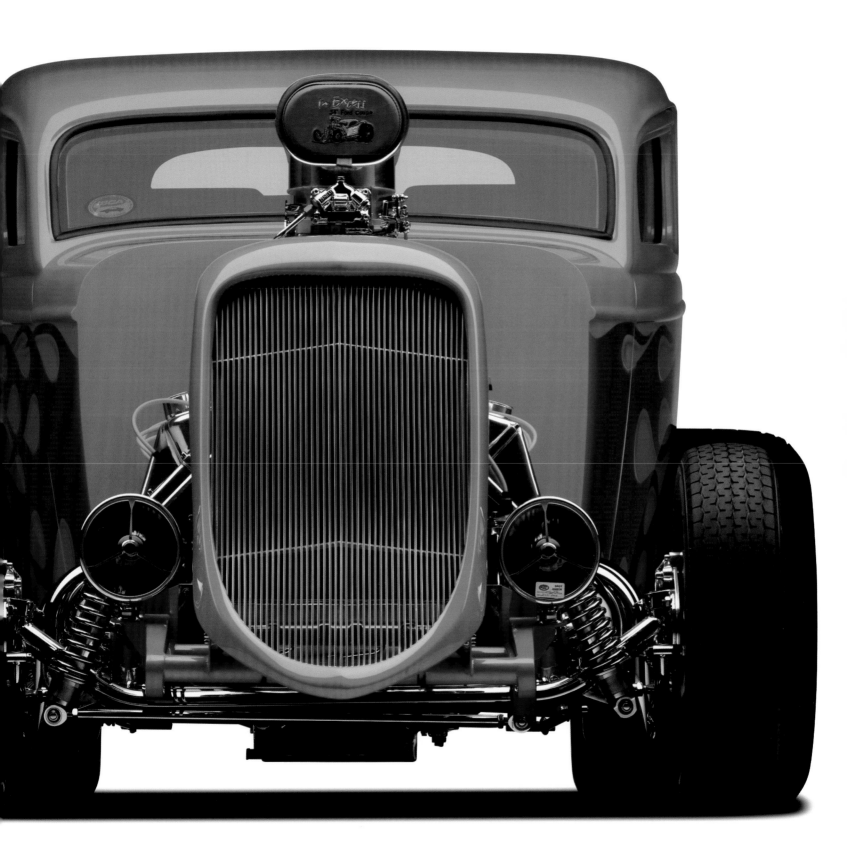

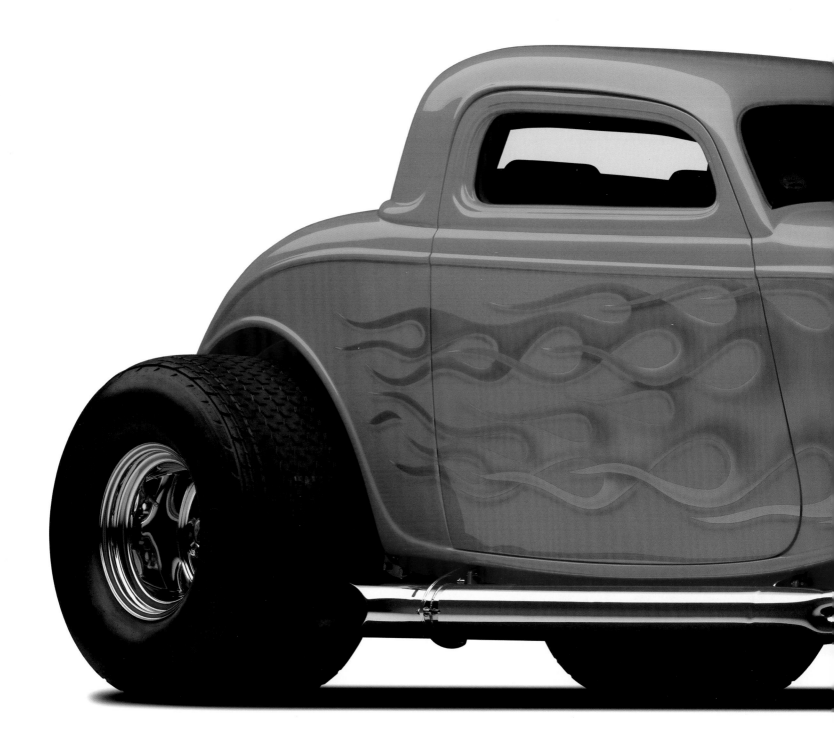

1934 FORD CUSTOM COUPE "IN EXCESS"

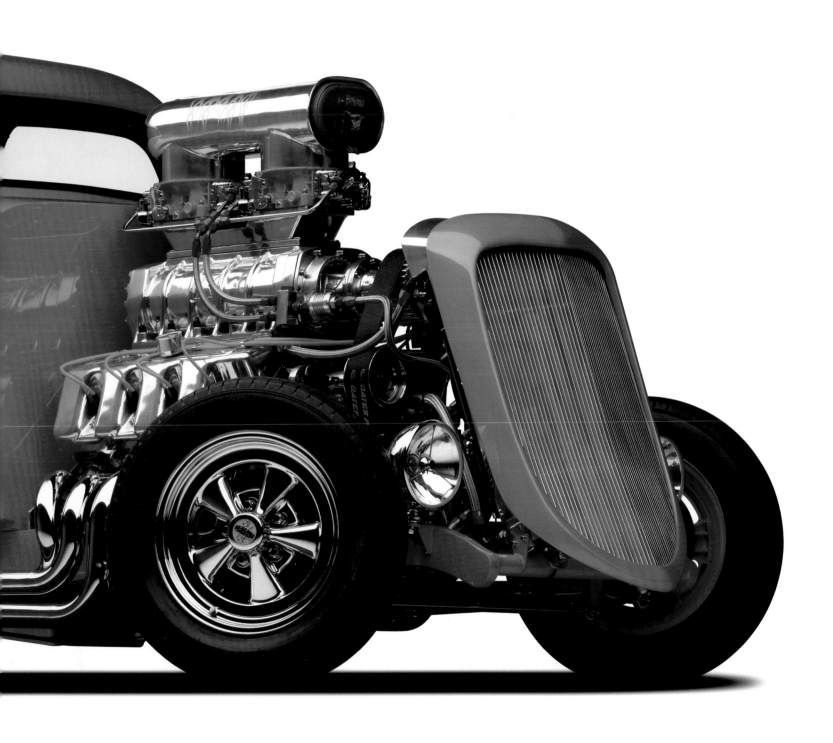

three inches chopped out of it and the door hinges are completely hidden. Thanks to the huge Hoosier rear tires, the entire car is aggressively raked forward. But the most striking part of the entire car — after that massive blower — is the metallic pearl Tangelo Orange paint with pearl silver flames.

Open the doors and note the interior features a smoothed dash laden with Automater phantom gauges seen through a Billit Specialties steering wheel mounted on a Billit steering column. The Pontiac Fiero bucket seats and the interior is trimmed in beige leather and fabric. Like so many street rods, *In Excess* is fitted with a monster stereo system that still has no hope of drowning out 1,000 horsepower of supercharged Ford with open headers.

A multiple award winner, *In Excess* is the International Show Car Association SCA 2003 International Rod Champion. This tangerine monster shows what a massive supercharger, a truck-load of imagination and a lot of effort can achieve.

There's very little '34 on this 1934 Ford, although unlike many Ford Street Rods, power actually comes from the blue oval, in the form of a highly-supercharged 428 cid engine (right). The transverse leaf springs Henry Ford swore by are long gone, replaced by and coil-over shocks (above).

1939 CHEVROLET STREET ROD

MODEL: MASTER 85, SERIES JB | STYLE: BUSINESS COUPE | SERIAL NUMBER: 1JA0426059

The business coupe style became popular in the 1930s, when an increasing number of traveling salesmen took to America's ever-expanding roadways. Their cars needed to be inexpensive, accommodate one or two people and carry product samples and luggage for a week or two at a time. In addition to a capacious trunk, most business coupes had a large luggage platform behind the single bench seat. An additional requirement for any business coupe was that it needed to be reliable and relatively economical to run and maintain.

Chevy's base coupe sold for just $628 in 1939 and was the least costly — and lightest — model in the Chevrolet product line that year. It was powered by a sturdy overhead-valve, 85 horsepower straight-six engine and fitted with a three-speed manual transmission. Stopping duties were the responsibility of four-wheel hydraulic drum brakes. Thanks to a weight of just 2,780 pounds and those 85 horses, as a side benefit the Chevy offered reasonable performance on top of its other merits.

With their rounded tops and lack of

a back seat, business coupes are favored platforms for many street rodders who simply don't want to build up a family-sized car. This nicely-executed all-steel Chevy street rod uses the silhouette of a 1939 Chevrolet Master 85 business coupe.

With the exception of the body shape and basic chassis, there is little remaining that harks back to that original 1939 Chevy. The straight-six and three-speed "tranny" are long gone, replaced by a 454 cid Chevrolet big block mated to a Turbo Hydra-Matic automatic transmission. That big block has been balanced, blueprinted and fitted with a performance cam. Cooling is handled by an all-aluminum radiator and the exhaust leaves by way of a Flow-Master large diameter exhaust system.

The original '39 Chevy front suspension was removed from the stock frame, to be replaced by front end components and suspension from another rodder's friend — a Ford Mustang II. Suspension is further augmented by sway bars to help the now nose-heavy Chevy corner flat. Gone, too, are the original drum brakes, which were replaced by power-assisted

1939 CHEVROLET STREET ROD

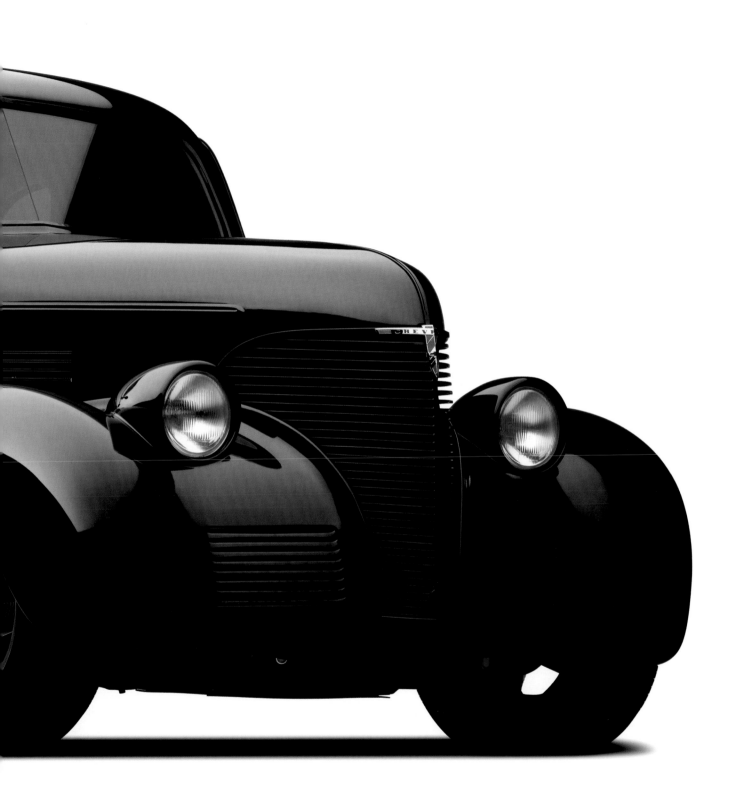

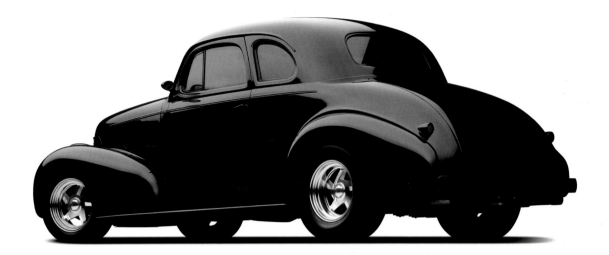

discs. With such a heavy mill up front, steering effort is greatly reduced by the use of power steering. The entire package rolls on handsome Budnick billet wheels fitted with aggressive modern rubber.

Body modifications include head-lights molded into the front fenders and custom running boards. The rear bumper is smoothed and moved closer to the body. This Chevy street rod is finished in a color favored by many rodders — basic black. The interior is fitted with a pair of bucket seats and is trimmed in beige leather and cloth.

There is no such thing as a typical street rod, although most street rods combine classic looks with modern performance and drivability. Thanks to the period Chevy coupe silhouette and the well-proven and potent 454 engine and transmission combination, this rod has what it takes to cruise effortlessly in style wherever the road may take it.

This Chevrolet displays two things that rodders have loved since almost the beginning of time: the business coupe body style and basic black. Few rods look better than when they're painted black. In fact, even the grille on this '39 Chevy has been blacked out.

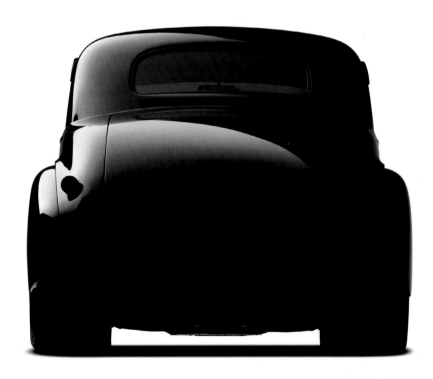

1963 DODGE POLARA "MAX HEMI" CUSTOM COUPE
BY BOYD CODDINGTON

MODEL: TD2H POLARA | STYLE: 622 TWO-DOOR HARDTOP COUPE | SERIAL NUMBER: 6432170771

Through the 1950s, all cars built by Dodge were full-sized cars. But that changed in 1960. With the introduction of the Dart, the company had two model lines. That didn't mean that the Dart — with a 118-inch wheelbase was a small car. It was simply a smaller car. The full-sized Dodges wore the Matador and the Polara nameplates, with the Polara being the top model.

The evolution of the Dodge lineup continued in 1961. The compact Lancer series was added beneath the Darts and the Polaras remained on the top of Dodge's world, a place it would continue to hold into 1963. That year, the Polara series was offered in four body styles: four-door sedan, two-door hardtop coupe, four-door hardtop sedan and two-door convertible. Both the coupe and the convertible were also offered in top line Polara 500 trim.

Dodge built fewer than 40,000 Polaras for 1963; only 2,200 used the plebian 225 cid slant-six, while the rest were powered by a variety of V-8s. The smallest of the options included three versions of the 383, ranging from 265 to 330 horsepower. The bigger 426 Hemi

came in 410 and 425 horsepower versions. A three-speed manual transmission was standard, although a three-speed TorqueFlite automatic was optional. Front suspension was independent and a live axle was used in the rear. Drum brakes were fitted at all corners.

When the "Max Hemi" Polara was built in 2005 and televised on The Discovery Channel's *American Hot Rod*, 17-year-old Max Cohen was suffering from acute lymphocytic leukemia. The high school student's primary interest was in designing cars and motorcycles. To make his dreams of custom cars into reality, Make-A-Wish Foundation worked with the newly-founded Boyd Coddington Foundation to grant his wish — to design a custom car to be built by Boyd Coddington's Garage in La Hambra, California.

When Max first flew from his home in Illinois to meet with Coddington and his crew, he had a basic concept for a custom to be based on a 1963 Polara. At first glance, it seemed like an odd choice, but the Polara would be inexpensive to source and would serve as a unique

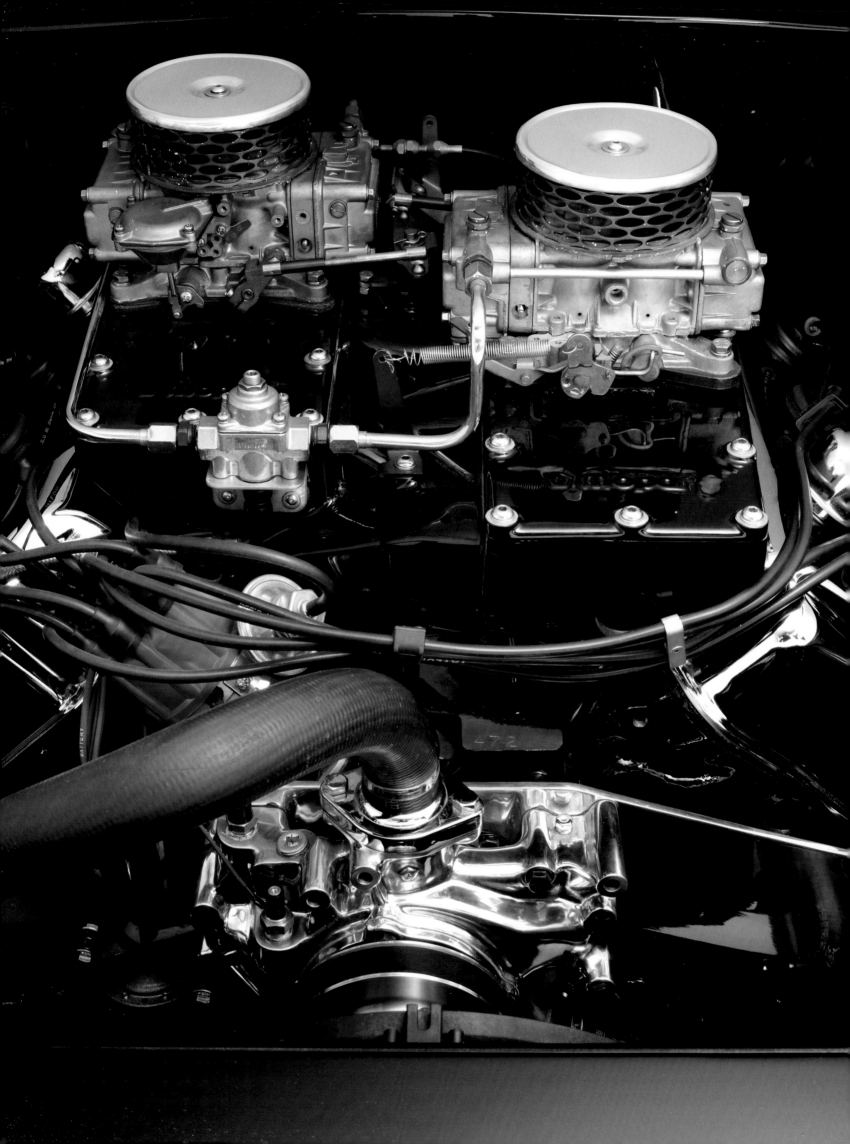

foundation for a high-profile street machine. He envisioned a car virtually free of bright trim and finished in the toughest color of them all — basic black.

While the shop's designers were working on sketches, Coddington located and acquired a 1963 Dodge Polara two-door coupe through eBay. The decision as to how to power the creation was easy — plop in the biggest, baddest crate Hemi Chrysler could supply and mate it to a TorqueFlite automatic transmission. Because the Hemi-powered street machine was being built for Max Cohen, the name "Max Hemi" came naturally.

The car that arrived at Coddington's shop was far removed from the six-passenger coupe that left the Dodge assembly plant way back in 1963. It wasn't particularly rusty for a car of its age, but it had been modified and painted on several occasions. The Polara was immediately disassembled to the unibody and sent out for media blasting to both remove the paint and show where rust had taken hold. The next step was to replace the rotted panels, fabricate wider inner wheel wells and a new firewall. It was also fitted with new radiator and motor mounts, as well as a front subframe and suspension able to handle 525 Hemi horsepower and 540 pound-feet of torque.

Working from a bare shell, the car had to be smoothed, filled and painted in record time as the television cameras recorded every phase. Because the car was going to be finished in black, the bodywork had to be absolutely perfect or it would show every wave and dimple. Along the way, Max Cohen was also invited back to work on "his" car, which really was a dream come true for the young man.

With the fresh paint gleaming, the car was trucked to Gabe's Street Rods & Custom Interiors. There, a complete custom interior — in classic red leather to contrast the black exterior — was sewn and installed in just three days.

Back at Boyd Coddington's Garage, final assembly was completed and the mighty Hemi was fired up for the first time. Coddington himself took it for the maiden drive with a very happy Max Cohen by his side.

On August 27, 2005, the Max Hemi was unveiled at a Hot Rod and Custom Car Show at Coddington's garage. After making the rounds of many other shows, the one-of-a-kind Max Hemi was sold at the 2006 Barrett-Jackson Scottsdale auction. When the gavel fell, all of the proceeds of the sale went to the Make-A-Wish Foundation to help fund more dreams for critically ill youths.

The heart of this 1963 Polara built by Boyd Coddington's Garage is a 525 horsepower crate Hemi breathing through a pair of four-barrels. But the heart of the project came from Max Cohen, a young man whose dream came true thanks to the Make-a-Wish Foundation and the Boyd Coddington Foundation.

1963 DODGE POLARA "MAX HEMI" CUSTOM COUPE BY BOYD CODDINGTON

2006 FORD MUSTANG "STALLION" CHIP FOOSE CUSTOM

MODEL: MUSTANG | STYLE: TWO-SEAT COUPE | SERIAL NUMBER: 001

Ford's Mustang had humble beginnings. Although the sporty two-seat bodywork was new and fresh, the platform on which it was built was essentially that of the Falcon economy car. Like the Falcon, the base engine was a straight-six mated to a three-speed manual transmission. However, many V-8 variations were offered through the life of the Mustang.

The Mustang grew bigger in 1967 and more aggressive-looking in 1969. Some would say that the greatest Mustangs of them all were the high-performance Boss 302, 351 and 429 models of 1969 and 1970. Of course there was the smaller and less potent Mustang II of 1974 through 1978 and the long-lived and very successful Fox-platform Mustang that was built from 1979 through 2004. With that last batch of Mustangs, the model clawed back a good bit of performance thanks to a pair of Turbo-charged fours and a wide range of V-8s. Those eights included the venerable 302 cid overhead-valve unit, a 4.6-liter single-overhead cam engine and one with twin cams per cylinder bank.

For the all-new 2005 Mustang, Ford pulled much in the way of design influences from the 1969 and 1970 Boss series and Mach 1. Although the exterior was decidedly retro, the underpinnings were entirely new for the first time in 25 years.

The new chassis structure used MacPherson struts for the independent front suspension and a three-link live rear axle. Stopping was handled by power-assisted vented disc brakes front and rear. Power came from either a 4.0-liter single-overhead cam (SOHC) V-6 rated at 210 horsepower or from a 300 horsepower version of the SOHC V-8. Powered by the V-8, the 3,500-pound Mustang GT would scramble from 0–60 in a very quick 5.5 seconds.

Nationally-known custom car builder and designer Chip Foose saw the Mustang shape as an excellent starting point for his own take on the legendary American pony car. Although Foose retained the basic Mustang shape, he changed the look by redesigning the front and rear fascias, grille, rear lighting and hood. He also added C-pillar ducts, revised side marker lights and a new rear spoiler of his own design.

To alter the stance of his new "Stallion," he changed the springs and

2006 FORD MUSTANG "STALLION" CHIP FOOSE CUSTOM

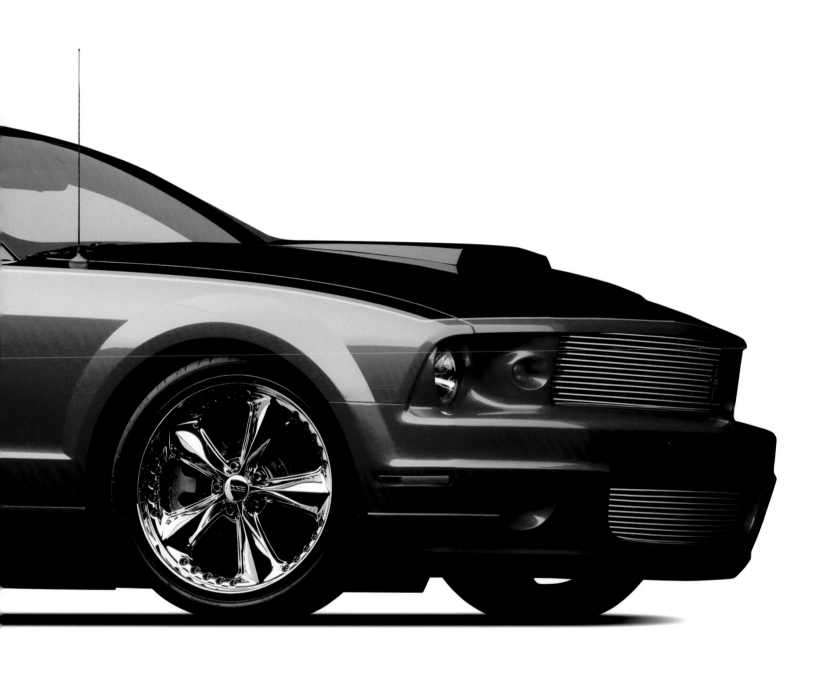

shocks and fitted 20-inch Foose wheels with sticky BF Goodrich tires. He also fitted a strut tower brace to stiffen the chassis and billet rear trailing arms. Stopping was enhanced by the use of Baer Brakes four-piston front calipers with cross-drilled Eradispeed rotors front and rear. Although the engine wasn't altered internally, output was increased to 325 horsepower by the use of high-flow air filter and a free-flowing exhaust system from the catalytic converter's back.

Foose's shop was well-equipped to build a single custom car or rod, but it wasn't set up to accommodate a production run. As a result, he partnered with Unique Performance to assist in the engineering and development of the Stallion as well as to manage all marketing activities. Detroit based Tecstar accepted responsibility for the engineering, validation and assembly of the special Mustangs.

When announced in the summer of 2005, Stallion production was to be limited to 3,000 units a year, which would be offered through select Ford dealers.

This, the very first Ford Mustang Stallion, number 001, was built and shipped to the 2006 Barrett-Jackson Scottsdale auction. On the auction floor it attracted much interest and the winning bid took it to Gateway, Colorado, where it joined other significant customs and street rods. Like the Packard Darrin of 65 years ago, it continues the tradition of private initiative joining major manufacturers to bring better cars to market.

A radical change was wrought on Ford's 2006 Mustang with relatively few new panels. Revised front and rear fascias (below), a new hood and grille and a lower stance – not to mention unique wheels (right) – combined with two-tone paint to make the Stallion a Mustang like no other.

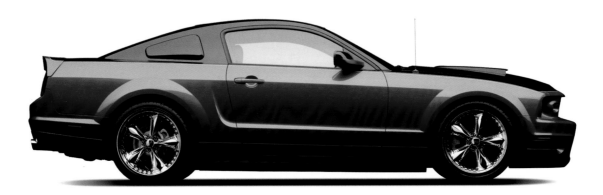

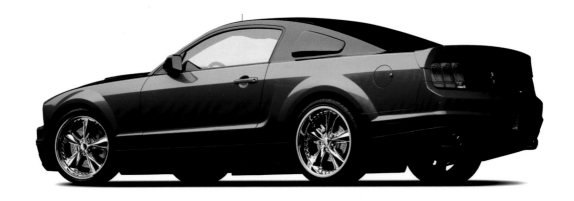

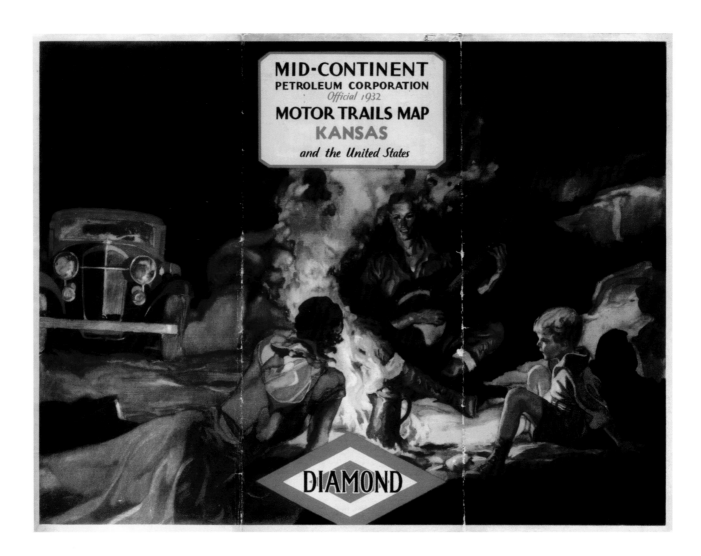

MID-CONTINENT
PETROLEUM CORPORATION
Official 1932
MOTOR TRAILS MAP
KANSAS
and the United States

DIAMOND

ACKNOWLEDGMENTS

In the course of this book project, many people have stepped forward to assist me and help with facts and memory. But before noting the many contributors, I'd like to thank Michael Furman for inviting me into the project, as well as John Hendricks for providing this opportunity. It was also a complete pleasure to work with designer Susan Marsh who showed equal parts professionalism and creativity. And once again I was delighted to work with artist Peter Hearsey. I also have to thank my wife, Beki, and daughter, Remy, who put up with my many long hours at the computer.

The many people who aided my research included: Gorden Apker, John Biel, Jon Bill, Tom Brownell, Pete Costisick, Robert Ebert, Randy Ema, Patrick Ertl, Patrick Foster, Joseph F. Freeman, Pat Gauntt, David L. George II, Bernie Golias, Ken Gross, Greg Jones, Beverly Rae Kimes, Michael Lamm, Tara Mello, Mike Mueller, Douglas Neale, Jed Rapoport, L. Spencer Riggs, Jim Sitz, Gene Tareshawty, Michael Tillson, Jim Wagner, Gordon White. I'd also like to thank John Hendricks' staff and the dozens of people who answered a single phone call or e-mail and referred me on to another source.

The maps and advertisements pictured in the book are just a small sampling from the Hendricks Collection, which is on display at the Gateway, Colorado Auto Museum.

BIBLIOGRAPHY

Antonick, Michael, *Corvette Black Book: 1953-2003*, Michael Bruce Associates, 2003.

Borgeson, Griffith, *Errett Lobban Cord: His Empire, His Motor Cars: Auburn Cord Duesenberg*, Automobile Quarterly, 1983

Burton, Jerry, Zora Arkus-Duntov: *The Legend Behind Corvette*, Bentley Publishers, 2002.

Dunham, Terry and Gustin, Lawrence, *The Buick: A Complete History*, Automobile Quarterly, 1992.

Ema, Randy, "The Man Behind the Machines: Friedrich S. Duesenberg," *Automobile Quarterly*, Volume 30, Number 4, Summer 1992, pages 4-13.

Flammang, James M. and Kowalke, Ron, *Standard Catalog of American Cars, 1976-1999*, Krause Publications, 1999.

Fenster, J.M., *Packard the Pride*, Automobile Quarterly, 1989.

Fenster, J.M., "The Battle of the Hollywood Hills," *Automobile Quarterly*, Volume 27, Number 1, Fourth Quarter, 1989, pages 382-395.

Foster, Kit, "Terraplane: Flying by Land," *Automobile Quarterly*, Volume 39, Number 1, May 1999, pages 64-79.

Georgano, Nick, *The Beaulieu Encyclopedia of the Automobile*, The Stationery Office, 2000.

Georgano, Nick, *The Beaulieu Encyclopedia of the Automobile — Coachbuilding*, The Stationery Office, 2001.

Gunnell, John, *Standard Catalog of American Cars, 1946-1975*, Krause Publications, 1987.

Hendry, Maurice D. and Holls, David, *Cadillac Standard of the World*, Automobile Quarterly, 1990.

Katz, John F, *Soaring Spirit: Thirty-Five Years of the Ford Thunderbird*, Automobile Quarterly, 1989.

Kimes, Beverly Rae, "Billy Durant," *Automobile Quarterly*, Volume 40, Number 3, August 2000, pages 18-33

Kimes, Beverly Rae, *The Cars That Henry Ford Built*, Automobile Quarterly, 1978.

Kimes, Beverly Rae, *Packard: A History of the Motor Car and the Company*, Automobile Quarterly, 2002.

Kimes, Beverly Rae, Pioneers, *Engineers and Scoundrels: The Dawn of the*

Automobile in America, SAE, 2005.

Kimes, Beverly Rae, *Standard Catalog of American Cars, 1815–1942*, Krause Publications, 1989

Kowalke, Ron, *Standard Catalog of Independents*, Krause Publications, 1999.

Lamm, Michael, "Mysterious Ways: The Long, Strange Trip of the 1954 Oldsmobile F-88," *Collectible Automobile*, October 2003.

Lenzke, James T., *Standard Catalog of American Light-Duty Trucks*, Krause Publications, 2001.

McCoy, Theresa L. "1955 Chrylser C-300: Grandaddy of Muscle," Automobile Quarterly, Volume 34, Number 1, April 1995, pages 100–109.

Mroz, Albert, *The Illustrated Encyclopedia of American Trucks and Commercial Vehicles*, Krause Publication 1996.

Mueller, Mike, "By Invitation Only," *Automobile Quarterly*, Volume 30, Number 3, Spring 1992, pages 4–13.

Mueller, Mike, "When the Skylark Soared," *Automobile Quarterly*, Volume 40, Number 2, May 2000, pages 6–17.

Ralston, Marc, *Pierce-Arrow*, A.S. Barnes & Company, 1980.

Rosenbusch, Karla A., "Chrysler 300C," *Automobile Quarterly*, Volume 39, Number 2, July 1999, pages 100–109.

Rosenbusch, Karla A., "Walter P. Chrysler: An American Workman," *Automobile Quarterly*, Volume 32, Number 4, April 1994, pages 6–17.

Schooling, Dwight, "Taking the High Road: People Who Owned Them," *Automobile Quarterly*, Volume 30, Number 4, Summer 1992, pages 70–79.

Stern, Philip Van Doren, *Tin Lizzie: The Story of the Fabulous Model T Ford*, Simon and Schuster, 1955.

Tast, Alan, *Thunderbird 1955–66*, Motorbooks International, 1996

Ward, James A., *The Fall of the Packard Motor Company*, Stamford University Press, 1995.

Weiss, Bernie, "Early Success," *Automobile Quarterly*, Volume 28, Number 4, Fourth Quarter 1990, pages 12–33.

Weiss, Bernie, "The Big Pierces," *Automobile Quarterly*, Volume 28, Number 4, Fourth Quarter 1990, pages 34–53.

COACHBUILT PRESS
PHILADELPHIA

Coachbuilt Press

115 Arch Street

Philadelphia, Pennsylvania 19106

www.coachbuiltpress.com

Published in conjunction with

Gateway Colorado Auto Museum

43200 Highway 141

Gateway, Colorado 81522

ISBN 0-9779809-0-1

Library of Congress Control Number: 2006925319

Photographs by Michael Furman made with PhaseOne digital capture on Sinar 4x5 and Hasselblad H1 cameras.

Studio lighting by Broncolor. All photographs taken at Hill Theatre Studio, Paulsboro, New Jersey.

Studio assistants include Esteban Grenados, Dave March, Bill Wynes, Dan Mezick, Ken Burgess, and Shawn Brackbill.

Digital imaging by David Phillips and Mary Dunham performed on Mac G5 computers running PhotoShop software.

Illustrations by Peter Hearsey

Manuscript edited by Merrill Furman

Typeset in Neutraface, a typeface designed by House Industries

Text and cover design by Susan Marsh

Printed on Galerie Art Gloss 100# Text

Printed by Brilliant Studio, Inc., Glenmoore, Pennsylvania

Bound by Advantage Book Binding, Inc., Glen Burnie, Maryland

FIRST EDITION